GREAT TREASURES OF

POMPEII

& Herculaneum

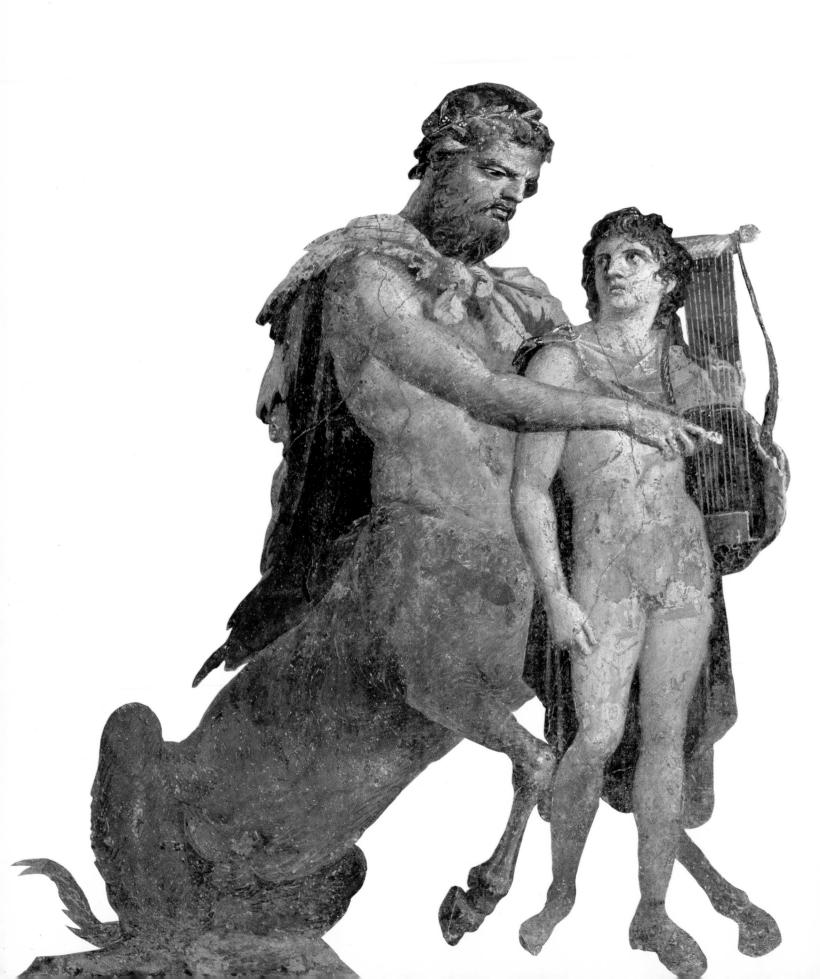

GREAT TREASURES OF

POMPEII & Herculameum

INTRODUCTION AND COMMENTARIES BY

THEODORE H. FEDER

ABBEVILLE PRESS, INC. • PUBLISHERS • NEW YORK

The following photographs were supplied by:
Scala/Editorial Photocolor Archives (EPA): pages
13 through 25, 29 through 37, 41 through 71, 75
through 103, 107 through 127, 131 through 135,
145 through 151, 155, 157
Xerox Corporation: pages 27, 39, 73, 105, 129,
137 through 143, 153

Library of Congress Cataloging in Publication Data

Main entry under title:

Great treasures of Pompeii and Herculaneum.

1. Art, Greco—Roman—Italy—Pompeii. 2. Art—Italy—Pompeii. 3. Pompeii. I. Feder, Theodore.

N5770.G73 709'.37'7 78-15505
ISBN 0-89659-021-6

© Copyright by Abbeville Press, Inc., 1978. All rights reserved. No part of this book may be reproduced or utilized in any form or by any means, electronic or mechanical, including photocopying, recording or by any information storage and retrieval system, without permission in writing from the Publisher. Inquiries should be addressed to Abbeville Press Inc., 505 Park Avenue, New York 10022. Printed and bound in U.S.A.

CONTENTS

The Forum, Pompeii	Rehearsal for a Satyr Play58-59
Bacchus and Mount Vesuvius	The Actor King60-61
Crossroads of Stabia and Nola Streets 16-17	Menander
Bakery Stall	Scene from a Comedy64-65
Mill and Bakery of Modestus 20-21	The Street Musicians66-67
Amphora With Cupids22-23	Consultation With a Sorceress
Cupids as Goldsmith Workers24-25	The Amphitheater of Pompeii70-71
Gold Lamp	Chariot Race72-73
Cupids as Flower Vendors28-29	Wall Decoration With Apollo Victorious
"Beware of Dog"30-31	Over Python74-75
Atrium, Tablinum, and Peristyle: House	Three Graces76-77
of the Menander32-33	Perseus Frees Andromeda78-79
Banqueting Scene	Pentheus Slain By Maenads80-81
Lovers on a Couch	Chiron Teaching Achilles to Play
Silver Patera	the Lyre82-83
The Astragal Players40-41	Hercules Strangles the Serpents84-85
The Citharist	The Ixion Room86-87
Street in Herculaneum44-45	Daedalus Presents the Cow to Pasiphae 88-89
Waterside Villa46-47	Sacrifice of Iphigenia90-91
Portrait of a Young Woman With Stylus 48-49	The Surrender of Briseis92-93
Double Portrait50-51	Primavera94-95
Portrait of a Woman52-53	Diana96-97
Bust of So-called Scipio Africanus54-55	Court of the House of Neptune and
Scenographic Wall Decoration56-57	Amphitrite

Punishment of Dirce100-101	Harbor Scene
Apollo	Idyllic Landscape With Sailing Vessel132-133
Statue of Aphrodite104-105	Sacred Landscape
Dancing Satyr106-107	Pan and the Nymphs
Maenad108-109	Gold Necklace, Armband and Bracelet138-139
Villa of Mysteries: Lustration110-111	Earrings140-141
Villa of Mysteries: Silenus112-113	Cobalt Blue Goblet142-143
Villa of Mysteries: Winged Daemon114-115	Bowl with Birds and Cat144-145
Villa of Mysteries: the Flagellation116-117	Marine Still Life146-147
Scene from Boscoreale118-119	Still Life in Two Registers148-149
Alexander Mosaic120-121	Still Life With Bowl of Fruit
School of Plato	Leopard
The Trojan Horse124-125	Fauna of the Nile
Judgment of Solomon126-127	Death, the Great Leveler
Ceremony in a Temple of Isis128-129	Bibliography

INTRODUCTION

In the First Century A.D. Juvenal complained in his *Satires* that the Rome in which he lived was plagued by muggers, overcrowding, noise, inflation, crumbling tenements, and traffic jams. He advised a friend to repair to the Campanian town of Cumae, about thirty miles from Pompeii, and proclaimed his own intent to go to the countryside. His friend concurred: "Farewell Rome, I leave you to sanitary engineers and municipal architects, who by swearing black is white, land all the juicy contracts." He can no longer stay in the capital city because he has never learned to lie, nor to puff a bad book.²

Campania, said the geographer Strabo, was the most blessed of all plains, ringed by fruitful hills, and producing the finest grains, vegetables, olives, and wines.3 Romans went there to escape the tensions of the capital, some to retire in their old age, others simply to vacation. Sojourners, intending to stay briefly, fell in love with the area and settled, discovering there a great number of residents of the same culture as themselves. Campania's chief resort centers and towns were Cumae, the smart watering spot of Baiae, Sorrento, the Island of Capri, and the regions around Puteoli, Naples, and Pompeii. Herculaneum was known as a particularly healthful place, because it sat on a promontory running out to the sea, which admirably caught the southwest breezes. Pompeii was a bustling commercial, agricultural, and resort town, built on the foothills of Vesuvius, and receiving gentle sea breezes in the day and cool mountain breezes at night. The whole of the coast along the Bay of Naples was adorned by towns, residences, and plantations, which intervened in unbroken succession, presenting the appearance of a single city. This is still very much the case today, and the tradition seems to be unbroken; in the fourteenth century Boccacio described the region as "full of little cities, of gardens, of fountains, and of rich men."

Above these places loomed Mount Vesuvius, whose slopes were dotted with dwellings, vineyards, and beautiful farms. There had been no eruption there in recorded history, although Strabo suspected from the burnt rocks at its summit that it had once been an active volcano. To this he attributed the fruitfulness of the lands around the mountain, saying that it had already been shown at Mount Aetna that volcanic ash was particularly suited for the vine. The essayist Varro had a farm on Vesuvius, which he greatly valued for its wholesome and light mountain air. The elder Pliny maintained that no region on earth was more joyously touched by nature.⁵

As there was certainly no reason to be fearful, there was no reason to avoid the beautiful region, though judging from the settlements which crowd the area today, it is doubtful that even the knowledge of danger would have kept people away. Nevertheless, a disastrous earthquake—a portent of things to come—occurred without warning on February 5 in 62 A.D., seventeen years before the cataclysmic eruption. The event was described by Seneca in the *Naturales Quaestiones:*

We have heard that Pompeii, the very lively city in Campania where the shores of Surrentum and Stabiae and that of Herculaneum meet and hem in a lovely, gently retreating inlet from the open sea, has been destroyed by an earthquake which also struck the entire vicinity. This occurred in winter, a time which our fore-

fathers always held to be free from such perils . . .The region had never before been visited by a calamity of such extent, having always escaped unharmed from such occurrences and having therefore lost all fear of them. Part of the city of Herculaneum caved in; the houses still standing are in ruinous condition.⁶

This was a terrible blow but not a mortal one, and the energetic inhabitants set about rebuilding their ruined towns. Gradually over the next seventeen years, life returned to its normal pace, save that there is some evidence of an economic reshuffling in Pompeii, as patricians ruined by the quake made way for a resilient and prosperous bourgeoisie. These tradesmen took over many of the patrician mansions and rented out parts of the premises for shops and taverns. The city's vibrant political life continued as before, and over fifteen hundred wall inscriptions, promoting various candidacies, survive from its last year alone. Fisheries, farms, and vineyards returned to normal production. Pompeii's permanent theaters, which predated those of Rome, continued to present their plays, and judging from the innumerable theater motifs which crop up in Pompeian wall decoration at this time, plays were more popular than ever, influenced, no doubt, by the example of the stage-struck Nero, who had appeared on the boards in nearby Naples in 64 A.D. Then, amidst returning prosperity, there came into the lives of these industrious, indomitable, and pleasure-loving people a second and final catastrophe, from which it was impossible to recover.

It struck on the morning of August 24, 79 A.D., ironically only a day after the annual celebration of the Volcanalia, the festival of the Italian god of volcanic fire and forge, Volcanus. History owes an inestimable debt to Pliny the Younger, who witnessed the catastrophe, albeit from a short distance, and left a description in two letters addressed to the historian Tacitus. Pliny was staying with his uncle, the noted author Pliny the Elder, at Misenum on the Bay of Naples (about fourteen miles by water from Herculaneum and twenty from Pompeii), where the elder Pliny was stationed as admiral of the fleet:

On August 24, mother drew my uncle's attention to a cloud of unusual size and appearance . . . best described as being like an umbrella pine, for it rose to a great height on a sort of trunk and then split off into branches. Sometimes it looked white, sometimes blotched and dirty, according to the amount of soil and ashes it carried.⁷

The elder Pliny ordered the fleet out to help as many as possible. He also went to the site to give aid and to observe the phenomenon. As his ship approached Stabiae, about four miles from Pompeii, ashes were already falling, hotter and thicker, followed by bits of pumice and blackened stones. On Mount Vesuvius, broad sheets of fire and leaping flames blazed. Pliny spent the night on the shore, during which "the buildings began to shake and swayed to and fro as if torn from their foundations." It seemed better to risk going outdoors, but as there was the danger of falling pumice stones, even though these were light and porous, the party tied pillows to their heads.

As the hours of day came, it was still "blacker and denser than any ordinary night." Then came the flames and smell of sulphur, mephitic vapors that drove Pliny's companions to flight. He rose to leave, but suddenly collapsed from the noxious fumes and died. His nephew, remaining near Misenum, saw the sea sucked away and forced back by quakes, leaving a quantity of sea creatures stranded on dry land. A dark cloud spread over the earth like a flood and covered the sea: it blocked out Capri and the promontory of Misenum. "You could hear the shrieks of women, the wailing of infants, and the shouts of men, some were calling their parents, others their children or wives . . . I derived some poor consolation in my mortal lot from the belief that the whole world was dying with me, and I with it."8 Finally, when light came two days later, everything in Misenum had changed, buried deep in ashes, like snowdrifts.

At Herculaneum, Pompeii, and nearby Stabiae, things were much worse. From 12 to 18 feet of volcanic ash and pumice buried Pompeii, and only the tops of the tallest buldings showed through. All who had not left the city in the first hours died, either from the accumulation of

volcanic debris (lapilli) the collapse of buildings, or in many cases, the poisonous vapors. It is estimated that of an approximate population of twenty thousand, two thousand, who were trapped in the city, or who for some reason chose to remain, perished. Herculaneum did not suffer from the same fall of lapilli. Instead, it succumbed to huge flows of lava mud, which had been churned up by the boiling steam emitted from Vesuvius, and the torrential downpours that this caused. The river of mud and lava which descended upon the town covered it over to a depth of fifty to sixty feet. This mass hardened to the consistency of concrete. Many centuries later, while it is comparatively easy to dig beneath the surface of Pompeii, it is still difficult to excavate the rock which encapsulates Herculaneum. The oozing mud scorched cloth and wood, but frequently it did not destroy but only carbonized them. As a result, much organically transformed material remained in existence. Many buildings were left damaged but standing, preserving their durable contents within. So too at Pompeii, practically everything not crushed by the weight of the accumulated debris survived; glassware packed in straw, eggshells, household goods, wall paintings, objets d'art-all were sealed in a protective casing of volcanic ash.9

On August 25 and 26, a harmless thin white ash rained on Rome, borne by winds driven from Vesuvius, one hundred and sixty miles to the south. The Emperor Titus looked out upon the capital covered as if by snow in summer, and when told of its cause, appointed two former consuls to head an investigation and to oversee rebuilding in Campania. He visited the disaster site himself a year later, but all meaningful efforts at reconstruction had to be abandoned. At best, and only at Pompeii-where it was possible to dig beneath the surface—former residents and possibly thieves sank shafts in search of personal and other valuables. Some of these early excavators died when they encountered pockets of the noxious vapors, and gradually all efforts to recover the sites were abandoned.

Titus, who had earned his reputation as the conqueror of Judaea, had been emperor less than two months when the catastrophe oc-

curred. Curiously, the eruption struck practically nine years to the day after his legions had sacked and burned the Temple in Jerusalem, and massacred its defenders. A year later, in 80 A.D., a great famine occurred, producing a plague in Rome, "the likes of which had hardly ever been seen before." It was possibly brought on by a crop failure in Campania. Titus's reign was short-lived; he died outside Rome on September 13, 81 A.D.

Of the eruption, the Campanian poet Statius asked in the *Silvae*, "Will future centuries, when new seed will have covered the waste, believe that entire cities and their inhabitants lie under their feet, and that the fields of their ancestors were drowned in a sea of flames?"

As memory of the event waned and other misfortunes befell the Empire, future generations did not believe because they did not know of the catastrophe. The planted fields which overgrew Pompeii came to be called Civitas, Civita, or La Citta, preserving in this simple name the vestigial identity of "city," though no one knew which town the words commemorated. The cities were not mentioned in the Middle Ages, but in the literature of the Renaissance they received some attention, and in 1551 Leonardo Alberti, using ancient sources, described the eruption in his *Descrittione di tutta Italia*. 11

Pompeii was discovered inadvertently in 1592, when Domenico Fontana, the Roman architect, cut a canal across the city; but neither he nor his patrons associated its artifacts with the legendary Pompeii, and serious excavation was not undertaken for another one hundred and fifty years. In 1602, the Prince d'Elboeuf explored a well sunk on the sight of Herculaneum and discovered the remains of the theater. In the next thirty years, through mine shafts and tunnels he had dug through part of the town, he despoiled the treasures he had discovered and dispersed them to various European cities.

It was not until the middle of the nineteenth century that a systematic program of excavation—in keeping with the best archaeological principles of the day—was undertaken. Under Giuseppe Fiorelli (1860-1875), Michele Ruggiero (1875-1893), Vittoria Spinazzola (1910-1924), and Amadeo Maiuri (1924-1961), i increasing

portions of the towns were unearthed and for the most part carefully preserved, some objects being moved to the National Museum in Naples, some carefully retained where they were found. About a quarter of Pompeii and a larger proportion of Herculaneum still remain to be excavated.

Today, we know that Pompeii was a thriving town of modest size, deriving its income in part from the production of wine (under the labels vinum vesuvium and the highly prized Falernian), the pressing of olives, the cultivation of cabbage, onions, and vegetables. Its mercantile and artisanal life was no less important; it was the chief port for the inland towns of the Sarno plain, Nuceria and Nola. It packaged and shipped throughout the Empire the much loved fish sauces garum, liquamen, and muria, which Pliny says were among the best brands available. It supported corporations of dyers, cloak-cutters, and fullers, and had an active wool trade, which was housed in the Building of Eumachia, an early form of guild hall. The other professions that it supported included carpenters, wheelwrights, plumbers, jewelers, goldsmiths, gem-cutters, marble workers, painters, prostitutes, hotel keepers, and many others

Its great theater (ca. 200-150 B.C.) could seat five thousand, and predates the first permanent stone theater of Rome by over a century. Its smaller roofed theater, the theatrum tectum, had accommodation for approximately one thousand two hundred and served as an odeum for music, dance, mime, and recitation. The amphitheater, with a capacity of twenty thousand, was the oldest of its kind and predates the Roman Colosseum by one hundred and fifty years. It had enough places for every inhabitant in town, but it is likely that it drew its audience from surrounding settlements as well. Thus, while it is narrowly correct to say-as many have—that Pompeii was not a town of great importance and that it produced no famous men. it should be pointed out that it had an unsung significance, disproportionate to its size, even in its own day. The relatively high cultural level may in part be attributed to the influence of

men of attainment who lived in or near Pompeii, even if only seasonally. To cite a few of the examples we know: Cicero had a villa at Pompeii, which he declared gave him much pleasure. The Emperor Augustus's adopted son, Agrippa Postumus, owned a villa nearby at Boscotrecase. Claudius, the future emperor, occupied a house there, where his son Drusus is said to have choked to death on a pear while playing in its garden.

Today, Pompeii eclipses all its urban rivals, save Rome, for what it miraculously and tragically bequeathed to us. It is, for example, chiefly through the wall paintings discovered in the buried cities that we can piece together the history of Greek and Roman painting to that time. Not one mural painting by any of the famous Greek masters comes down to us, while at Pompeii alone, hundreds of wall paintings—copies and originals—survive. Nowhere else do we have such a full and beguiling picture of Roman life, one which resembles our own perhaps more than any other intervening period in history.

- 1. Satires, III
- 2. Satires, III, 42-3
- 3. Geography, V, 4
- 4. Geography, V, 4,8
- 5. Natural History, III, 40
- 6. VI, De Terrae Motu, (trans. in Kraus, 10)
- 7. Letters, VI, 16
- 8. Letters, VI, 20
- 9. Grant, 32
- 10. Suetonius, The Deified Titus, VIII, 3-4
- 11. Kraus, 13
- 12. Kraus, 16

I am indebted to a number of writers who have made important contributions to a study of the Vesuvian cities and to an understanding of the life and art of the period. They are: August Mau, Amadeo Maiuri, Margarete Bieber, Michael Grant, Theodor Kraus, and Jocelyn Toynbee. In addition, I would like to express my gratitude to Professor Paula Gerson for her very kind aid and encouragement, and to Professor Mark Morford and Leslie Naughton for their generous help.

THEODORE H. FEDER

GREAT TREASURES OF

POMPE!

& Herculaneum

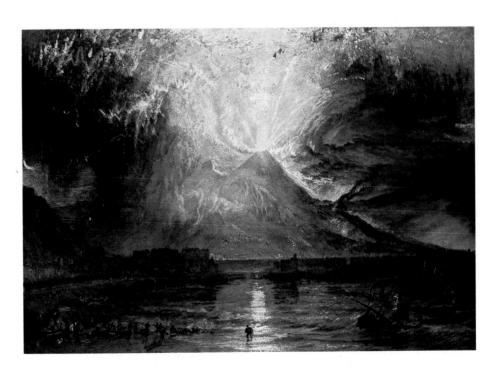

Vesuvius in Eruption, a painting by J. M. W. Turner Courtesy, Yale Center for British Art, Paul Mellon Collection

The Forum, Pompeii

T HE FORUM OF POMPEII was the commercial and administrative center of town. Its great open space, paved with flags of limestone, served as a plaza for meetings and strolls and was reserved for stalls on market days, which as we know from an inscription fell on Saturday.\(^1\) A permanent meat, fish, and provision market, the Macellum, abuts the Forum at the northeast corner. It had a large central courtyard surrounded by many stalls in which fresh produce was sold every day. Nearby, on the east side is the Sanctuary of the City Lares, the Temple of Vespasian, and the Building of Eumachia, the seat of the corporation of wool merchants.

This view of the Forum faces north toward Vesuvius, which has developed its distinctive double peaks since the days of Pompeii. Its contours change with every major eruption, which over the last three centuries have occurred on an average of once every thirty-five years; the last eruption occurred in 1944.

On the south side, three buildings housed the administrative offices of the town government; the Chambers of the Duoviri, the principal municipal officers who exercised a mayoralty power; the Hall of the City Council; and the Office of the Aediles, who supervised public works, markets, streets, and civic services. All these officials were elected annually by vote of the qualified electors.

The Forum was delineated by a series of two-story colonnades going around three sides, forming covered walkways for the populace and porticoes for the buildings behind. The only structure to intrude into the Forum rectangle is the Temple of Jupiter at the north end, with its facade much ruined from the quake of 62 A.D. and the eruption.

Vehicles were not allowed into the Forum, and great pains were taken to block them by placing steps at the street exits or by the raising of stone blocks, which served as permanent barriers. Many empty plinths attest to the multiplicity of commemorative statues that originally stood in the Forum.

1. C.I.L., IV, 4182

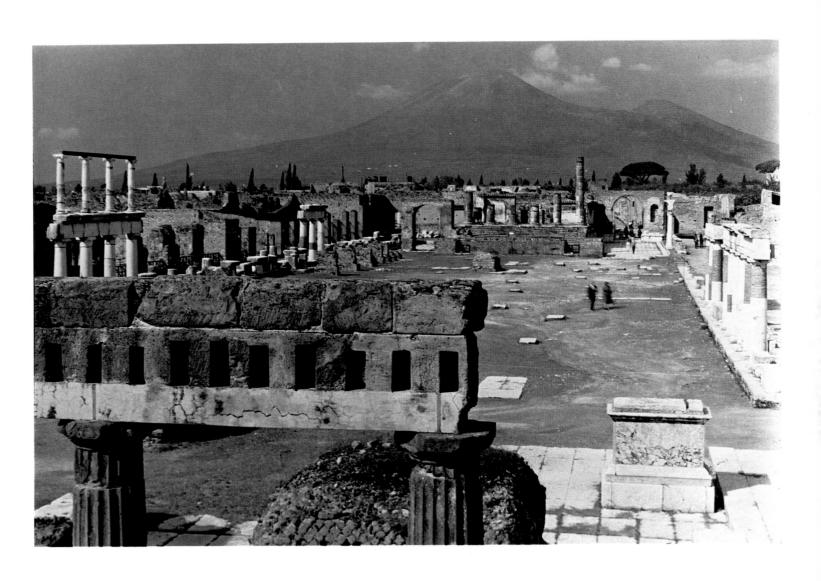

Bacchus and Mount Vesuvius

Wall painting from a household shrine. House of the Centenary, Pompeii, Museo Nazionale, Naples

No other painting better represents the beneficent location and prosperity of Pompeii in its heyday than does this work. It shows the divine and fertilizing Bacchus at the foot of Mount Vesuvius. Bacchus, the god of wine, vegetation, and religious orgia, is himself shaped like a bunch of grapes, and their fullness infuses him with the properties of abundance and well-being, which by association extend to the town. This motif of plentiful riches echoes in later Christian art through the many-breasted Charity, who gives life through the milk of her breasts, much as the vineyards of Vesuvius give sustenance to the town of Pompeii. Trees and trellised vineyards are depicted along the slopes of the mountain, while the rocky summit is barren, exactly as Strabo, the Greek geographer, described it. 1

Bacchus holds the thyrsus, a wreathed and tipped wand that is one of his attributes, and because this is a painting in a household shrine, or lararium, he is shown pouring out the wine as an offering to the household spirits. The panther at his feet is one of the wild species sacred to him. The serpent at bottom approaches an altar on which food, cakes, or fruit have been placed; he represents the tutelary spirit of the house come to partake of the offering.

Wine played an important role in the economy of the town. Nearly all the *villae* rusticae outside the walls were engaged in the production of wine, including a table wine, the *vinum vesuvium* (now bottled as *Lacrima Christi*) and the more highly prized Falernian, which was shipped around the Empire.

The poet Martial, recalling the days before the eruption, spoke of both Bacchus and Vesuvius. His lament in the *Epigrams* could serve as a commentary to this painting: "This is Vesuvius, shaded yesterday with green vines, here had its far famed grapes filled the dripping vats. These ridges Bacchus loved more than the hills of Nysa, on this Mount of late the Satyrs set afoot their dances. This was the haunt of Venus, more pleasant to her than Lacaedamon; this spot was made glorious by the name of Hercules. Now all lies drowned in fire and grey ash . . ."²

1. Geography, V, 4 2. IV, 44

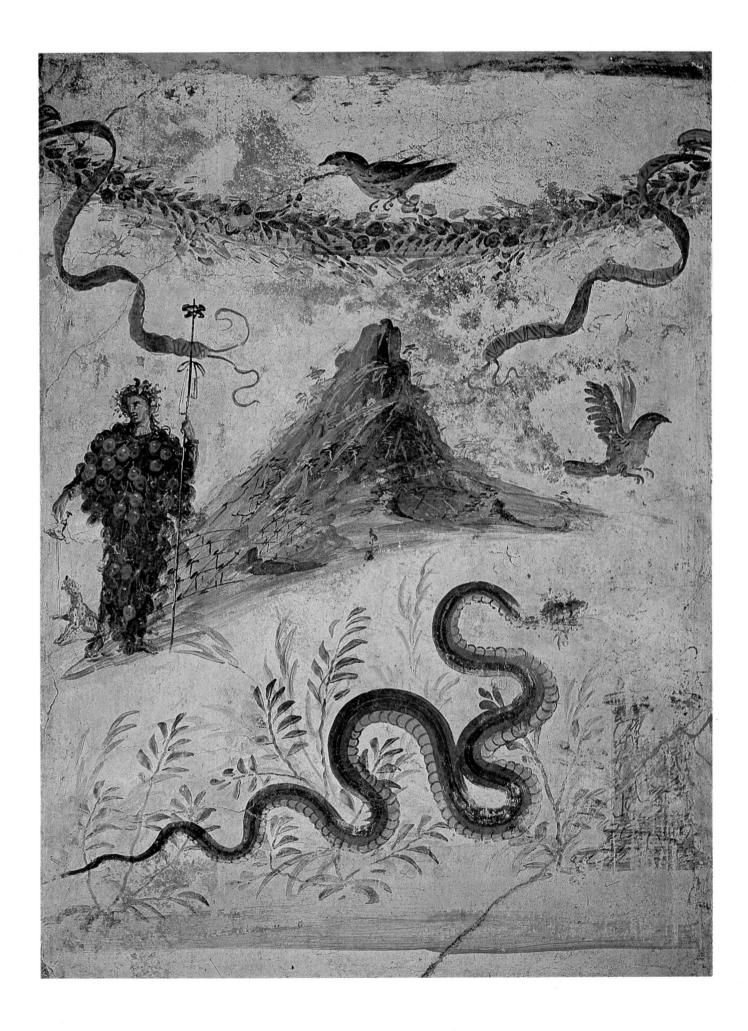

Crossroads of Stabia and Nola Streets, Pompeii

Modern urban street engineering owes much to Roman advances in the field. The intersection of Nola and Stabia streets seen here was one of the busier crossroads in Pompeii. All the principal streets were paved with polygonal blocks of basalt, which were laid so well that they still withstand the considerable tourist traffic. The sidewalks are raised higher than they would be today, and usually bear a curbing of basalt or tufa. Steps lead into the street at the corner for those who need to descend there, but the usual way of crossing was to employ the large stepping stones that were placed at principal points and at every corner. These enabled the pedestrian to cross to the other side without running into sewage or water flowing down the thoroughfare. When it rains, streams of water course down the inclined streets and collect in large storm sewers at the city walls. The stepping stones indirectly help to moderate traffic, as they force drivers to slow their vehicles while guiding the wheels through the spaces between them. Doubtlessly, this also contributed to a certain standardization in the wheel placement of vehicles and in the height of the undercarriage.

To the left, this corner has a water fountain—as many intersections do—composed of four slabs of basalt joined at the sides to form a rectangular catch basin. Another raised basalt block, carved with a drunken silenus, carries the feed pipe, which throws a jet of water through the open mouth of the silenus. Behind the fountain is a street-side shrine, consisting of an altar and a low wall terminating in a tiled gable. Such shrines, dedicated to guardian deities, were quite common and have obviously been incorporated into later Christian practice in Latin countries.

To the rear of the shrine is a high columnar structure with a groove running down the side. This was one of the many local water towers which served as neighborhood reservoirs; the groove held the principal feed pipe which brought water from the main reservoir. Many smaller water pipes led from the tower to the adjacent houses. As Mau has pointed out, most comfortable homes had running water; the nearby House of the Vettii, had sixteen running jets, regulated by stopcocks.

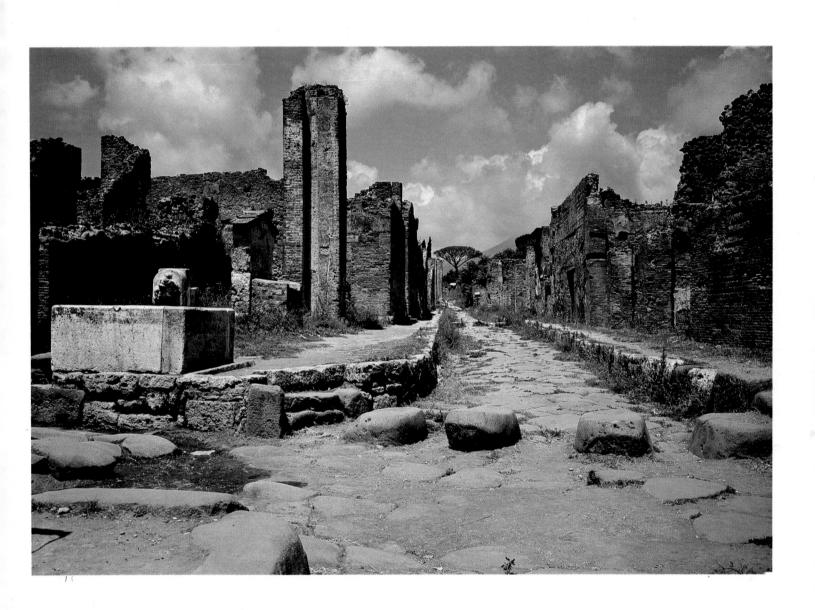

Bakery Stall

Wall painting from Pompeii, Museo Nazionale, Naples

 $T_{\rm HIS}$ is one of the many scenes of daily life for which we are so indebted to Roman painters. They were much more inclined to depict the day-to-day routine of average people than were their Hellenistic predecessors, and it is they who are the great pioneers in genre painting.

This painting shows a baker selling bread from a makeshift stall, possibly of the kind set up on market days in the Forum square. The round notched loaves were typical of the period and a variant is still available today in Italy. The perspective of the stall, piled high with its bread, is very convincing.

It has been suggested—because of the somewhat lordly air of the man behind the counter—that this is not a baker at all, but an official distributing bread as an act of public charity. This would perhaps explain his somewhat elevated position behind the counter, as well as his air of composure. The theory is interesting, but not proved. There were occasional bread shortages, and it has been intimated by Petronius that bakers and food overseers would collude to drive up prices.

It is possible that both of these theories are true: this may be a baker who was also an official of the town. Records show that one Paquius Proculus, a baker, was elected to the high office of aedile, whose principal function was the supervision of the markets and public works. One of the duties of new officials was to undertake at their own expense some civic work. While many contributed to public games or construction, Paquius may have spent his money in an official bread distribution, one which was very likely to fix his name and profession in the eyes of the ever-watchful electorate. Fittingly, Proculus, or another baker in a similar situation, might well have wished to commemorate such an event through a painting.

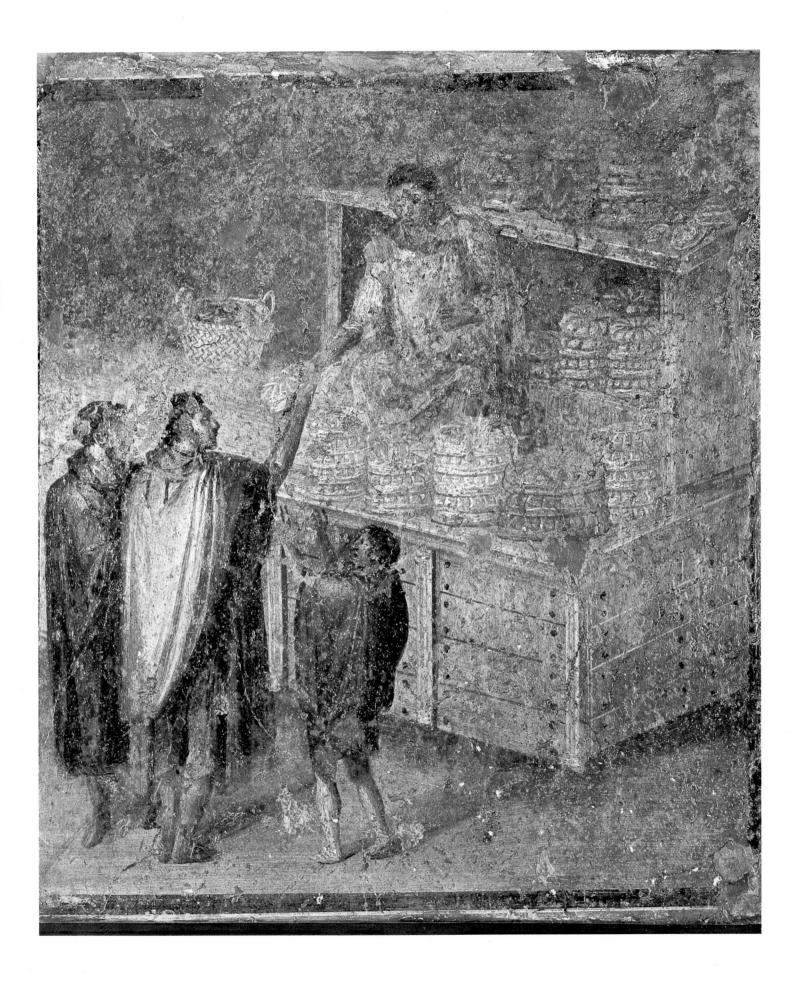

Mill and Bakery of Modestus, Pompeii

 $F_{\text{ORTY BAKERIES HAVE BEEN DISCOVERED}}$ thus far at Pompeii, indicating that there was at least one for every small neighborhood. The bakers milled the grains and baked the bread on their own premises, and the surest sign of a baking establishment is the presence of such a mill. We know of at least ten varieties of bread baked by the Romans. 1

This shop, with four mills and an adjacent oven, belonged to the baker Modestus. Each mill is composed of two millstones made of local Vesuvian lava or from the more crystalline lava of Rocca Monfina. One conical stone is placed below, and another biconical stone fits over it. An iron pivot in the lower stone keeps the upper one just far enough above to permit it to revolve freely. Two rectangular openings at the waist held the wooden beams that turn the mill. The beams are pushed either by human force—very likely slaves—or by beasts of burden. The grain was poured into the funnel at top and was collected at the bottom in trays after it was ground.

Vesta, the goddess of the hearth, had a festival that was celebrated with much revelry by bakers (the Vestalia) on July 9, and by Roman householders, recalling the days when their forebears baked bread on the domestic hearth. (Bakers began to take over this function in the middle of the second century B.C.) During this festival, the mills were crowned with wreaths, and the animals who turned them were garlanded with flowers and loaves of bread.

Modestus the baker must have been busy at work the morning of the eruption. When his bakery was excavated, eighty-one loaves of bread were found nearly intact within the almost airtight oven. There had been no time to remove them.

1. Grant, 197

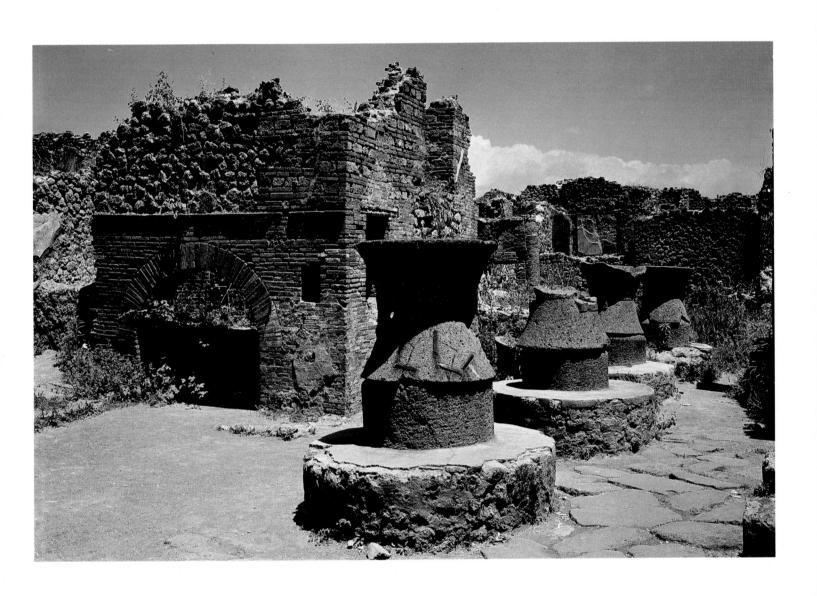

Amphora With Cupids

Museo Nazionale, Naples

T HIS NARROW-NECK AMPHORA BEARS a scene depicting amorini, or cupids, picking grapes and enjoying the fruit of the vine. The cupids, vines, and other objects are carved from a layer of opaque white glass that has been laid over the blue glass vessel. The technique—which resembles that employed for the making of cameos—is a sophisticated and costly one. This much-prized amphora was discovered in a tomb on the Via dei Sepolchri, just outside Pompeii, and is today known as the "Blue Vase."

The side pictured here shows a cupid standing on a pedestal and picking grapes. Another amorino at the far left does the same. Since pedestals normally support statues and not living beings, these are something of a tour de force, used playfully to cloud the line between reality and illusion. The cupid at center has put some grapes into the bowl balanced on his head and dangles a bunch over the outstretched hand of a reclining and somewhat dissipated figure below. This lounging cupid partakes of the fruit while listening to the music of the lyre played by a companion; he presents a perfect picture of the leisured life of the privileged. Vine tendrils, leaves, and large grapes fill the surface at the sides, and in the lowest register there is a band of alternating trees and reclining animals. On the opposite side, amorini are shown pressing grapes.

It has long been known that wine was a very important local commodity, produced on many farms and surburban estates. Wilhelmina Jashemski has recently shown that a vineyard existed even within the town walls. Her excavation of one near the Amphitheater at the edge of town has thus far unearthed the cavities of over two thousand vine roots. They were laid out according to the principles of Pliny and the agriculturalist Columella at intervals of four Roman feet, with paths intersecting the rows of vines. Part of the produce was sold to passersby at the owner's wine shop, which adjoined the busy Via dell' Abbondanza.

1. Kraus, 208

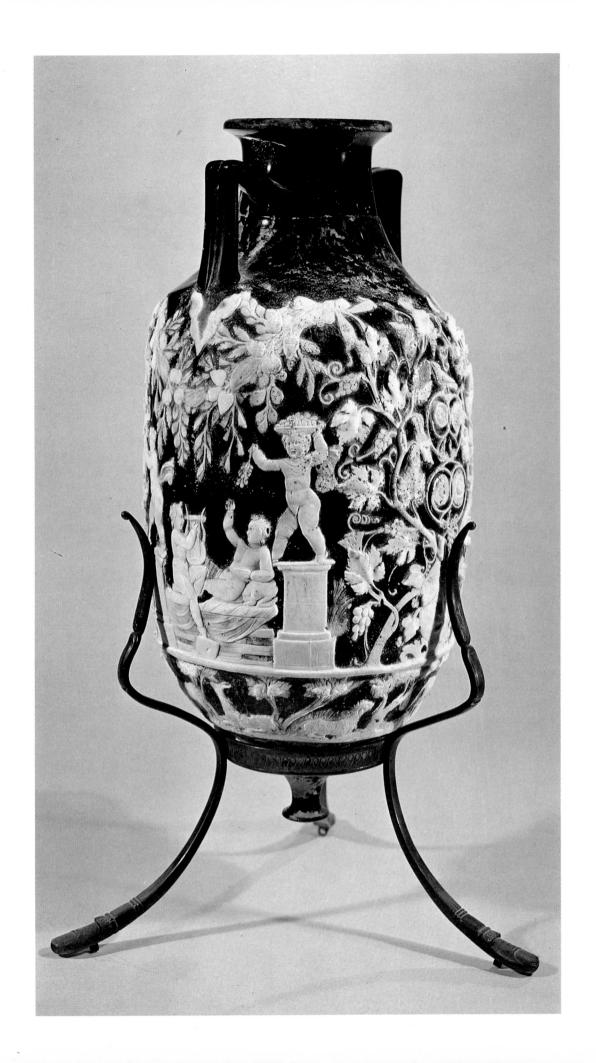

Cupids As Goldsmith Workers

Wall painting from the House of the Vettii, Pompeii

 $I_{\rm N}$ a beautiful sequence of narrow wall paintings from the House of the Vettii, cupids are shown laboring at the various crafts practiced in Pompeii. This scene shows them working as goldsmiths. At the right, a cupid places a gold object held by pincers into a furnace, while he controls the intensity of the flames through the use of a blowpipe. The cupid behind the forge, at the far right, is working on a large gold bowl, possibly with a graving tool. To the left of the furnace, a seated cupid hammers at a small anvil. Next to him, at the center of the shop, is the counter, very similar to such counters today, composed of three retractable drawers, filled with rings, bracelets, and other jewelry. On the counter are two jeweler's scales.

A female visitor, portrayed by a psyche (the female counterpart of a cupid), visits the shop and is seated rather grandly on a cushioned chair, left of center. The cupid attending her, possibly the owner of the establishment, weighs out an object that has caught her fancy. It is obvious that he is doing his best to make a sale, but he may be having some trouble with the question of weight, as she gestures to one side of the scale, he to another.

The two cupids at left work jointly over an anvil. One holds the object down with pincers, while arching his body to avoid the blow, and the other raises the hammer. The forge at right is adorned with a head of Hephaistos, the smith-god and patron deity of goldsmiths. Homer attests to Hephaistos' skill as a smith when he reports that the deity, who was known to be lame, constructed two movable maidens of gold, whom he employed to lean on when he walked. He worked equally well with clay, as he is said to have fashioned the first woman, Pandora, from that substance.

The figures are painted in yellow, brown, and gold against a burnished black background, with the result that these small luminescent cupids seem like jewels themselves. The artist's familiarity with the goldsmith trade indicates that he carried out a meticulous study of the profession.

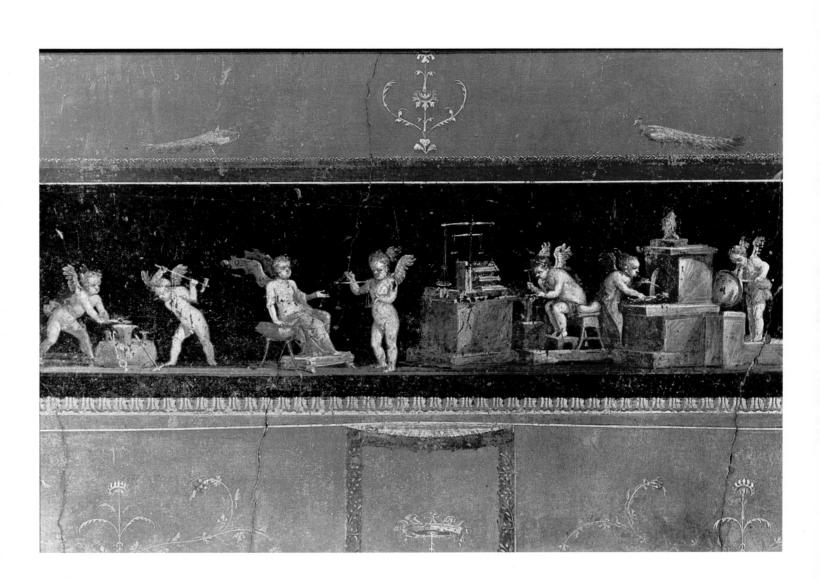

Gold Lamp From Pompeii

Museo Nazionale, Naples

R oman Lamps came in many forms, but the one shown here is unusual because it is made of gold. We know from numerous ancient sources that Romans collected plate made of silver and gold; but a gold lamp was a conspicuous luxury, since such fixtures were almost always made of clay or bronze. This portable example is handheld and could be set down at the bearer's will, perhaps amid guests who could the more easily admire it. Hanging lamps, by contrast, bore projections to which chains were affixed.

Lamps gave off a dim and somewhat smokey light, but it was possible to augment the candle power by increasing the number of nozzles. This lamp has two nozzles, and some have been found with as many as twelve. Candelabra were also used widely, and they normally supported lamps hanging by chains. One such surviving lamp holder is in the shape of a tree, with a lamp hanging from each outstretched branch. The vessel worked simply: oil was introduced to the bowl, usually through a hole in the lid, and the nozzle bore a hole through which the wick was drawn and later ignited.

The shape of the bowl and handle indicates that the design of this lamp was inspired by gold plate and cups. The nozzles and gold base were cast separately and were soldered on afterwards. Without them, the vessel has the distinctive appearance of the gold cups that have come down to us in a number of Greek and Roman examples. The nozzles and base are undecorated, while the bowl is ornamented with a subtle design of lotus leaves—raised in shallow relief through the use of a punch—and the reflective flap has a palmette design.¹

1. Ward-Perkins I, 31

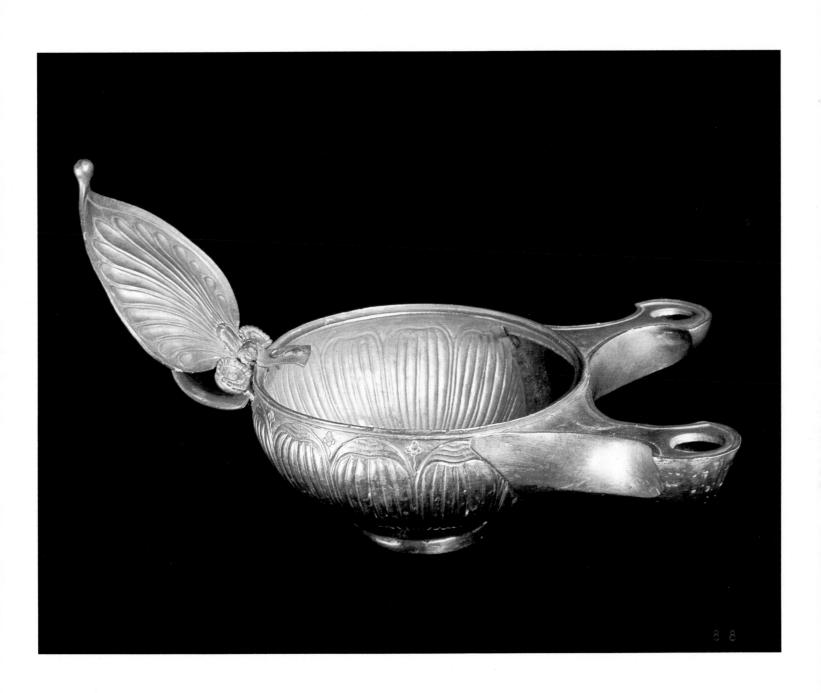

Cupids as Flower Vendors

House of the Vettii, Pompeii

 $I_{\rm T}$ is evident from this and two other works pictured previously that Pompeians were fond of representing cupids engaged in human occupations. Perhaps this is because cupids seem to transform toil into enjoyable child's play. Here they are busy at the flower trade. A farmer or gardener at center leads a goat to market, laden with full baskets of small red roses. A boy follows behind, bearing another basket of flowers slung over his shoulder. The goat marches in step, perhaps made happy by the lightness of his load. They are headed for the counter of a flower dealer, to whom they will sell their flowers to be made into garlands. The dealer stands at an ornate marble table of a type which survives from Pompeii, and which is already covered with such garlands. He hands two garlands to an assistant, while another helper places some in a wicker basket.

Garlands were worn at banquets and on numerous holidays and are often shown adorning shrines. Pompeians did not have to go far to obtain a variety of flowers. In season, innumerable town gardens and the countryside around abounded in them. Perfume was one of the products of Pompeii as well as of other towns in Campania. There was a significant flower trade at the permanent provision market off the Forum, where one of the surviving murals depicts cupids plaiting and selling floral wreaths. The mural pictured here was painted for the industrious Vettii, who prospered in the last years of Pompeii and who may have been engaged in the flower trade as well as a number of other businesses.

1. Grant, 201

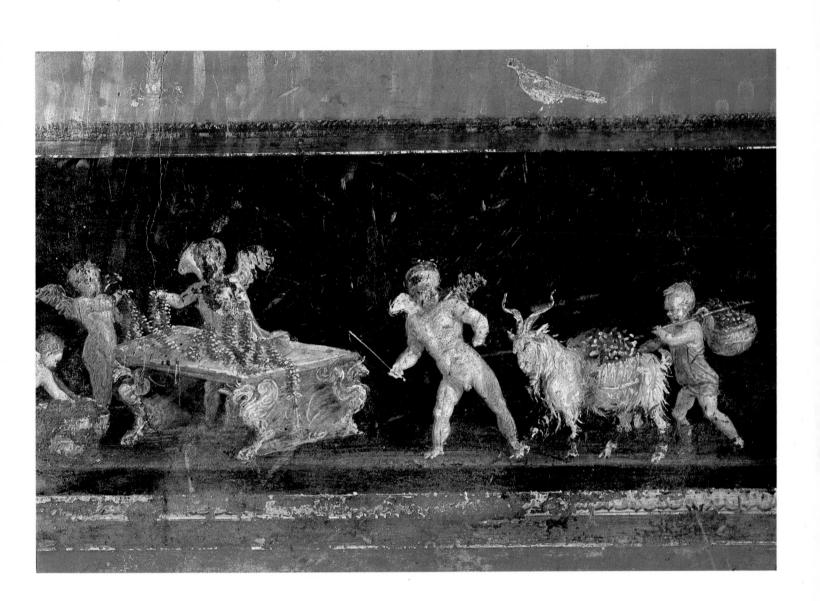

"Beware of Dog"

Mosaic from Pompeii, Museo Nazionale, Naples

 $P_{\text{LINY THE ELDER,}}$ writing in the middle of the first century, lamented the vast number of burglaries in Rome and blamed them on an undermanned and ineffective police force. At Pompeii, the construction of houses with solid, almost unbroken outer walls had long been a safeguard against intruders. This contrasted with the lightfilled atria and peristyles which awaited the visitor within. The vulnerable entranceway was protected by double locks, a vigilant hall porter or door keeper, and occasionally, by a dog.

It was a fairly common custom to advertise the presence of a dog by depicting it in mosaic or in a wall painting at or near the threshold. Some representations also bore the warning, "Beware of Dog," cave canem. This example has no such inscription, but the message is clear. The dog is alert and seems to strain at its tether. As it bares its teeth and arches forward, it is clearly poised and ready for action. A visitor may still see such dogs at Pompeii today, kept by the town's guardians, nestled within a ruined entranceway.

The work is executed in large cubes, rather than in the small tesserae reserved for more delicate subjects. Nevertheless, the depiction is very forceful and convincing. Three areas of red break the monochromatic and powerfully simple color scheme of black on ivory: the outstretched tongue, the leash, and a highlight in the eye. The background consists of rows of cubes laid in straight lines, except at the outline of the body, where two rows follow the shape of the contours.

In the *Satyricon*, the hero almost falls over when he sees such a dog, seeming to take it for a real one (XV, 29). In all probability, Petronius was here poking fun at the provinciality of the home owner, Trimalchio, and so it is likely that the taste for such motifs was not universally shared.

1. Grant, 132

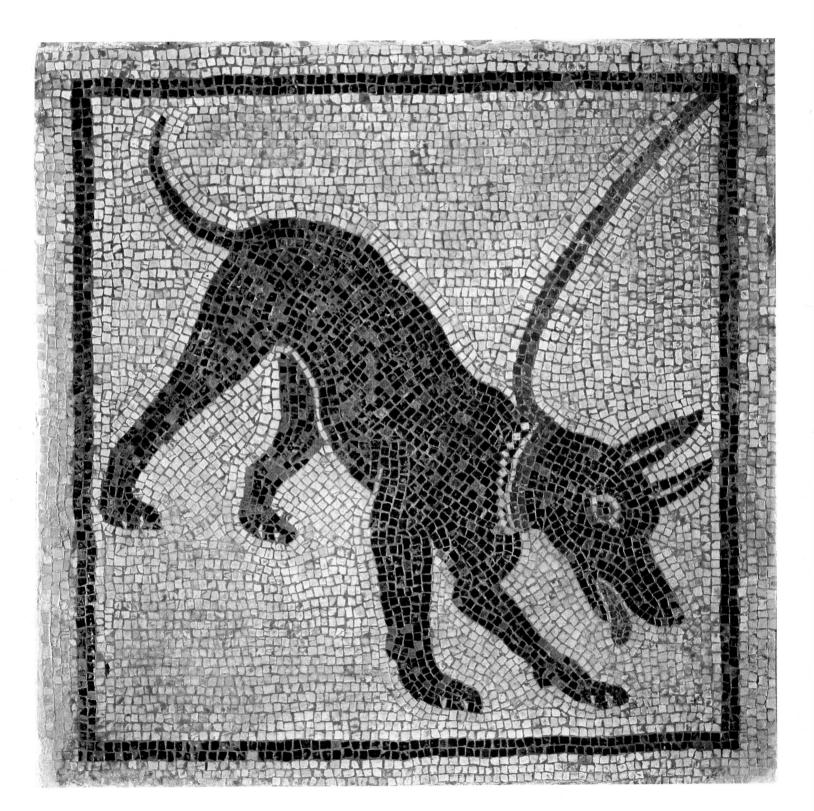

Atrium, Tablinum, and Peristyle of House of Menander, Pompeii

Pompeian town houses did not depend for light on windows or openings to the street, but presented a nearly solid facade to the outside, while gathering light and air from interior courts. Upon entering the house and passing through a vestibule, the visitor arrives at a large, high room, called the atrium. This photograph is taken from within the atrium of the House of the Menander, a notable and well-preserved home. Atria are distinguished by their high ceilings, pierced by a square or rectangular aperture, open to the sky. The light that falls across the photo at right enters from the opening, which admits not only light but rain as well. Water falling within is caught in an ornamental catch basin, the edge of which can be seen in the lower corner of the photo.

The atrium is the center of smaller houses, and in larger residences it is the core of the front apartments, with the kitchen, some servants quarters, store rooms, front bedrooms, and reception room grouped around it. The large room at the left, separated from the atrium by engaged Corinthian columns, is the tablinum. Retractable doors or portieres often hung from these columns or pilasters. They could be drawn at will, and when they were left open, air circulated more freely between the front and back parts of the house. In early houses, this cool, airy chamber was often used as a dining room, but as houses grew larger, it came to be employed more frequently as a reception area, particularly one in which the master received clients or business guests.

Beyond the tablinum is the peristyle, a colonnaded corridor passing around an inner rectangular court or garden, open to the sky. Gardens were often adorned with fountains and sculptures, and the walls around them were ornamented with paintings. This pleasant core of the house is shielded from the public business that was conducted in front, and most of the private domestic areas are found here, including bedrooms, baths, indoor and outdoor dining rooms, and intimate reception areas. On an axis with the atrium and tablinum, across the peristyle garden, is a broad recess (exedra), containing the portrait of the Greek playwright Menander, from which the house derives its modern name.

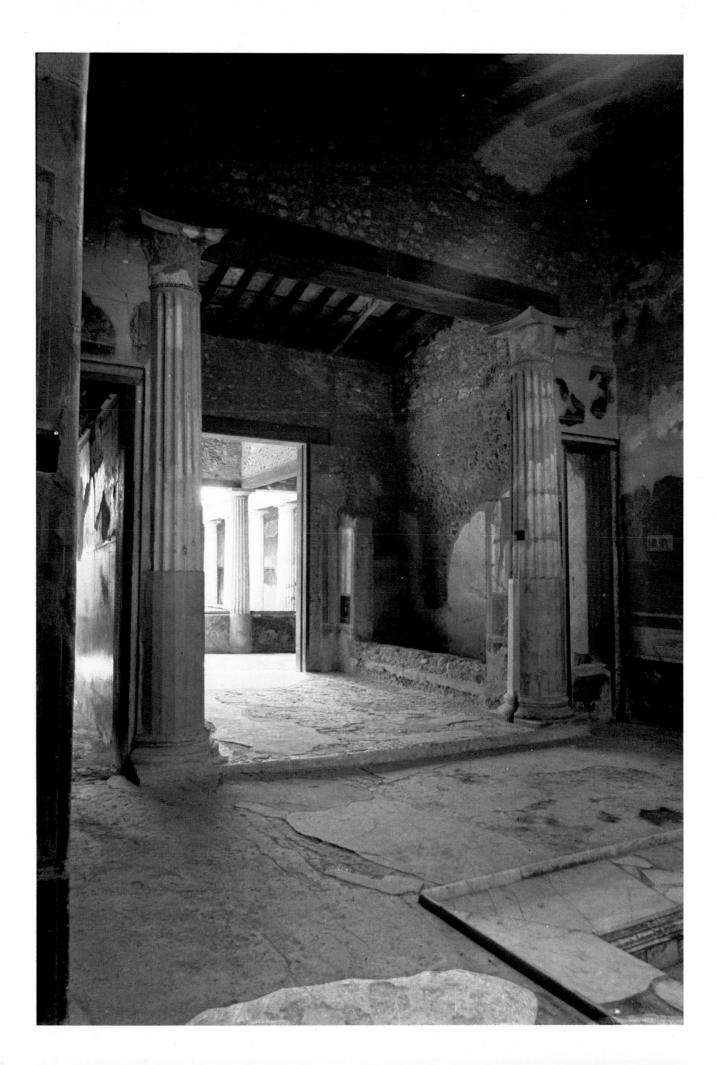

Banqueting Scene

From Pompeii, Museo Nazionale, Naples

T his fascinating but amateurish mural painting depicts Pompeians at a banquet. The guests are seated on three couches, the standard complement for a dining area, or triclinium. Trinclinia—a word that refers both to the dining area and to the couches—were sometimes constructed of permanent masonry. In those cases the couches, of course, could not be moved; they were made comfortable by the addition of upholstery and cushions. They are always arranged in a U-shape, and the example in the painting is slightly splayed to give a better view of the proceedings.

A custom borrowed from the Greeks prescribed eating in a reclined position, while leaning on the left arm and stretching the feet behind. Children, however, sat upright at their own table, which was sometimes placed at the foot of the grownups. This scene appears to depict the beginning of the banquet, since the tables have not yet been brought in. The slave at center brings a cup of wine to the newcomer at left, while another unfastens his shoes. An inscription from the triclinium wall of the House of the Moralist shows this to be rather standard procedure, "Let the servant wash and dry the guest's feet. A towel protects the pillows, be careful of our linen."

The guest at right foreground has regard for the linen, but not for the floor. He has probably just arrived or has had to rise precipitantly. Already deep in his cups, he leans heavily on a slave, who helps him to vomit. Debris was swept from the floor at regular intervals, and at this early stage of the banquet, we can see flower petals strewn there. The practice of sweeping floors cluttered with droppings was satirized by the mosaicist Sosos, who created a much imitated floor mosaic depicting strewn trompe l'oeil chicken bones, pits, apple cores, etc., which came to be called "The Unswept Floor."

The two men at left seem to be exchanging warm greetings. The man at center is being aided, possibly by his own servant, as guests were sometimes encouraged to bring their own slaves to dinner. The reclining figure at far right seems most in the swing of things. A faint inscription over his head reads *bibo*, 'I drink'. He has a happy, slightly besotted smile; he holds a bowl of wine and appears to observe the plight of the drunken reveller in front of him with self-interested amusement.

1. Brion, 135

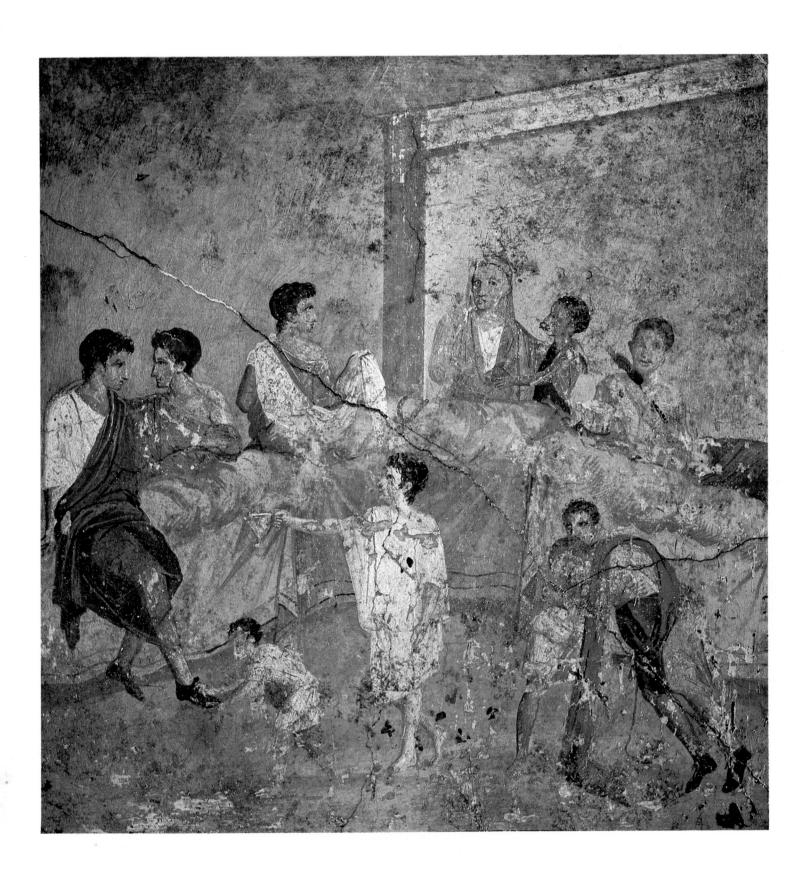

Lovers on a Couch

Wall Painting from Herculaneum, Museo Nazionale, Naples

T his amorous couple occupy a couch, which was commonly used for dining, but could also be employed for love. He reclines on his left arm in the customary manner and drinks wine, which he pours from a drinking horn, or rhyton. She wears a diaphanous gown and seems to be observing the effects of the wine on her partner. At the appropriate time, she will be ready, but at this moment she motions to an attendant to bring her something. The obedient servant girl looks at her and holds the box that her mistress has summoned.

A gracefully proportioned three-legged table bears other ingredients, which may be taken separately or mixed with the wine. These include herbs and possibly an aphrodisiac. Both Venus and Bacchus were sacred to the region, and its inhabitants seem to have been inspired by these gods of love and wine. Sexual mores were as liberal then as they are today, if not more so, and the bonds of matrimony were by no means tight. Divorces were commonplace, and at times they could be effected by either partner merely expressing the desire to part. In addition, there was a widespread disinclination to marry, and incentives had to be offered to promote marriage, such as the *Lex Papia Poppaea*, a law passed by Augustus in 9 A.D. limiting the rights of bachelors and spinsters to inherit property. A live-for-today mentality rationalized the search for pleasure in all areas of life.

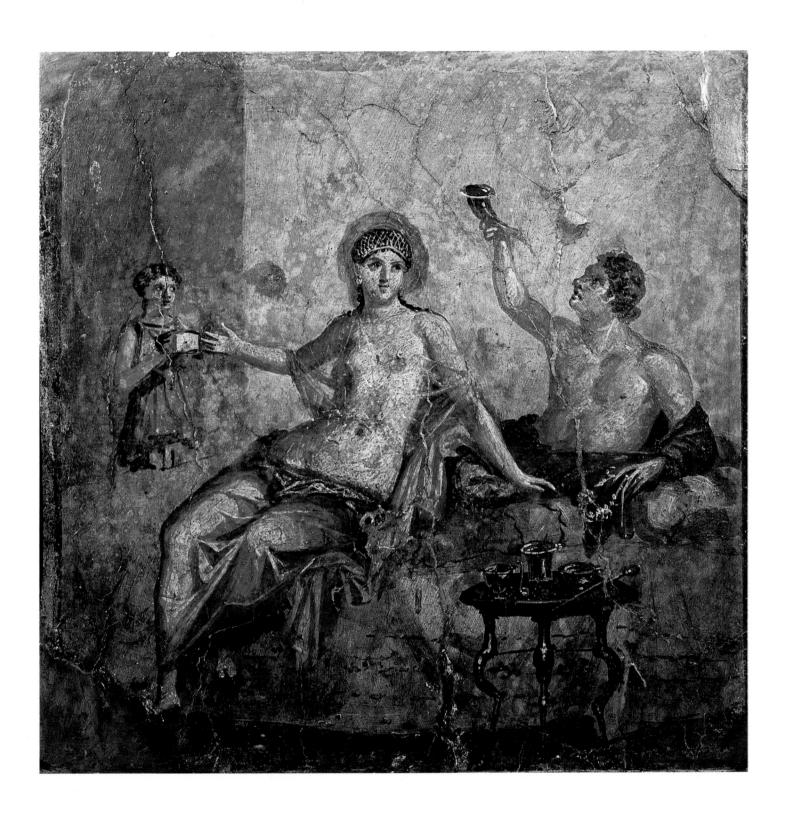

Silver Patera

From Boscoreale, Museo Nazionale, Naples

T his is a decorative silver bowl, or patera, from a cache of fine show plate and silverware unearthed in 1895 at Boscoreale, about two miles northwest of Pompeii. It was discovered along with 108 other pieces of silver and over one thousand pieces of gold, secreted in an oblong wine vat of a sumptuous villa. The owner or custodian of the objects had sought refuge there, and his skeleton was found lying alongside the treasure.

The phiale-like bowl is ornamented at the center with a figured bust of a man, modeled realistically in the round, in the style of the Augustan period. The figure has a faint wry smile and rather large protruding ears. It is likely that it was intended as a recognizable depiction of an esteemed member of the household. It has a companion piece, bearing a figured medallion of a woman, which has become detached from the bowl and is now in the British Museum. In both cases, the busts were modeled separately and attached to the bowl. The shallow wide shape of the vessel is typical for paterae, which were often employed for libations in ceremonies and sacrifices. They are frequently depicted in paintings and in funerary and commemorative sculpture.

Show plate, to which class this object belongs, were displayed on side tables or on stands. Romans avidly collected them, and Martial reports that fortunes were spent for signed antique pieces. The prominence of silversmiths in the first century, and their importance in the economic life of the Empire, is borne out by measures Nero took in the rebuilding of Rome after the disastrous fire of 64 A.D. His plans allotted them between one hundred and fifty and two hundred new shops, and the export of silver plate at this time was an important part of foreign trade.¹ Pliny the Elder has left us with an interesting and perplexing observation about smiths, saying that the route to fame for them is to work in silver, not in gold. "Curiously enough, none have become famous as gold chasers, many as chasers of silver."

1. Strong, 155ff. 2. Natural History, XXXIII, 154

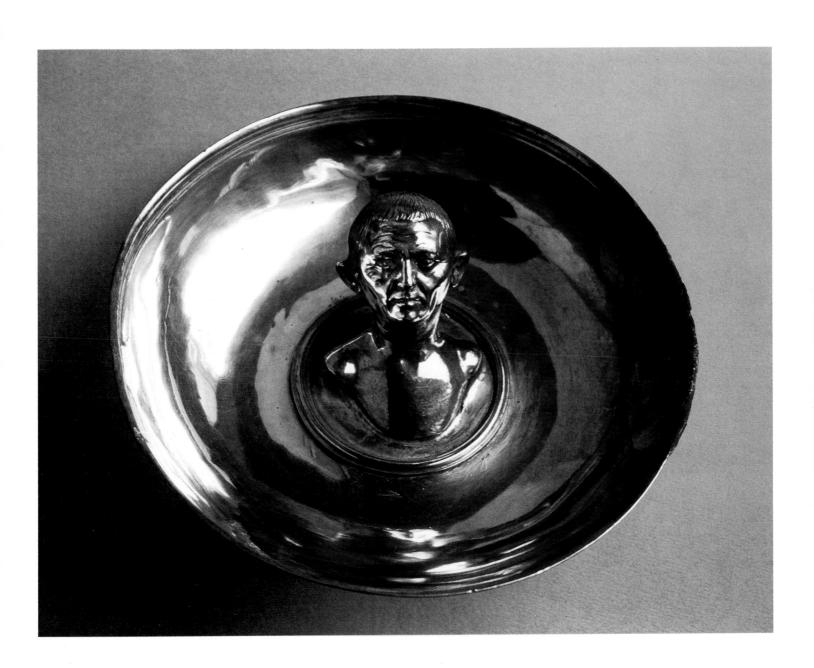

The Astragal Players

(Monochrome on Marble) From Herculaneum, Museo Nazionale, Naples

T his is a monochrome painting on marble, executed in the encaustic technique. Encaustic involves a mixture of pigment and beeswax, which is heated, applied to the surface, and burnished. A laborious technique which often produced fine and enduring results, it is employed here to depict five women of grace and beauty, in the style of high Greek classical art (ca. 450-400 B.C.). The work is in fact signed in Greek letters by one Alexander of Athens, but we do not know if this is an original Greek work of the classic period or a faithful copy.

On one level, nothing could be more charming than this picture of young women playing with astragals, or knuckle-bones. Astragals were game pieces usually made of the bones of sheep or goats, but were also produced in bronze, ivory, or terracotta. The game was popular among Greeks and Romans, and the form played here resembles some modern pick-up games such as jacks. However, knuckle-bones could also be played as a dicing game, with numbers indicated on the long and short sides, and were therefore commonly employed for gambling.

Unfortunately, what should be the most innocent of pastimes is here rife with tragic overtones. Inscriptions over the heads of the characters tell us who they are. The standing woman at left is Leto, a goddess who has borne two children, Apollo and Artemis. The woman at center who reaches toward her is Niobe. She has boasted that she is superior to Leto in beauty and wealth, but most of all because she has seven sons and seven daughters, and Leto's two are nothing by comparison. In the *Metamorphoses* (Book VI), Ovid relates how the indignant Leto appeals to her children to avenge these insults. They descend and kill all of Niobe's children, first the boys, who were playing with horses and wrestling, and then the girls. This may be the moment when the contrite Niobe appeals to Leto to spare two of her unsuspecting daughters, Aglaia and Ilearia. She has offered her hand to Leto, but to no avail. After all are killed, Niobe will be turned to stone. It is characteristic of the Greek high classical style that even at such a critical moment, the characters are poised and do not betray their emotions.

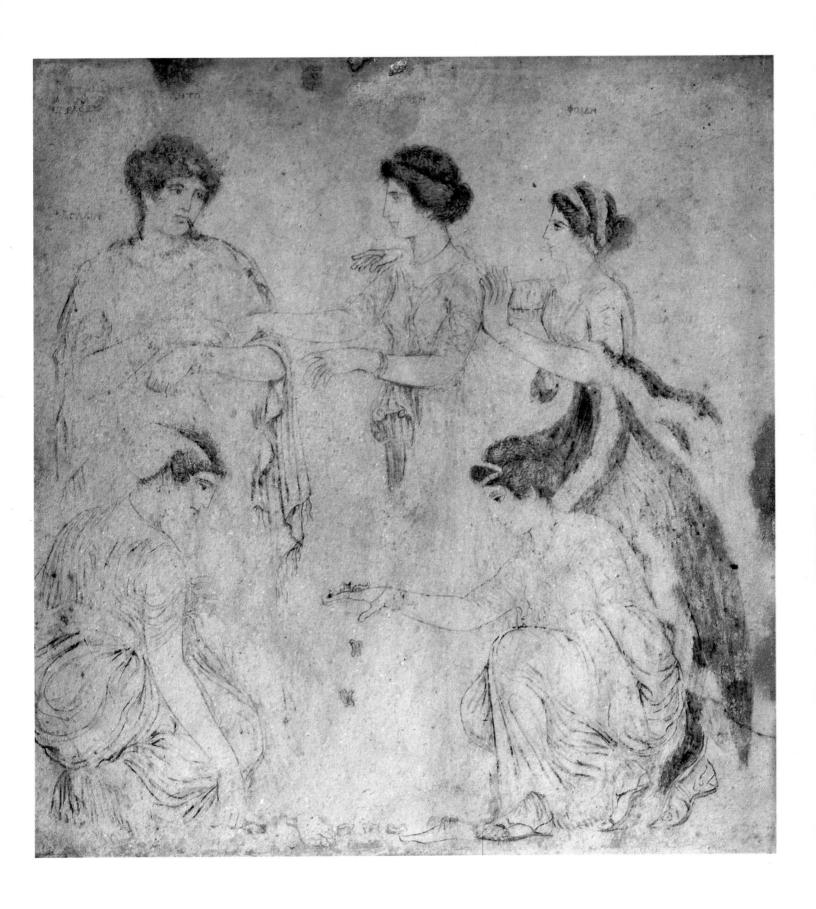

The Citharist

From Stabia, Museo Nazionale, Naples

 $T_{\rm HIS}$ painting of an intimate chamber recital conducted among friends is noteworthy for the expressiveness of the emotions in the faces of the listeners. The women have gathered in a room of a private home, fronting on an open peristyle court. The night is probably a cool one, as each wears ample robes bundled securely around her. The aristocratic and matronly figure at center sits on a couch draped with a rich coverlet bearing a design of multicolored squares and rectangles. With her left hand she plays the cithara, or lyre, and with her right accompanies herself on the smaller stringed instrument at her side. She rests her feet on a low footstool.

The woman at left places the fingers of one hand to her lips, seeming to register something which has touched her. She warms the other hand in the folds of her mantle. Her contribution to the evening may be the recitation of verses, judging by the poet's wreath that she has donned for the occasion.

The standing woman at right is a remarkably lifelike figure. Unselfconsciously, she leans forward and gives the music her rapt attention. She seems to want to absorb as much as possible with her wide, transfixed eyes, as if by gazing she will take in sound as well as sight. The seated listener at far right resembles the composed concertgoer of our own day. She sits calmly and does not openly show her emotions, although her satisfaction is revealed by a slight smile and by the relaxed way she leans against the pillar. Few ancient paintings so masterfully convey the aura of a cultural soirée and the communion of friends.

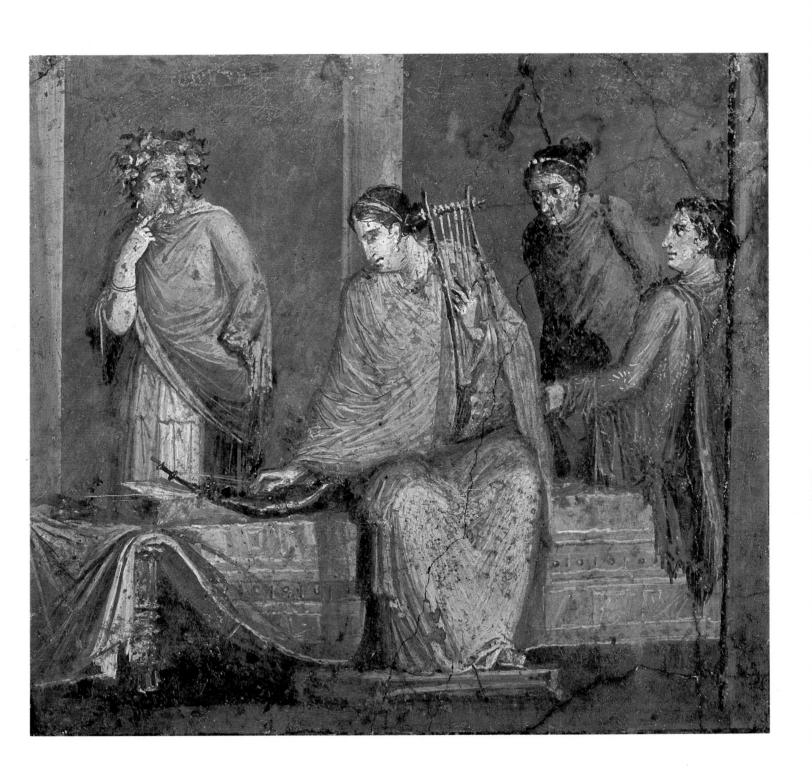

Street in Herculaneum

Only a small portion of the seaside town of Herculaneum has been fully excavated. Much of the city still lies under the mass of lava mud that buried it to a height of sixty feet and hardened to the solidity of concrete. The town of Resina came to be built on top of this alluvium, and so excavations are further impeded by a reluctance to uproot its inhabitants. However, the streets that have been unearthed lie in a regular gridlike plan of north-south cross streets (cardines), which traverse the east-west arteries (decumani) at right angles.

This is a view of Cardo IV, looking away from the original marina where it began, towards the houses of Resina, which sit on a cliff of rock-hard tufa at the end of the street. More of the upper stories of buildings survive at Herculaneum than at Pompeii, partly because official excavators have been more careful here than were the early excavators of Pompeii, paying great attention to the elevation as well as to the ground plan of buildings.

The house at the left foreground has a steeply pitched roof overhanging and shading the sidewalk. Beyond it is the interesting two-story Trellis House, which was built of inexpensive rubble masonry held together by a framework of wood timbers and a latticework of cane. Its apartments were rented to different families, who shared the light of its inner courtyard and the water from its well. The second floor apartment was reached by its own flight of steps. This is a small version of the urban apartment house that was commonly found in Rome at this time, and which was beginning to appear at Herculaneum and Pompeii. The Trellis House is characterized by a street-level portico through which pedestrians had to pass, and a gallery or loggia which overhangs the street at the second story.

Just beyond, we can see the top of the House of the Wood Partition, with its jutting roof. It began as a unified patrician home, but some of the rooms were later divided to form separate shops and humble apartments. It derives its name from the surviving wood partition which separated the tablinum and the atrium, most of which has been extracted from its hardened mud casing. Dwellings with comparable overhanging roofs dot the other side of the street, which is composed of raised sidewalks and a roadway paved with Vesuvian trachyte. The street we see here differs surprisingly little in appearance from the typical small-town Italian street of the following two millennia.

^{1.} Mauiri, Herculaneum, 32

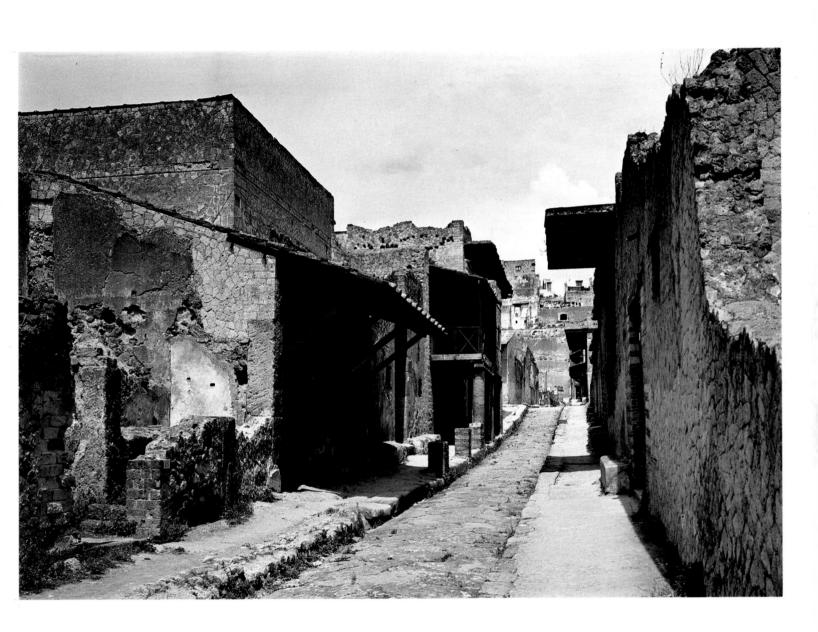

Waterside Villa

From Stabia

Romans delighted in their country villas, and they were conscious of the interplay of their houses with the natural surroundings. Indeed, their country retreats set a standard for comfort and luxury that has not been equaled until our own time, if at all. The younger Pliny wrote of his villa at Laurentum that it overlooked the sea on three sides, and that its dining room was built out over the shore in such a way that it was gently washed by the spray of breakers when the seas were high. Windows and doors were carefully placed to take maximum advantage of cool breezes in summer and the warming sun in winter and late afternoons. Trees and plants were selected with great concern for the properties of the terrain and for their suitability to the climate. In western architecture, not until Frank Lloyd Wright in our time has there been similar concern for the interplay of house and nature, or as Wright said, for bringing the outdoors gradually into the house, the house out to nature.

This painting of a house, from a villa at the seaside resort and settlement of Stabia, is designed to take optimal advantage of its natural setting. Instead of being constructed flush to the shore, it is built out over an inlet on concrete foundations sunk into the water. This satisfies the owner's love of the sea, and brings the house and water into inescapable rapport.

A U-shaped colonnaded portico encompasses a garden terrace from which a clear view of the sea is always obtainable. The main part of the house is in two stories and is accented by two round belvedere towers, which house rooms and afford a splendid view of the surrounding countryside, including Mount Vesuvius. Unlike the town house of Pompeii, which is externally closed and inwardly directed toward private courts, the country villa is intentionally opened, porous, and outward-reaching toward its environment. Anyone walking between the wings of this house passes along the portico and is thus constantly exposed to the changing vistas of water and mountains. A list of the amenities commonly to be found in such wealthy homes would impress even today's country squire. The younger Pliny's house had several dining rooms for the different seasons, a gymnasium, heated swimming pool, ball court, extensive baths, a library, sun parlor, steam heat, soundproof study, and many domestic rooms for guests and servants.

1. Letters, II, 17

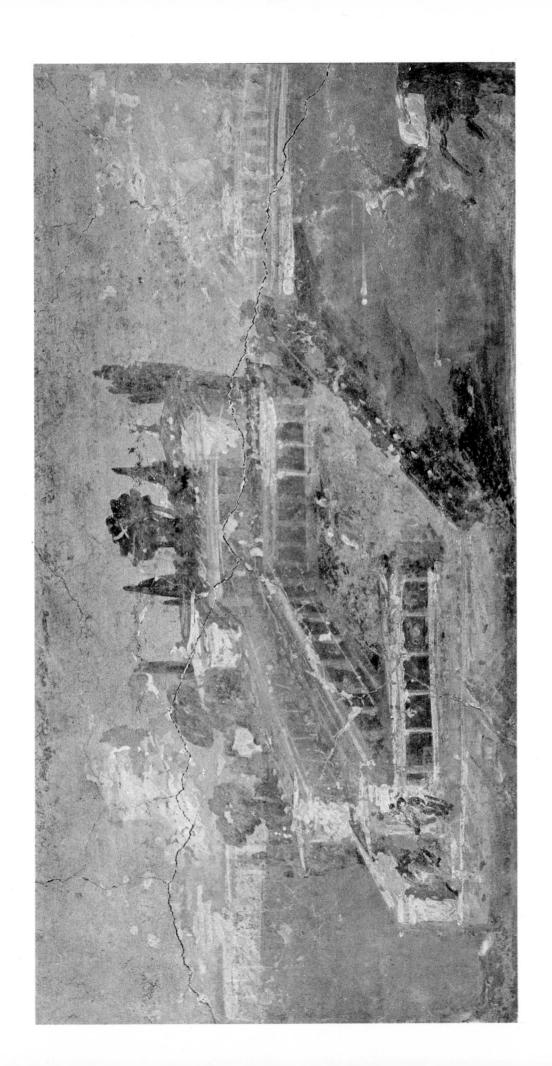

Portrait of a Young Woman With Stylus

Wall Painting from Pompeii, Museo Nazionale, Naples

T his lovely portrait of a woman in the act of writing is framed within a circular medallion, a favored format for portrait busts in the last years of Pompeii. This view resembles a candid photo, as if she has been caught unawares, in a moment of reflection. She appears to be contemplating her words, but whether for some verse or love letter, we shall never know. When she has decided, she will remove the stylus from her lips and apply its point to the wax tablets held in her left hand. The flat end of the stylus is employed for smoothing down the wax in its application to the tablets, and for erasures. These writing tools give her an aura of refinement as well as beauty, and although they are somewhat conventional for female portraits, their inclusion here is appropriate to her well-bred manner.

She is tastefully attired in a green tunic and violet mantle, and her chestnut hair is held in place by a gold fillet and net, which allow her curls to fall around her forehead and cheeks, where they are echoed by two gold earrings. Because of the classic regularity of her features, it is rather difficult to fathom her character. The wide-focused eyes show some inner strength, but since the head is bathed in almost uniform light, there are few shadows in which the artist might have implanted wrinkles or facial nuances to add a depth of character.

The Romans were the first to develop a tradition of commissioning private portraits to be handed down from generation to generation as family documents. They had a far greater interest in realistic portraiture than their Hellenistic predecessors, so much so that in the *Natural History* Pliny remarked (at about the time of this portrait): "For many generations, realistic portraiture has been the highest ambition in art."

1. Natural History, XXXV

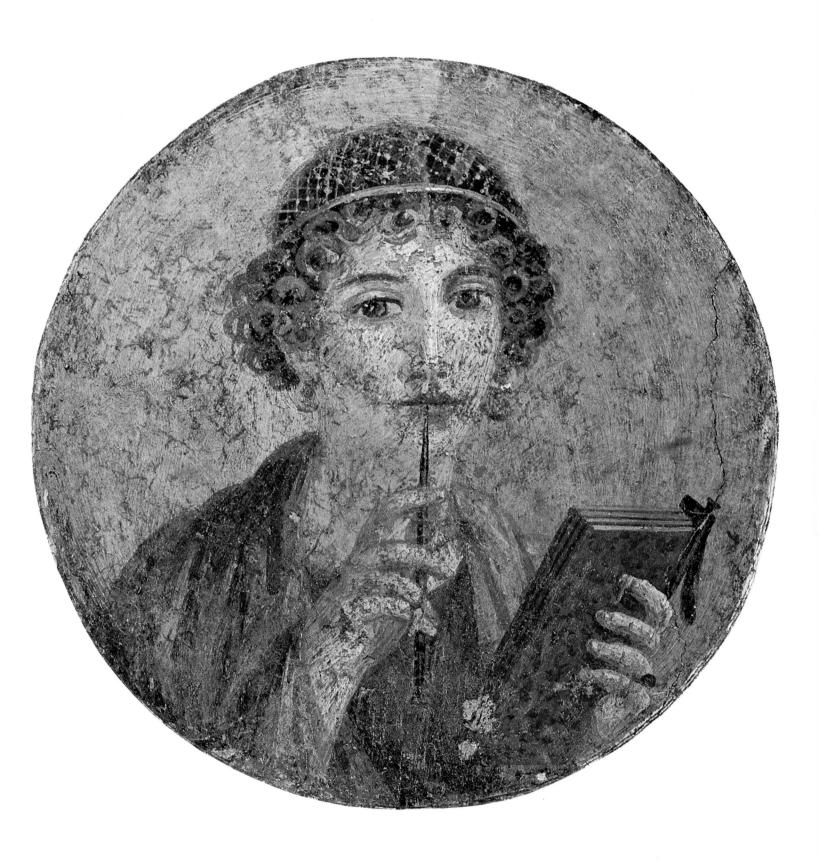

Double Portrait

From Pompeii, Museo Nazionale, Naples

T HIS PORTRAIT OF A MAN AND WIFE is executed in a style that is both realistic and naive, and dates to the last years of Pompeii. It was originally thought to portray a prominent attorney, Terentius Neo, and his wife. Ever since it was discovered that the house in which it was found was joined to a bakery, it has come to be identified with the wealthy baker P. Paquius Proculus. Such an identification is shaky, but we do know from a surviving wall inscription that Proculus was a leading citizen of the town and that on at least one occasion he served in the high office of aedile: "All the Pompeians have created Paquius Proculus, who is deserving of the honor, aedile." 1

The painter aims for a convincing likeness and makes little effort to idealize him. His large lips, flat nose, and high cheeks mark him as a man of the people. The wife is less particularized, and while he gazes at us with wide intelligent eyes, she looks away somewhat vacuously. Both carry attributes designed to convey an impression of refinement: he a sealed scroll, she wax tablets and a stylus. Some have deprecated what they see here as the literary pretenses of an obviously unlettered couple. We cannot be dismissive of the learning of a baker, however, since Proculus was elected aedile, a post which demanded some degree of education. From this and other evidence we can deduce that bakers and other tradesmen were occasionally educated.

The straggly beard and curls, which frame their respective faces, appear to have been added almost as an afterthought. The wax tablets are held by her frontally, as if they were being offered or displayed. There is no writing that can be read on either document, but in later art such objects almost always bore words that related to the life of the subject.

1. Brion, 131

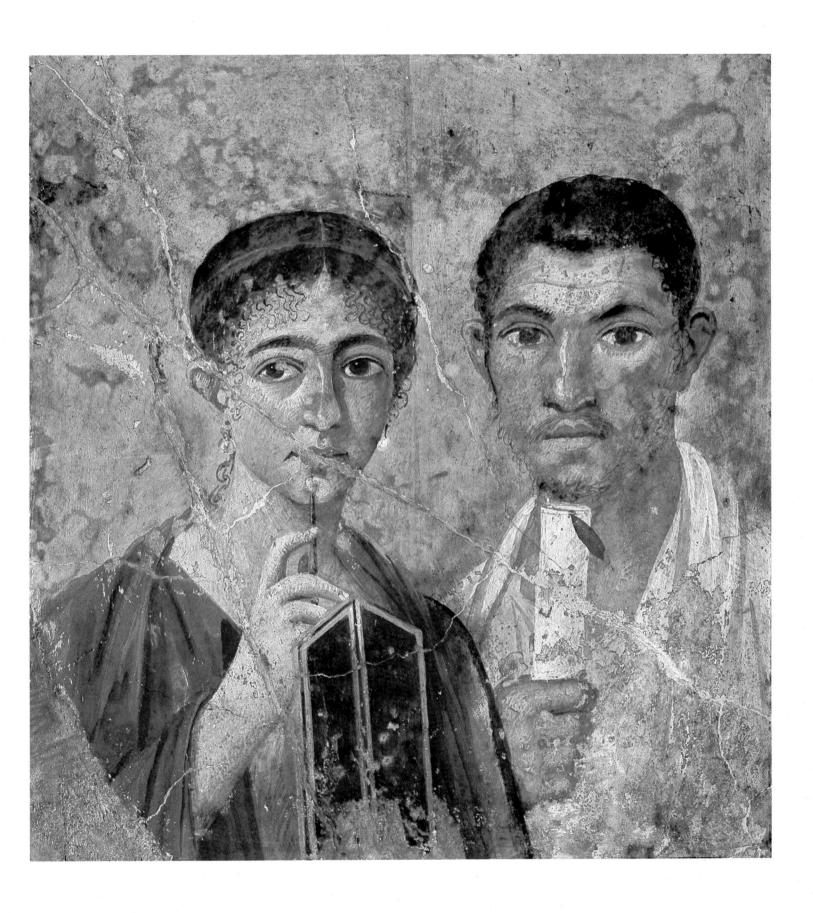

Portrait of a Woman

(Mosaic) Museo Nazionale, Naples

 $F_{\text{EW PORTRAITS}}$ ACHIEVE the sense of intimacy conveyed by this study of a serious young woman. She does not rest deep within the picture plane, in lovely but frozen repose. Rather, she is projected forward, and observes us with wide curious eyes, even while she is being observed. The open lips, which reveal her upper teeth, seem to be parted for speech, and nothing gives a portrait a greater vivacity than the life sign of verbal expression, which Baroque artists revered as the "speaking likeness."

She wears the attire of a modest young woman of taste and means. She has gold and pearl earrings and a nearly matching necklace. Her white mantle is embellished with a fringe of gold and purple embroidery, and her hair is somewhat severely parted in the middle and pulled back at both sides.

The work is of small dimension and is executed in the most delicate of the mosaic techniques, *opus vermiculatum* ("worm like"). In such work, very small mosaic pieces, tesserae, are laid in wreathed lines resembling the undulations of worms. This wreathing is especially evident in the left side of the woman's face around the full cheek and near her nose. The horizontal layers of the background are in marked contrast to the technique employed in the face.

The highlights are accomplished in very delicate pinks at the cheeks, and in a stronger salmon line at the bridge of the nose. The nose itself casts a wonderful shadow composed of some twenty-five taupe mosaic tiles, and the lower lip is made to appear moist by a row of white tesserae which traverses it.

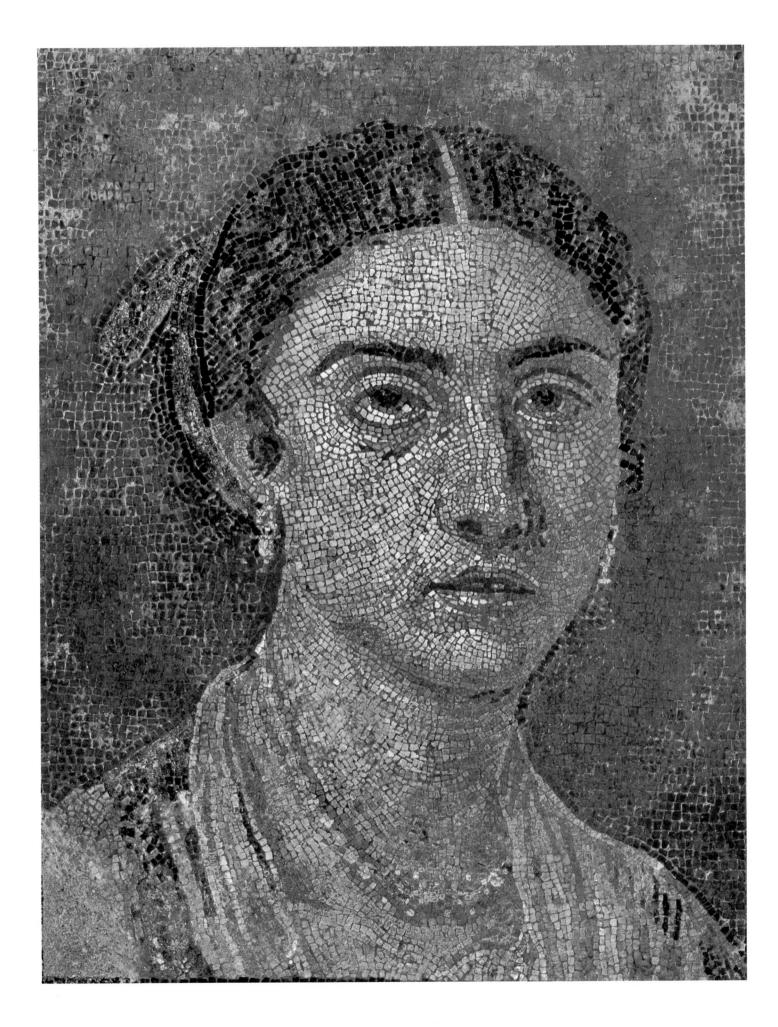

Bust of So-called Scipio Africanus

Museo Nazionale, Naples

 $W_{\text{E DO NOT KNOW THE IDENTITY}}$ of the subject of this realistic bronze portrait from Herculaneum. However, from certain resemblances to a portrait bust in the Capitoline Museum of Rome, it has been widely suggested that this is a representation of the Roman general Scipio Africanus Major. In both busts, the man is in his fifties, and has a craggy, rather narrow face, bald forehead, prominent ears, curved nose, and a firm mouth. The hair has been finely worked with a chisel point after casting, and the bushy eyebrows are also accented by a chisel. The piercing eyes are inlaid with enamel and semi-precious stones; they are the most striking feature of the work, and give the figure a startingly lifelike presence.

Whether or not this is Scipio Africanus, the head well represents an early Roman taste for realism in portraiture. This tendency can be traced in part to Etruscan funerary practices, where great efforts were made to depict the outward appearance of the deceased in order to insure his existence in the afterlife. While the classical Greeks had erected public portraits of a rather idealizing nature, to commemorate the deeds of famous persons, Romans made their portraits with careful regard to the facial peculiarities of the subject, including its imperfections. In addition, they cherished private portraits, even of individuals who were not famous, if for no other reason than to commemorate the worth of that individual within the family. It is for this reason, among others, that private as well as public portraits abounded in the Roman world.

The historical Scipio Africanus was a man of great self-esteem who enlarged the Roman domains in Spain, Africa, and the Hellenistic East. He is also credited with many innovations in military tactics and organization and was an early advocate of Rome's imperial mission in the world. In the last years of his life—about the time this portrait would have been made—he fell into disfavor, lost much of his influence, and retired embittered to his home in Liternum.

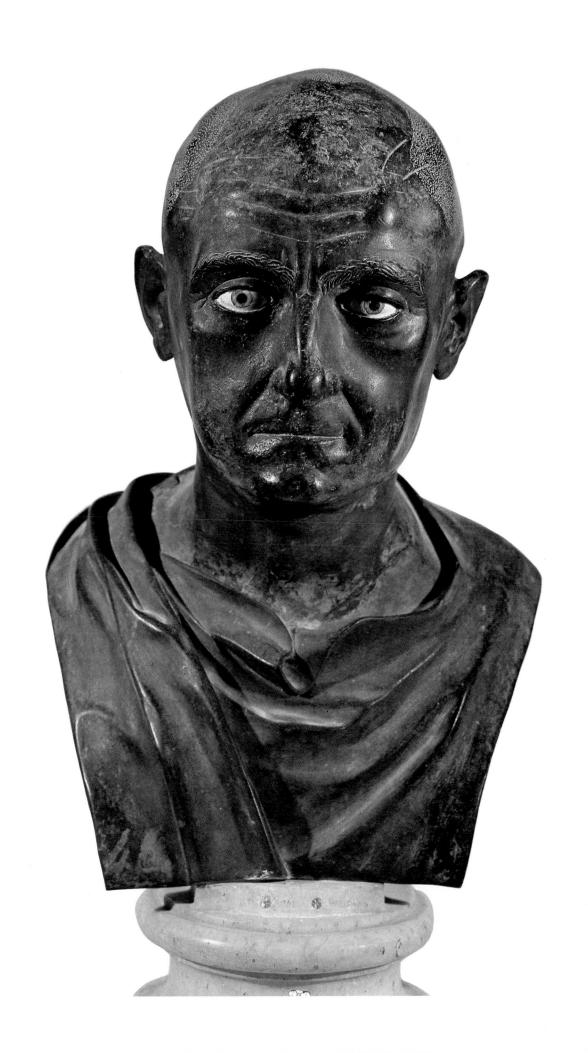

Scenographic Wall Decoration

From Herculaneum, Museo Nazionale, Naples

We are told that Sophocles invented the art of scene painting in the middle of the fifth century B.C., and that he was the first to place a specific background behind the actors. His contemporary Aeschylus is said to have gone on to decorate the theater on a grand scale with paintings, mechanical devices, tombs, altars, ghostly apparitions, and furies. At the games given by Claudius Pulcher at Rome in 99 B.C., the painting of the scenery excited great wonder, and Pliny reported that crows flew down to settle on the painted tiles, mistaking them for real.

A turn away from realism towards a fantasizing scenery was noted and decried by Vitruvius. He said the scene painter Apaturius of Alabanda made the great mistake of resting architraves on statues that couldn't possibly support them, and that he filled his scenes with improbable roof and pictorial ornament.3 Vitruvius would not approve this wall painting from Herculaneum, which depicts a Roman stage and scaenae frons in the tradition of Apaturius, whose taste had clearly prevailed by the middle of the first century A.D. It is crammed with fantasizing architectural and decorative motifs, which could never have existed in reality. The perspective is such that we are given the illusion of viewing the stage from below and to the right, as if we were spectators seated close by. Consequently, we cannot see the stage floor, nor the foundations of the tenuous architecture, which therefore seems more precarious and mystifying. The central intercolumniation is that of a rather flat archway in what may be a gate house. Its broken pediment is capped by a tragic mask, flanked by two hippocampi (half horse, half dolphin) and two pegasi. Medallions hanging from the archivolt are adorned with gold festoons, and the archway is succeeded by another one behind, shown lower in perspective and lighter in coloring to indicate distance. Through that arch looms another, and behind that, the projecting angle of a pediment.

There are more implausible structures above. A triumphal arch, delineated by four Corinthian columns, rises above the scenery but is broken in the middle as if its curious construction had suddenly been halted. Behind are the outlines of a colon-naded terrace, belonging to a massive building. All of the structures in the secondary planes are bathed in a glow which grows increasingly lighter the further back they go. Above everything is a drop curtain—a device invented by the Romans—which serves as a reminder that it is indeed the stage which inspired this painting.

 $^{1.\} Bieber, 22, 29 \quad \ 2.\ Pliny, \textit{Natural History XXXV}, 24 \quad \ 3.\ \textit{On Architecture}, \ VII, 5$

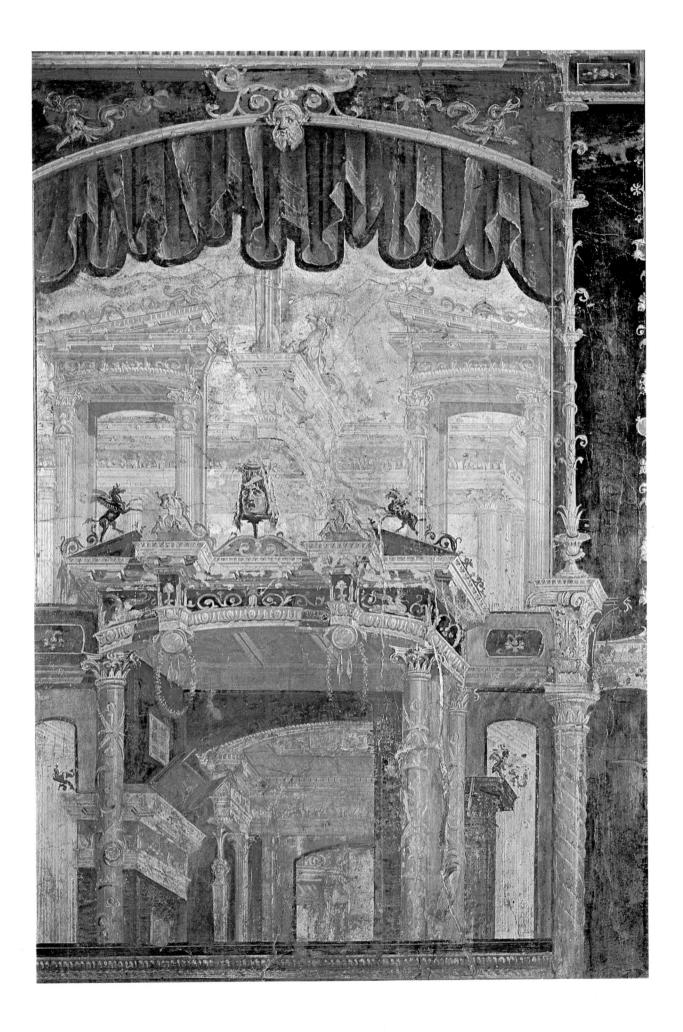

Rehearsal for a Satyr Play

Mosaic, from the House of the Tragic Poet (Pompeii)

Museo Nazionale, Naples

THE SATYR PLAY is one of the earliest forms of western drama. It developed when followers of Dionysus dressed in satyr costumes and sang of his exploits in the dithyramb. The satyr is part-man, part-goat, the sacred animal of Dionysus. The actor in a satyr play is a *tragos* (literally Greek for goat) and engages in a "goat song" (*tragodia*). Our word for tragedy ("goat ode") obviously derives from this.¹

The rehearsal is conducted by the director-playwright and chorus teacher, the bald older man seated right of center. He may in fact be the dramatist Aeschylus (525-456 B.C.), who was regarded as a father of satyric drama. His features strongly resemble those of his surviving busts, which show him with characteristic pointed beard and bald head. The bald head is very much a part of his persona and was the subject of a satiric tale; an eagle mistook it for a rock and dropped a tortoise on it to break the shell.²

He wears a himation and sandals, and at his feet are masks of an old silenus and of a woman, who wears a high headdress. He looks toward the young men, dressed in goatskins, who practice a piece of stage business, to the accompaniment of the double flute, played by a richly attired and wreathed flute player. All take their cues from the chorus master, and behind the flute player stands a young man with an open volume. In today's theater, he would be the assistant stage manager acting as prompter.

At the right, an actor draws a full-length goatskin over his head, aided by an attendant, whose conical cap (pilleus) may identify him as a newly-emancipated slave. The mask of the hero lies on the table beside them.

We are given a view of an interior showing a richly coffered and colonnaded hall. Although the two framing pillars and the two Ionic columns are on different planes, they intriguingly and improbably support the same architrave. The intercolumniations are decorated with medallions, festoons, and fillets, which are perhaps signs of former victories in the dramatic contests.

1. Bieber, 1-18 2. Bieber, 21

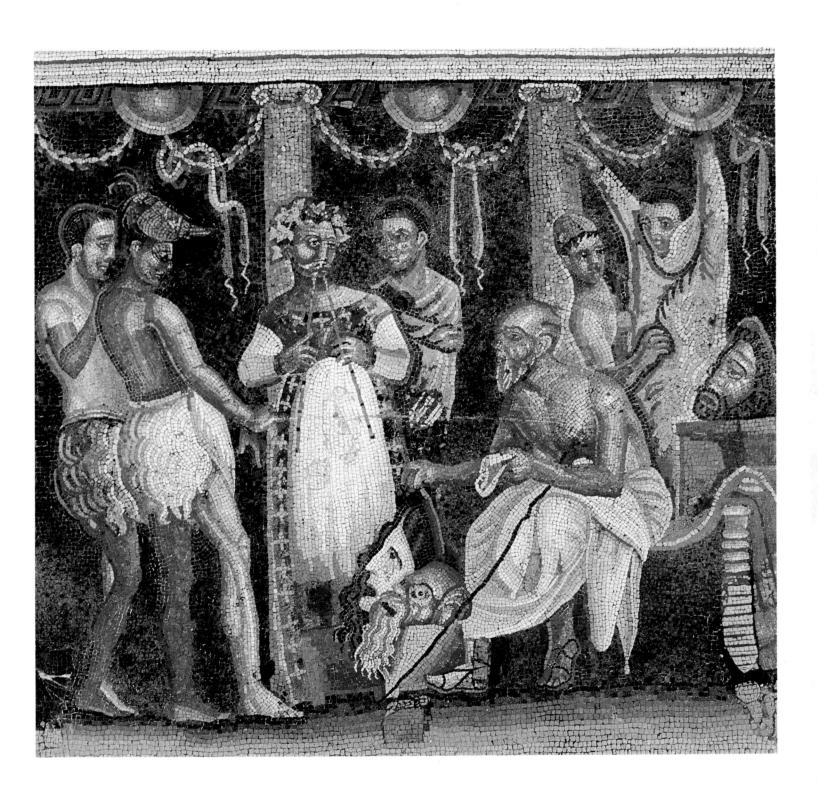

The Actor King

Wall Painting from a House in Herculaneum, Museo Nazionale, Naples

H ERCULANEUM HAD A LARGE and richly ornamented theater, which has only partly been excavated through the sinking of shafts, and its people seem no less devoted to the stage than those of Pompeii. This painting of an actor, who plays the role of a king, was found with others propped against a wall in a house at Herculaneum, indicating that it was about to be set into the wall when disaster struck. The painting is executed in a classic style and has been dated to ca. 25 B.C. 1

Depicted here are the actors' quarters, behind the stage, and it is very probable that a performance has just taken place. The principal actor sits exhausted but suffused in an ecstatic glow of achievement. He is still costumed in regal attire: long white chiton, high gold belt, purple mantle (which lies across his lap), and he still holds the royal gold-tipped scepter in one hand and the scabbard of a sword in the other.

There is a deep spiritual aura about him, as if he were still in the trance of his creative effort. Absently, he gazes at the kneeling woman, who writes a dedicatory inscription beneath his tragic mask. Masks, the chief part of the actor's costume, were sometimes dedicated publicly in sanctuaries of Dionysus, but this is a private votive offering, almost certainly expressing the actor's thanksgiving for his triumph and his petition for further divine aid. A second actor, seen removing his costume, looks on at left. The open door admits rays of light, which fall on the "actor-king," and bathe him in an almost divine radiance.

Theater masks had their advantages as well as their shortcomings. They enabled a small company to play a wide repertory of characters, and the same actor could easily appear in several roles in the same play. The parts of women could more easily be played by men, and the character's appearance was determined by the needs of the play rather than the actor's facial type. Pollux, in his *Onomasticon* (IV, 119ff.) gives a detailed description of 44 masks used in comedy alone. The eventually fatal limitation is that the mask did not allow for a change of expression, though Quintilian, the Roman rhetorician (ca. 35-100 A.D.) speaks of a mask which attempted this through one cheerful and one serious eye.²

^{1.} Kraus, 42 2. Beare, 184-196

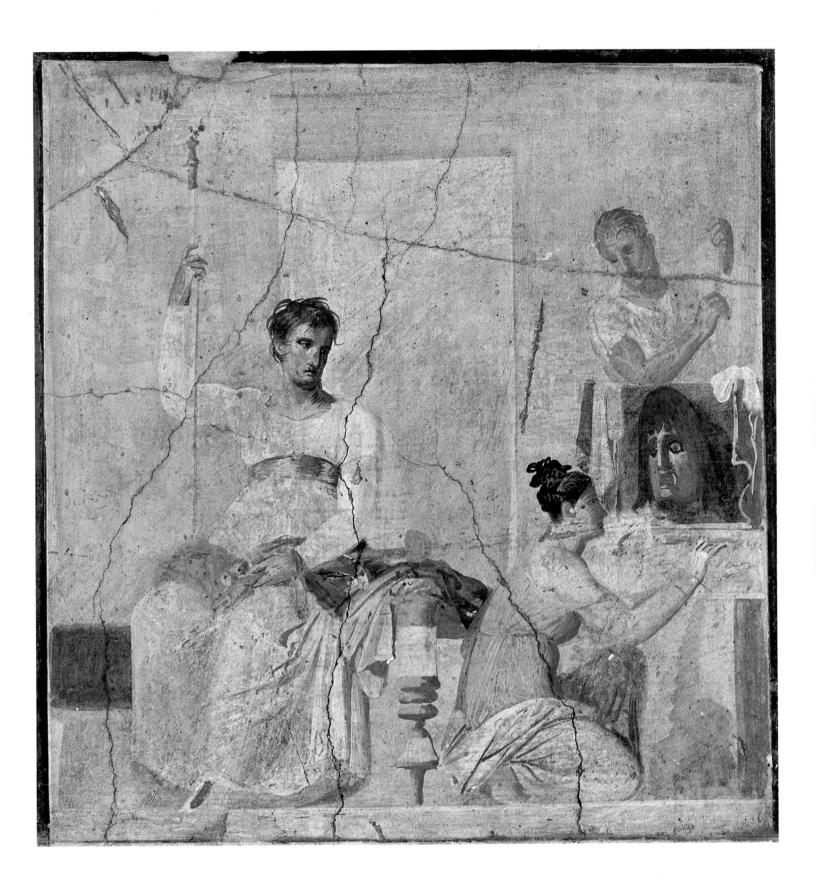

Menander

Wall Painting from the House of the Menander, Pompeii

This painting shows the greek playwright Menander (ca. 342–289 B.C.) seated on a curved Attic chair, and holding a scroll containing his comedies. The scroll bears an inscription that states, "Menander was the first to write New Comedy...", and the name of the playwright is inscribed once more on his cloak.¹ The mural painting dates from the mid-first century A.D., but it may be a copy of an older Greek work. It was found in an exedra off the peristyle garden of the house occupied by the wealthy Poppaeus family, of which Nero's wife, Poppaea Sabina, was a member; the dwelling is now known as the House of the Menander.

Of the three forms of Greek comic writing, Old Comedy, Middle Comedy, and New Comedy, the latter is most like our modern social and domestic comedies. Old Comedy (fifth century B.C.) was broadly based on the vilification of known personalities, political satire, and fantastic caricature, all within a formal structure of grotesque costumes, choruses, and parabasis. In Middle Comedy (ca. 400–330 B.C.), there were fewer open political attacks, and the focus shifted to the typical faults of mankind, mythological burlesques in which the gods were lampooned, and the development of stock characters who continued into New Comedy. These included: the garrulous cook, the bombastic soldier, the angry old man, the pimp, and the starstruck lover. The chorus was less frequently employed, and the digressive parabasis disappeared altogether, though pieces continued to be interpolated into the text.

New Comedy, of which Menander was the leading playwright, completed the trend away from public themes toward daily life. Realistic elements in the life of the family and the upper middle classes are shown in minutest detail. The plays are regularly constructed in five acts with a consistent theme and connected plot from beginning to end. The stock subjects are: love of a rich youth for a poor girl, an infant separated from its parents and united with them after many years, illicit love affairs, the machinations of cunning slaves, and the proper relationship between parents and a child. There is a greater naturalism in these plays, and more attention is paid to the delineation of character and mood. Conversely, the chorus declines, and becomes only an interlude sung and danced by a group of men. The everyday themes are reflected in the surviving titles of Menander's works; *Anger, The Sullen Man, The Girl from Samos, The Girl Who Gets Her Hair Cut.*

1. Bieber, 91

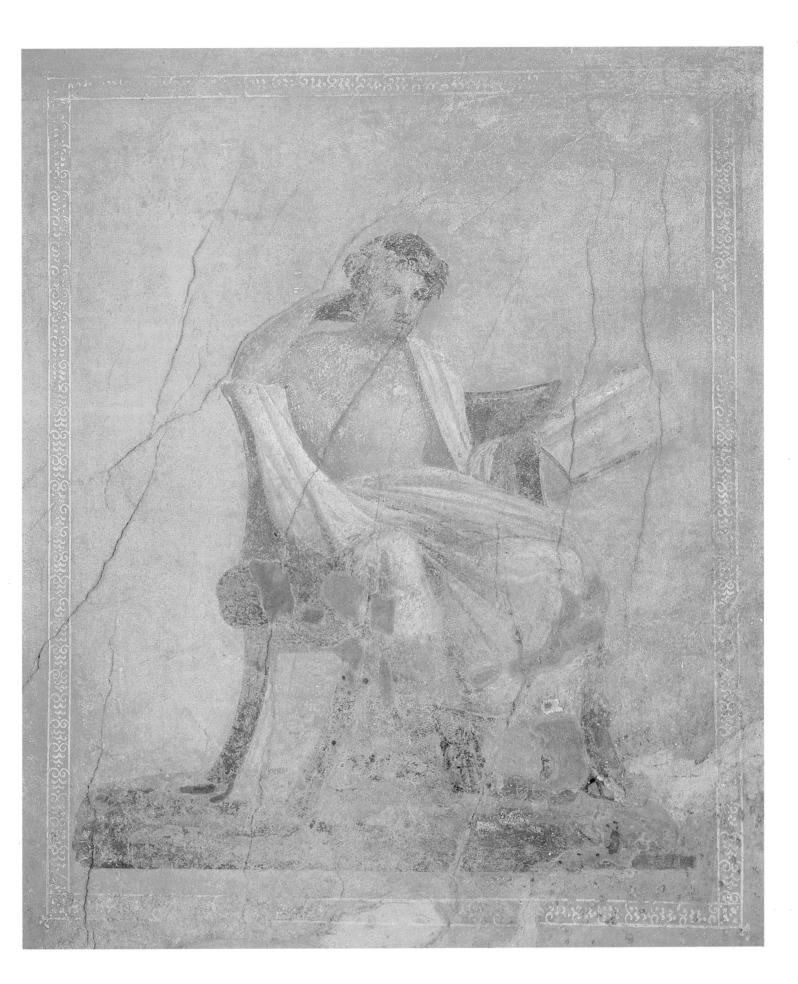

Scene from a Comedy

Wall painting, Pompeii

 P_{OMPEIANS} were very fond of the theater. The number of theater seats in town was disproportionate to the estimated population of twenty thousand and is greater than what we would find in cities of comparable size today, unless the town were nestled in a resort area, frequented by the rich of the big city, which was partially the case with Pompeii.

The city's great theater, which was built under Greek influence, ca. 200–150 B.C., could seat five thousand and predates the first permanent stone theater of Rome (erected by Pompey in 55 B.C.) by over a century. Its smaller roofed theater had accommodations for approximately one thousand two hundred, and is dated to ca. 80–75 B.C. It served as an odeum for music and dance recitals, mimes, and recitations. The beautiful masonry tiers of its cavea are still almost intact. A vast set of colonnaded porticoes connected the two theaters and formed a great and harmonious square where the public could gather before and after performances. About a third of a mile away stood the amphitheater, which had seats for twenty thousand.

The influence of the theater on the life of Pompeians is readily apparent in their decorations and wall paintings, especially those from the reign of Nero (54–68 A.D.). Nero had an absolute passion for the theater, and in 64 A.D. he even appeared as an actor on the stage in nearby Naples. He chose the theater as a setting for political ceremonies, and once had King Tiridates of Armenia pay him homage in a theater at Rome.¹

The illustration shows a scene from one of the comedies so loved by the people of Campania, who originated an influential comic form of their own, called the Atellan farce. The man at left wears the mask of a slave, with its typical flat nose, popping eyes, and wide, distended mouth. He appears to have come upon the pair by surprise and may be making the sign of the horns to mock them or to ward off their imprecations. It has been suggested from the dress and make-up of the woman at center that she is a courtesan.² She seems taken aback, and is comforted by her companion. The gestures and expressions are exquisitely observed. The painter models in volumetric masses, which cast shadows and give a very convincing impression of space displacement, despite the lack of objects in the background to orient us in space.

1. Picard, 62 2. Maiuri, 94

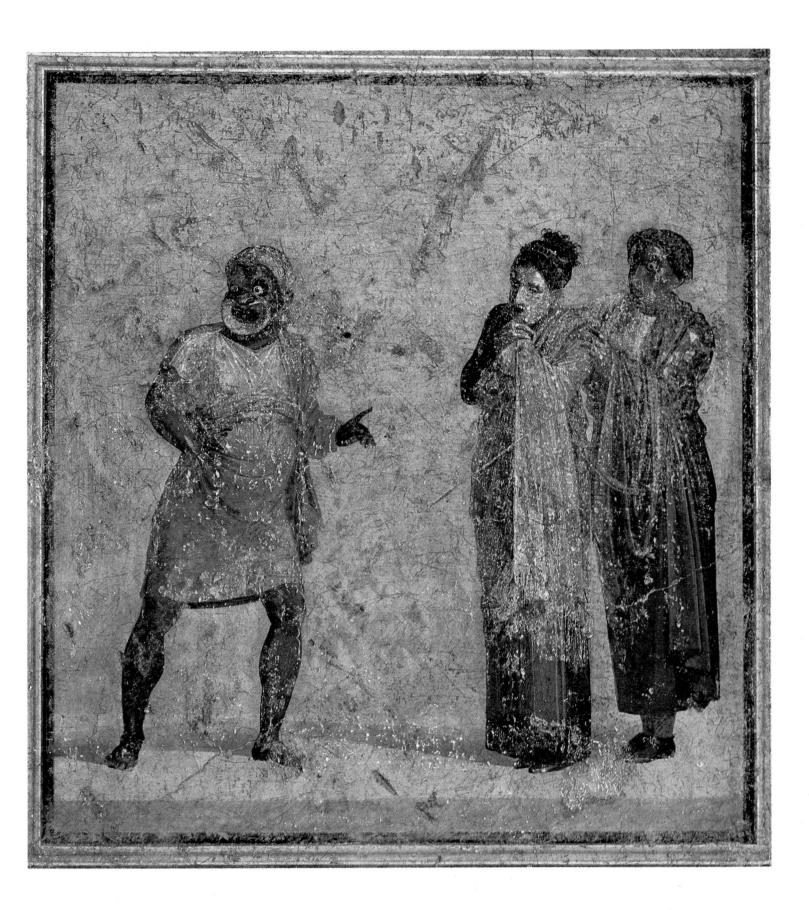

The Street Musicians

From so-called Villa of Cicero, Pompeii mosaic, Museo Nazionale, Naples

It is hard to tell if these are simply musicians who are taking their turn on the boards of a makeshift stage—to be succeeded by other acts—or whether they are participants in some elaborate comedy. They are masked, which gives them a formal theatricality, and there is a large door in the right quadrant of the stage. Vitruvius tells us that comedy is played before the facades of private homes, after the manner of ordinary dwellings, while tragic scenes are delineated before palace facades with columns and statues sacred to kings. The urban house facade of Pompeii, with its doorway and solid walls, resembles this set. It has also been suggested that this is a troop of metragyrtes, begging musicians in the service of Cybele, who figure in comedy and performed during intermissions.¹

All the instruments, or variants thereof, are still in use today. The figure at right does a little dance step, while accompanying himself on the tambourine. The characteristic gestures of someone dancing to this instrument are faithfully captured by the artist. The musician at center is wreathed and masked, as is the tambourine player; he dances and plays along with finger cymbals. The woman, attired in the mask and vestments of a courtesan, seems to blend into the wall, especially since her feet are not shown. She plays the double flute, or diaulos. To the left may be a small boy, but since he sports a five o'clock shadow, he is most often identified as a dwarf. Romans had something of a fascination for dwarfs and African pygmies. They are the subjects of a number of wall paintings at Pompeii, particularly those of Nile scenes.

The mosaic is small ($16 \frac{7}{8}$ " x 16") and is carefully composed of many tiny tesserae. It is one of the few works of the region to bear a signature, Dioskourides of Samos (in Greek letters), and although it is clearly a masterpiece and dates to ca. 100 B.C., we do not know if Dioskourides was the artist of this mosaic or if he was responsible for the prototype executed in the third century B.C., of which this is a copy.

1. Kraus, 47

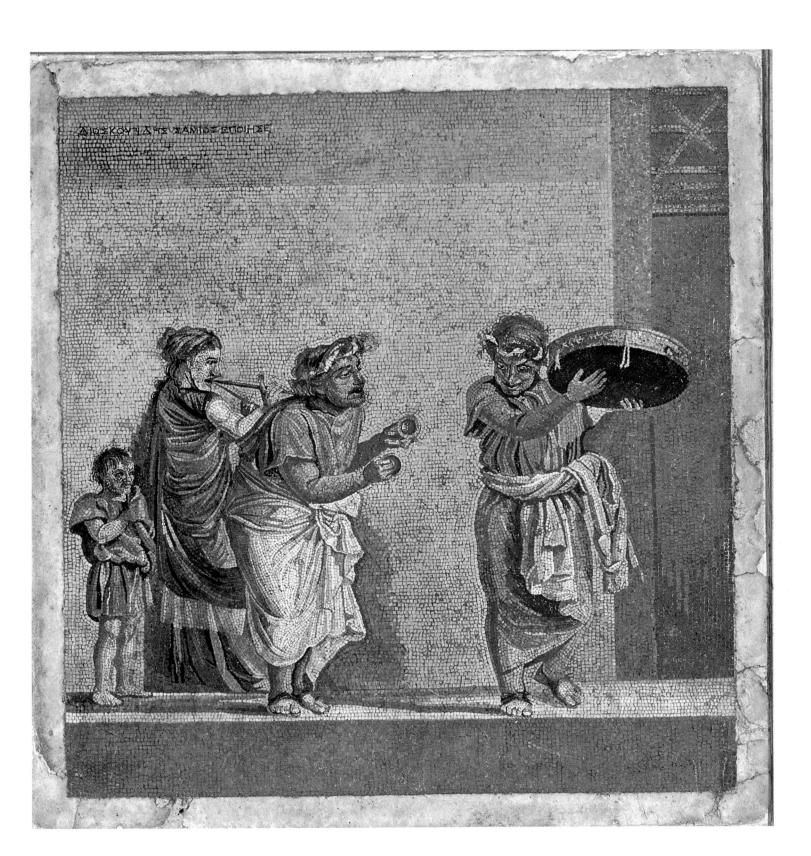

Consultation With a Sorceress

Mosaic from the so-called Villa of Cicero, Museo Nazionale, Naples

T his mosaic of a theatrical scene from the so-called Villa of Cicero is a companion piece to the preceding illustration and, like it, is signed Dioskourides of Samos. The scene is set within a small room, on a raised platform of three steps. Three women have gathered around a low table. The old woman at right wears the mask of a sorceress or witch. The other two have apparently come to consult with her, probably about an unrequited love. The old woman has prepared a brew into which she may have thrown some of the leaves from the branch which rests on the table. She conjures up the answers to the maiden's questions by consuming the brew, which she holds in one hand, or by reading the pattern of leaves within. She holds her left hand out expressively as if to emphasize her oracular pronouncement. The woman at center is the maiden client, though in reality she may be a false maiden, of the type that figures frequently in comedy and is described in the lists of Pollux. She echoes the gestures of the sorceress and clearly hangs on every word. Her dependency on a witch rather than on her own inner resources may explain why she has failed to get her man.

The woman at right sits on a richly cushioned and tasseled stool and immodestly straddles one leg of the table with her own. She may be an older friend of the girl at center, and in comic plays of this type she is often a courtesan. Open mouths are characteristic of the masks of both courtesans and false maidens, and so it is hard to say whether they are simply listening or are chanting in unison with the sorceress.

The lower step is richly ornamented with a variant of the egg-and-dart motif, the middle one bears a series of golden griffins, and the topmost step may be ornamented with faint bucrania. The room is interestingly shaded by tiers of light composed of vertical bands of different-colored tesserae, which recede into the picture plane at left. The table, whose legs end in lions' paws, is shown in exquisite, foreshortened perspective. On it, in addition to the branch, is a dish that probably held a potion, and a brazier which served to heat the brew.

Alogkovijahe zamoz enomije Konskantinika karantinika

is no neneno no no neneneno

The Amphitheater of Pompeii

T HE AMPHITHEATER OF POMPEII is the oldest of its kind. It was erected in 70 B.C. by Quinctius Valgus and Marcus Porcius, the same duoviri who had built the small theater. It occupies a beautiful plot of land in the eastern end of town, situated between three towers of the city walls, and adjoining the palaestra on the west with its great outdoor swimming pool. Directly to the north is the magnificent broken cone of Mount Vesuvius.

The amphitheater is sunk into the ground, so that the arena floor and lower tiers are below ground level. Its measurements are 444 feet long by 342 feet wide, smaller than the Roman Colosseum, which it predates by 150 years. It had places for 20,000 spectators, enough for every inhabitant of town, but it is likely that it drew its audience from the surrounding area as well as from Pompeii. It had none of the subterranean passages, rooms, and elevators for animals, which were to be found later at the Colosseum and elsewhere. However, it was equipped with a velum—an awning or linen roof—raised to protect the audience from the heat of the sun.

The attraction of the arena consisted of gladiatorial games and animal baiting, and this was no place for the squeamish. Spectators came to see combatants killed, and substitutes were sometimes provided to take the place of the killed and wounded, lest the action flag. Graffiti summarize the results with a startling brevity: "Pugnax, Ner III, vicit. Muranus, Ner III, periit." (Pugnax, from the training school for gladiators founded by Nero, 3 former combats, victor. Muranus, from the training school for gladiators founded by Nero, 3 former combats, killed.)¹

The precarious life and fleeting fame of the gladiators had an irresistible allure for some. They are variously described in surviving graffiti as "master," "healer," "answer to a maiden's prayer." It should be recalled that Spartacus led a temporarily successful revolt of gladiators in Campania in 73 B.C., for a while making his camp on the slopes of Vesuvius. Unfortunately, few Romans objected to the games. One who did was touchingly remembered in a graffito from the dining room wall of the gladiator's barracks, "The philosopher Seneca is the only Roman writer to condemn the bloody games."

1. Mau, 223 2. C.I.L., IV, 4870, 5275 3. Grant, 74

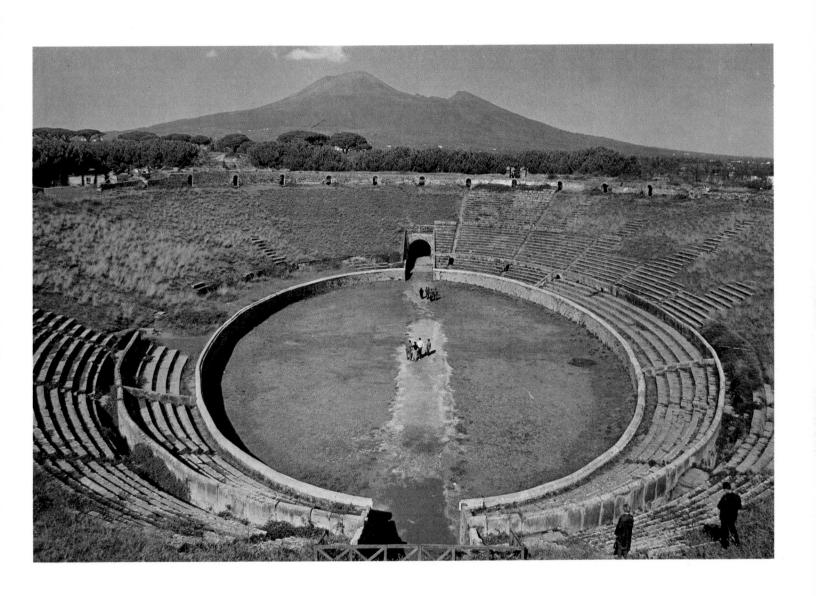

Chariot Race

Wall painting, Museo Nazionale, Naples

As far as we know, there was no permanent circus or hippodrome for horse racing at Pompeii or Herculaneum, and the arena of the Amphitheater of Pompeii would have been too small to allow for the racing of the four-horse chariots shown here. However, it would have been comparatively easy to set up the elements of a temporary track in a long field, the essential requirement being a low barrier called a *spina*, which ran the length of the field and around which the chariots were driven.

As these chariots were drawn by four horses, they were known as *quadrigae*, and their drivers called *aurigae*. This painting shows four chariots tightly vying for position. The drivers are dressed in the colors of the main racing factions of the day: green, red, blue, and white. As Alan Cameron points out in his *Circus Factions*, each color had a national and at times a fanatical empire-wide following. The Blues and Greens, who eventually absorbed the other colors, claimed a following of whole populations, who descended upon the tracks ready to root for their color and if need be to do battle for it. It has been argued that the emotions aroused by the theater occasionally produced results more bloody than the circus disturbances, but it is a fact that the passions engendered by the colors were so heated that a riot at the Circus of Constantinople in 532 left much of the city in ruins, and approximately thirty thousand dead. While riots such as this one sometimes manifested popular political unrest, the element of pure factional malice was rarely far removed and is reflected in this surviving inscription penned by a Green, "Burn here, burn there, not a Blue anywhere."

Passions of a somewhat comparable type erupted in the Amphitheater of Pompeii in 59 A.D. During the display of a gladiatorial show given by the disreputable ex-senator Livineius Regulus, Pompeians and a contingent of spectators from near-by Nuceria came to blows, and many were killed, especially from Nuceria. The matter was taken to Nero, who forbade the holding of games at Pompeii for ten years. Nero's wife, Poppaea, who had family in Pompeii, may have persuaded him to moderate this edict. The riot was described by Tacitus in the *Annales*, and is commemorated in a surviving wall painting from Pompeii.

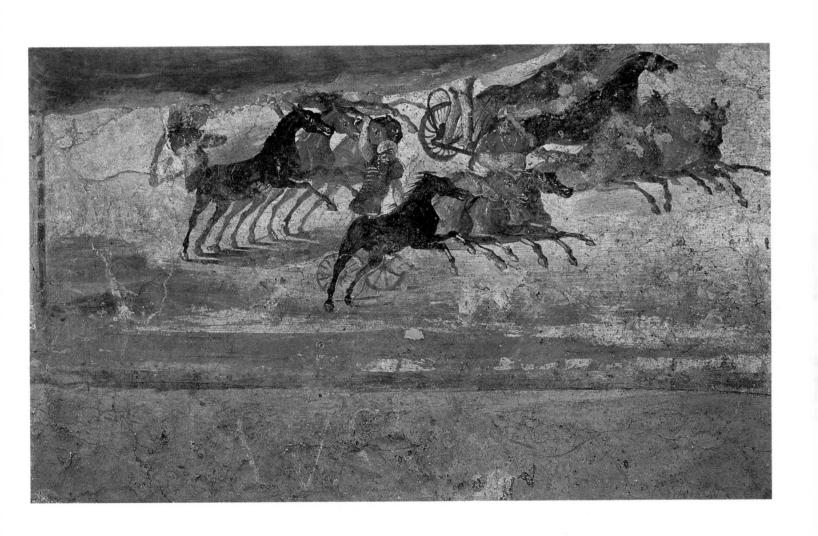

Wall Decoration With Apollo Victorious Over Python

House of the Vettii, Pompeii

T HE LOWER REGISTER OF THIS decorative wall is devoted to the early exploits of Apollo. Indeed, this is an unusual instance of a Roman work that combines episodes from several stories into one brief scene, a practice made common by later Christian artists who often infused their works with allusory symbolism.

Beneath a column to the left of center is the dead Python, offspring of Gaea and guardian of the seat of prophecy at Delphi. Apollo has slain it and thereby obtained control of the prophetic shrine, whose oracle subsequently prophesied in his name. He is said to have slain the Python with his first arrow shot, and having accomplished the task, he has hung his bow and quiver on the column. The dead and bleeding serpent is curled around the *omphalos*, a hemisphere that stood within the shrine and symbolized the center of the earth. Apollo, nude but for a flowing red cape, plays the lyre at right. The woman at the far right is most probably his sister Artemis with a staff and her attributes of bow and quiver. Apollo may be playing and singing a paean, a hymn that was often sung to him and sometimes to Artemis on occasions of thanksgiving for a victory or rescue.

The Pythian Games, which were second in importance only to the Olympian, were held in honor of Apollo at Delphi. They featured a musical contest celebrating the victory of the god over the Python. Winners were awarded wreaths and victory branches. In an allusion to this practice, Apollo wears a wreath, and a bough is seen at his feet.

The figures at the lower left have often puzzled observers, but the presence of the bull or cow—which may later be sacrificed—is almost certainly a reference to the story of the dispute between Apollo and his half-brother Hermes. Hermes is said to have invented the lyre on the morning of his birth, and to have stolen Apollo's herd of cattle in the afternoon. Apollo was so enchanted with the lyre that he forgave Hermes and allowed him to keep the herd in exchange for the instrument, which was forever after associated with Apollo. The figure at center and the bull or cow seem to be puzzled by Apollo's poor bargain, but Apollo clutches the lyre and appears to move away with it. A priestess standing by the animal holds the emblematic wand of Hermes, the caduceus, and points upwards.

Hermes himself appears in the second register, in the form of two columnar hermae, who flank the gilded woman playing the cymbals. She stands in front of an oval band of red and gold and is framed by lovely small blossoms of red, yellow and white. In turn, she supports a heavy candelabrum that rises above her, ornamented by tendrils and acanthi.

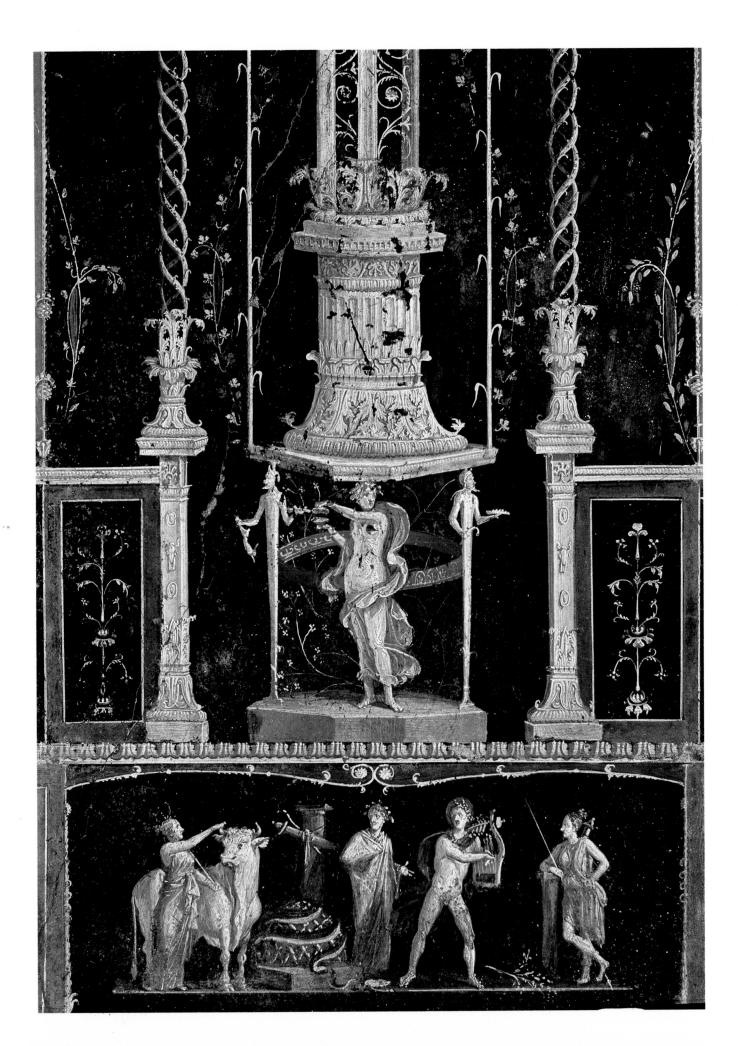

Three Graces

Museo Nazionale, Naples

T HE THREE GRACES ARE PROTOTYPES for beauty, grace, and artistic inspiration. They are the offspring of Zeus by different mothers, and although their number was originally indefinite, from Hesiod on they are usually spoken of as three: Euphrosyne (Joy), Thalia (Bloom), and Aglaia (Brilliance).

They make the spring flowers grow and have roses and myrtles as attributes. Generally, they symbolize the joys and benefits of fertile nature, but they are also fond of poetry, song, and dance, and are therefore invoked by poets, musicians, and all creative artists. They play supporting roles in many myths and are most often associated with Apollo, Eros, Aphrodite, and Dionysus.

In Greek, they are called Charites, and as models of beauty and grace, are represented in the form of beautiful maidens. Innumerable Roman representations of them survive, showing them standing side by side, usually nude, wreathed, and often holding spring flowers.

As they personify ideals of feminine beauty, their representations reflect the taste of the artist, and possibly of the age, in such matters. The Roman versions go back to a famous Hellenistic prototype, but the countless copies indicate it had an almost pin-up like popularity.

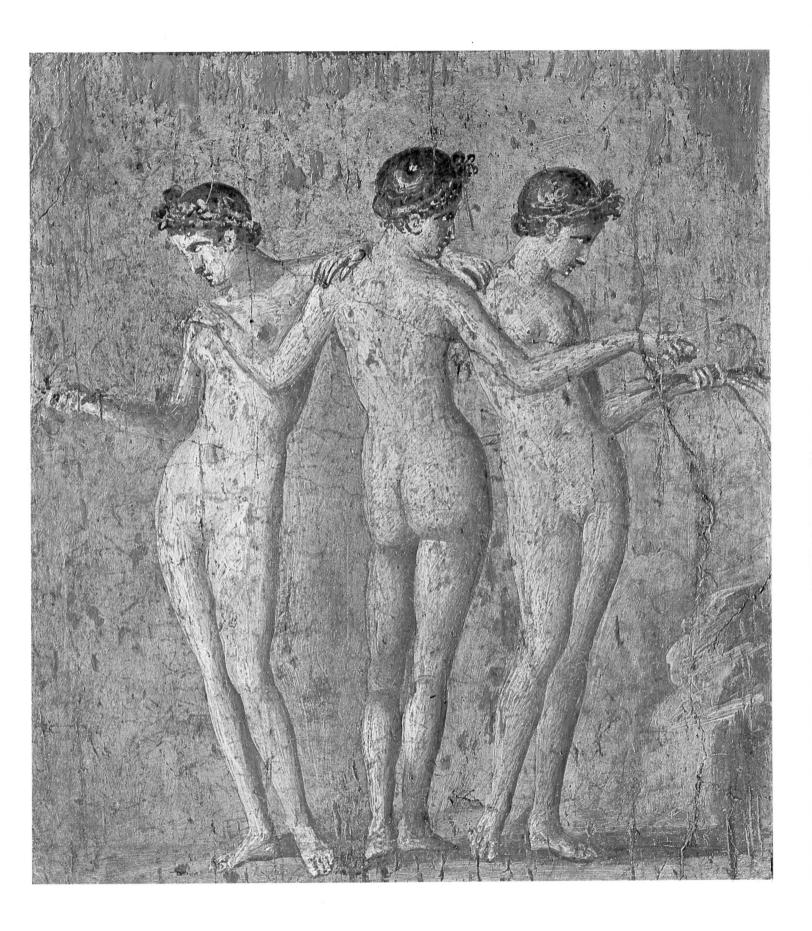

Perseus Frees Andromeda

From the House of the Dioscuri, Pompeii, Museo Nazionale, Naples

Andromeda, the woman shown here, was the daughter of the Ethiopian king Cepheus. When Cepheus's wife boasted that she was fairer than the beautiful nymphs of the sea, Poseidon punished her impiety by plaguing the land with a flood and a ravaging sea monster. Cepheus was informed that the only way to assuage the deity was to expose Andromeda to the sea monster by chaining her to a rock along the coast.

At this point in both story and painting, Perseus happens along, having recently beheaded the Gorgon Medusa, whose glance turns viewers to stone. He falls madly in love with Andromeda and obtains permission to marry her, provided he kills the monster and frees her. This he does, and here he is shown helping Andromeda down from the rock, holding her arm aloft, as if announcing a victory. Andromeda wears a gold and blue chiton, while he is nude save for a cape and winged sandals given him by his patrons Hermes and Athena. The sea monster lies dead in the left-hand corner.

Perseus still carries the head of Medusa, which he will soon need, but holds it behind him, shielded between thigh and cape, lest Andromeda suffer by looking upon it. At the wedding, Andromeda's uncle Phineus, to whom she had formerly been engaged, attacks Perseus, who turns his rival to stone by exposing the head. The couple go off to Argos and Tiryns, where they remain faithful to one another and produce six sons and a daughter.

There are many depictions of the episode, but this copy is thought to be the most faithful replica of the original painted by the Athenian Nikias (active in the latter half of the fourth century B.C.), famed for his ability to convey mass. Here, the statuesque figures are classical: Andromeda's robes fall in harmonious folds, and where they cling to the knee and leg, model them convincingly. Also typically classical is the accurate display of external anatomy, and the absence of emotions. The rocky coastline has some of the elements of a seascape. Nikias was praised in antiquity for his skill in making figures appear to stand out of his work. His sculptural qualities may derive from his experience in polychroming statues, an ability that was greatly prized by the sculptor Praxiteles.

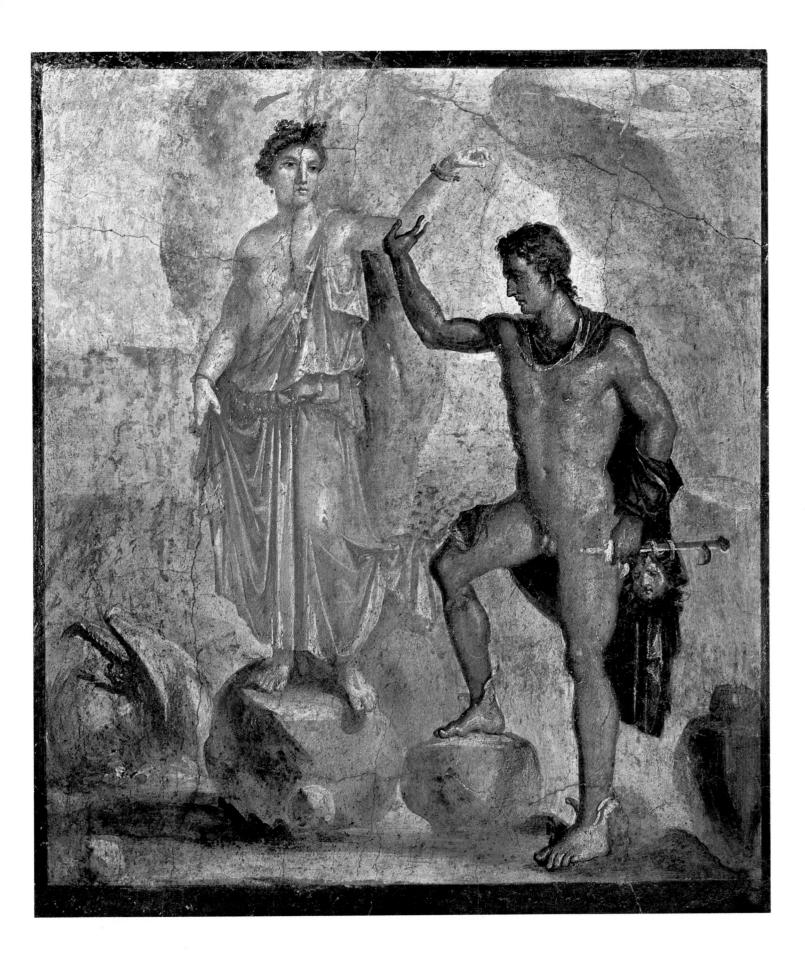

Pentheus Slain by Maenads

Wall painting from the House of the Vettii, Pompeii

 $T_{\rm HIS}$ symmetrical composition depicts the slaying of Pentheus by the Maenads. The story is fully told by Euripides in his *Bacchae* (written ca. 407 B.C.). Pentheus, son of Agave and Echion, was sovereign of Thebes. Of rational disposition, he refused to believe in the divinity of his boastful cousin Dionysus, who claimed to have been fathered by Zeus through Agave's sister, Semele.

Dionysus has just returned from the East, where he has successfully spread his rite, and has begun to gather a cult of maenads in Thebes. The maenads (also called Bacchantes) are bands of women who celebrate the god's gift of wine and unbridled love, through mysterious rituals and frenzied orgies. Pentheus's own mother, Agave, has become one of the maenads.

When the king hears that the cult intends to celebrate a Bacchic festival on Mount Cithaeron, he is persuaded to go there in disguise to observe the rites in secret. On Mount Cithaeron, he is discovered by the entranced and frenzied maenads, who take him for a wild lion and tear him to pieces. His own unknowing mother leads the way, aided by her sisters, Ino and Autonoe. In this manner, the implacable Dionysus takes his vengeance on the entire family.

In the painting, Pentheus is driven to the ground on Mount Cithaeron. The woman at right is his mother, for Euripides tells us she was the first to set upon him, and "seizing his left arm at the wrist," tore it out. The woman at left is probably Ino, who "scratches off his flesh." She bears a thyrsus, the pine-cone tipped staff carried by Dionysiac revelers. Directly behind is Autonoe, and two other maenads are at the sides. A few rocks and a boulder at rear set the mountain scene. The overall impression is one of violent agitation and wild excitement, heightened by the many nervous little folds of the billowing dresses, and by the busy, indistinct, and unsettling background.

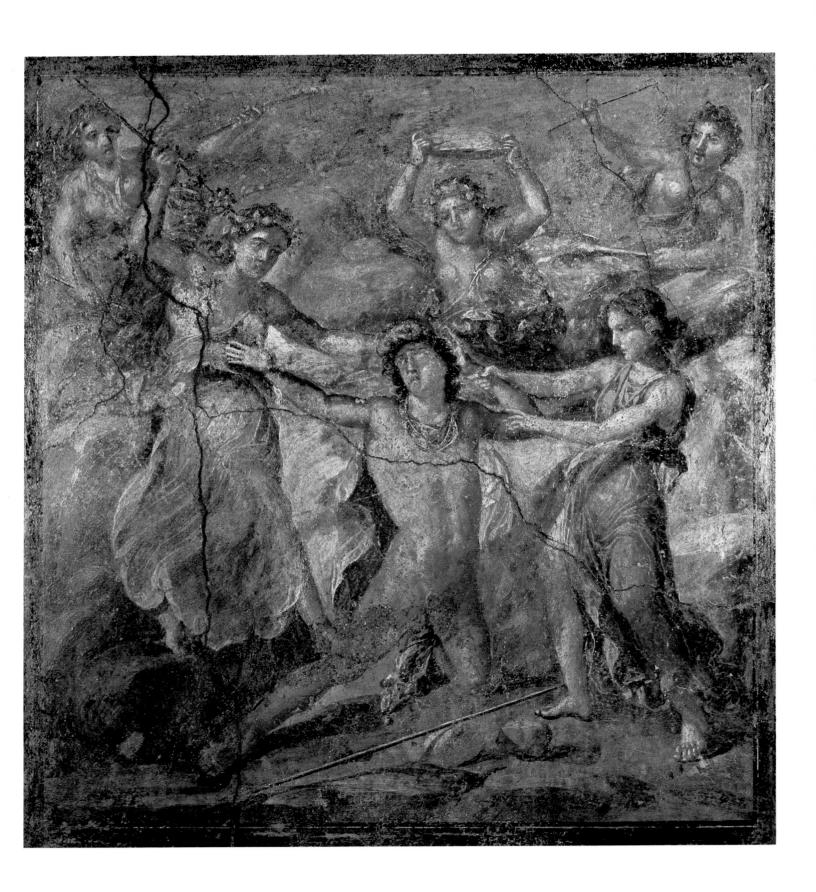

Chiron Teaching Achilles to Play the Lyre

Wall painting from the Basilica of Herculaneum Museo Nazionale, Naples.

ALTHOUGH CENTAURS ARE UNPREDICTABLE and wild creatures, often to be feared, one among their number had a reputation for civility and culture. This was the wise Chiron, who is said to have taught the art of healing to Asclepius, the Greek god of medicine. He is a tutor to many of the gods and heroes.

Peleus, the father of Achilles, puts his son in the hands of Chiron for tutelage and safekeeping. On Mount Pelion, the abode of the centaurs, Chiron instructs the boy in all the arts, and strengthens his body by feeding him on the entrails of lion and marrow of bear.

The masterful painter has transferred the scene from the wilds of Pelion to the interior of a richly decorated palace. There the centaur teaches young Achilles to play the lyre and holds a plectrum to the strings. Achilles looks up with the anxious expression of a novice, while placing his own fingers against the strings. Both are dressed in capes alone: Chiron's is made of the hide of an animal, possibly a lion, in the style of Hercules. This complements his forceful build, which is herculean in proportion. The lower body, that of the horse, reposes on its hind quarters.

The ornate room is richly adorned with gilt paneling, surmounted by a frieze of alternating medallions and ox skulls (bucrania). The light entering from the right falls fully on the face of Achilles and the upper body of Chiron, while leaving the equine half in shadow. Similarly, the colors of the spatially convincing room are brighter on the right side, where the light is stronger. The external anatomies, and the relationship between teacher and pupil are beautifully portrayed. This is an undoubted masterpiece and is a companion painting to one depicting Hercules discovering Telephus, also from the Basilica of Herculaneum, in which the features of Chiron are reproduced in the face of Hercules.

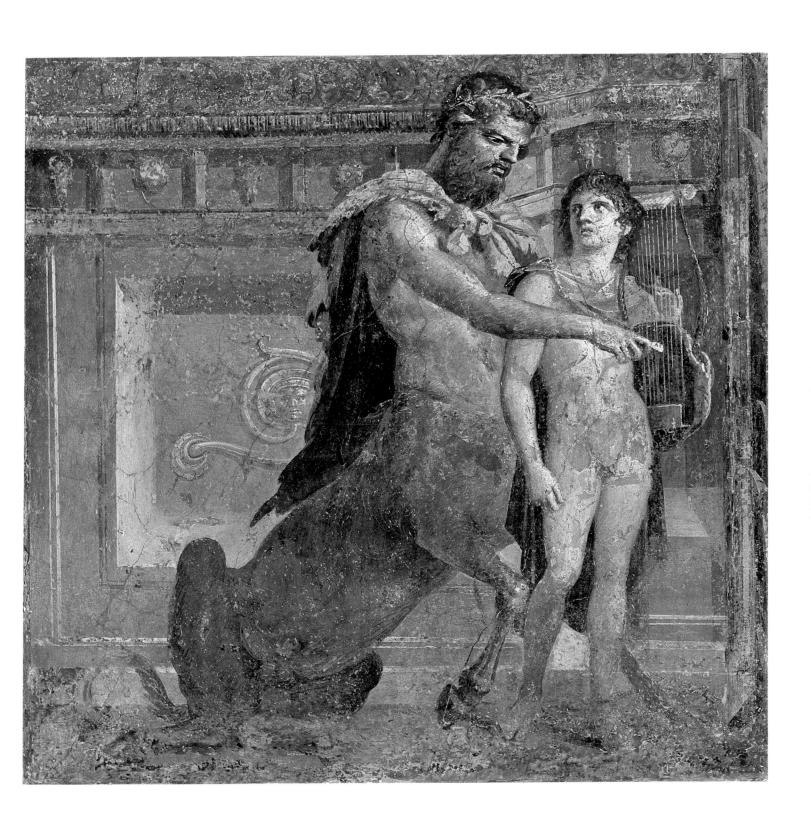

Hercules Strangles the Serpents

Wall painting from the House of Vettii, Pompeii

Zeus sleeps with the mortal alcmene, wife of Amphityron, prince of Tiryns, and their offspring is Hercules. Hera, the lawful consort of Zeus, learns of this liaison and vows undying hatred for Hercules.

Hera sends two serpents to strangle the newborn infant in his crib, but as we see in this painting, Hercules resists and eventually defeats them. The sceptered prince, Amphityron, is seated on his throne and looks on in wonder. He does not know that he is not the father of this prodigious infant. Behind him, the knowing and frightened Alcmene turns as if to flee. The boy at left is not part of the original story and has probably been introduced to balance the composition. Behind Hercules is a high altar on which an eagle perches and a garland has recently been placed, probably to celebrate the birth of the infant. Whether a piece of sculpture or a real bird, the eagle indicates the presence and guardianship of Zeus. The coffered room opens in the rear onto a vista of pale blue sky and the Ionic facade of an imposing temple.

This is the first great feat of Hercules, and although the designs of Hera are defeated here, she pursues him implacably for the rest of his life. It is she who inspires the Delphic Oracle to direct Hercules to enter the service of Eurystheus and to undertake the twelve labors. The second labor, the contest with the hydra snake, evokes the earlier battle with the serpents. For every head of the hydra cut off by Hercules, two new ones appear.

Hercules is the patron deity of gymnasia and palaestrae. He is invoked against poisonous snakes and is the hero of labor and struggle. He is usually shown nude, and his attributes are the lion skin and club. A toy club is shown here, propped against a rock in the foreground. Early Greek colonists spread his worship in southern Italy, and Herculaneum traces its name and founding to him.

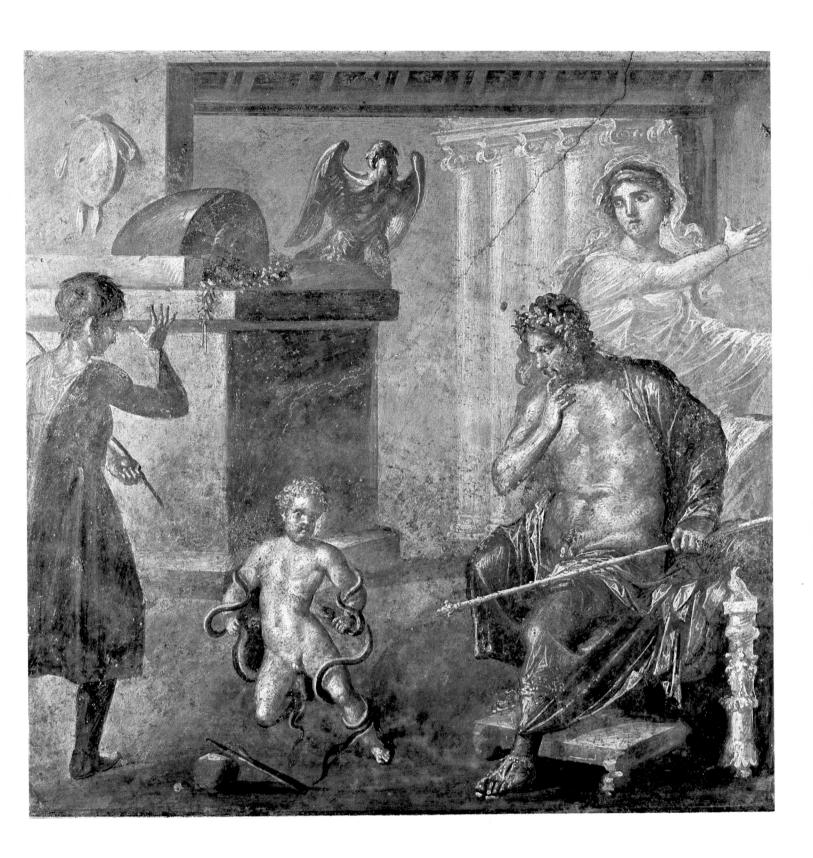

The Ixion Room

House of the Vettii, Pompeii

T He IXION ROOM OF THE HOUSE of the Vettii derives its name from the painting at the far right. It depicts Ixion being put to the wheel, his punishment for affronting the chastity of Hera. The painting at the far left shows Daedalus presenting the wooden cow to Pasiphae; it is discussed separately in the next commentary.

The room illustrates the complexity of late Pompeian wall decoration, sometimes called the Fourth Style, and dating to ca. 50–79 A.D. The walls are divided vertically into three tiers or registers. The lowest tier, the dado, is painted in imitation of variegated marble slabs. Early Pompeian wall decoration, the so–called First Style (ca. 200–80 B.C.), was composed almost exclusively of stuccoed walls painted in this manner to simulate blocks of marble.

The wide central register bears the principal wall paintings, the Ixion and Daedalus scenes mentioned above. These are bordered by thin dark strips, which create an impression of framed panel paintings attached to the wall of a museum or gallery. Visually complicating the central tier are auxiliary motifs having no relation to the main subjects they adjoin. These include a naval battle between oared galleys, a still life, theatrical masks, a winnowing basket, and airy pavilions, which open on infinitely clear but skyless vistas. The large white panel near the juncture of the two walls contains two lovely floating figures, a satyr and Carpo, goddess of the fruits of summer.

The upper tier is composed exclusively of fanciful architectural motifs that meander in and out, forming a running gallery of balconies, loggias, and verandas. Framed within some of these spaces are formally posed deities, who stand like well-trained extras in a theatrical spectacular. The airy architecture of the upper register and the pavilions of the central tier appear to open the chamber to undefined, limitless vistas, an illusion that expands the confines of the windowless room.

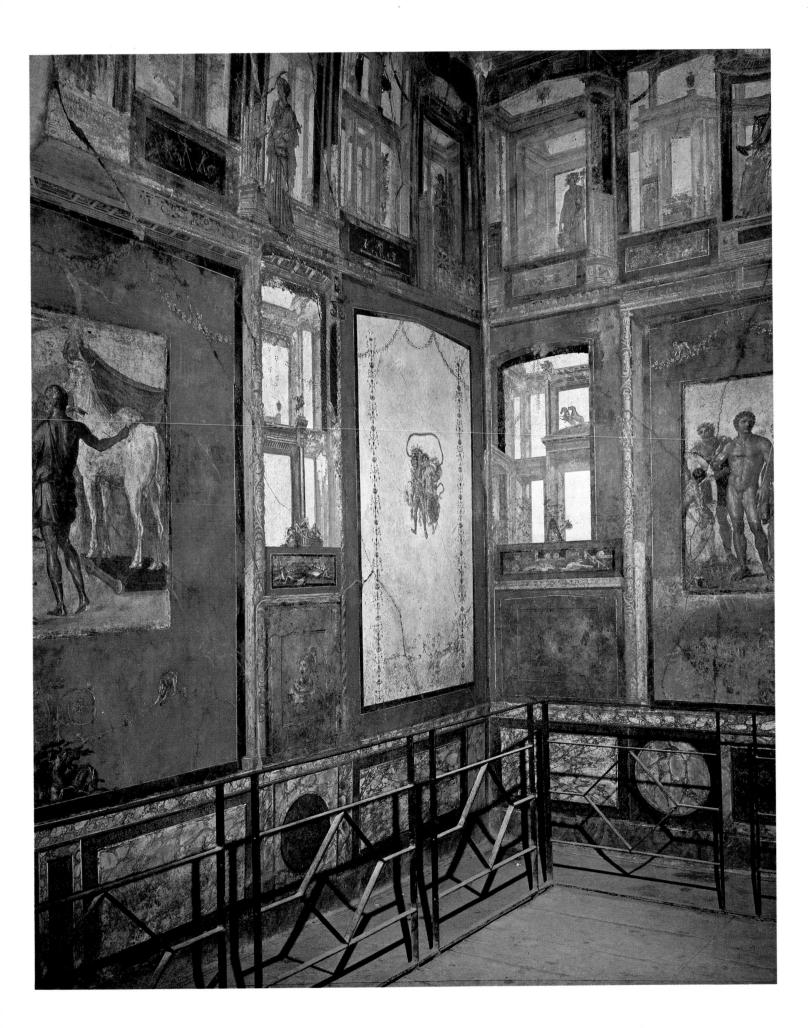

Daedalus Presents the Cow to Pasiphae

Wall painting from the House of the Vettii, Pompeii

 $P_{\text{ASIPHAE HAS COME TO VISIT}}$ the great inventor Daedalus in his studio. She is married to King Minos, who has just consolidated his rule over Crete. Minos implored his patron deity, Poseidon, to send him a bull so that he might sacrifice in thanksgiving. The god raised a great unblemished white bull from the sea, but Minos was so taken with it that he reneged and decided to keep it for his herd. To punish him, Poseidon causes Pasiphae to fall madly in love with the bull.

Not knowing how to consummate her love, Pasiphae seeks out the inventor Daedalus. He fashions a wooden cow for her, which he invites her to enter, so that she might mate with the bull. Here, the standing Daedalus displays the cow, which is mounted on a low wheeled platform. He holds open the trap door that will admit her. Her attendants are much taken by the invention, one points to it while another puts her hand to her mouth in awe. Pasiphae gazes at it intently. In her upraised hand she holds a gold bracelet, now only barely visible, which may be the reward she bestows on Daedalus. The little boy at front right, who works at a carpenter's bench, is certainly Daedalus's son, Icarus. Daedalus is the inventor of carpentry and of many of its tools—including the awl with which the boy works. Icarus inherited his father's creative and inventive traits, but not his prudence.

The room is low and plainly decorated. The figure of Daedalus is turned into the picture plane, drawing the viewer's attention within. The modeling for him is very sculptural, almost too much so by comparison with the other figures. The painter has given him an overall bronzelike coloring, which clashes with the treatment of the other characters. Given the typical classical pose of resting the weight of the body on one leg, the artist may have modeled Daedalus directly from a piece of sculpture. His outstretched arms bisect the picture surface; they encompass the moment by pointing with one hand to Pasiphae and with the other to the cow.

Later, Daedalus and Icarus are imprisoned in the maze constructed for the offspring of this unnatural union, the Minotaur. They fashion wings of wax feathers and fly out, but when Icarus soars too close to the sun, the wax melts and he plummets to his death in the sea, forever after a paradigm for "one who would fly too high."

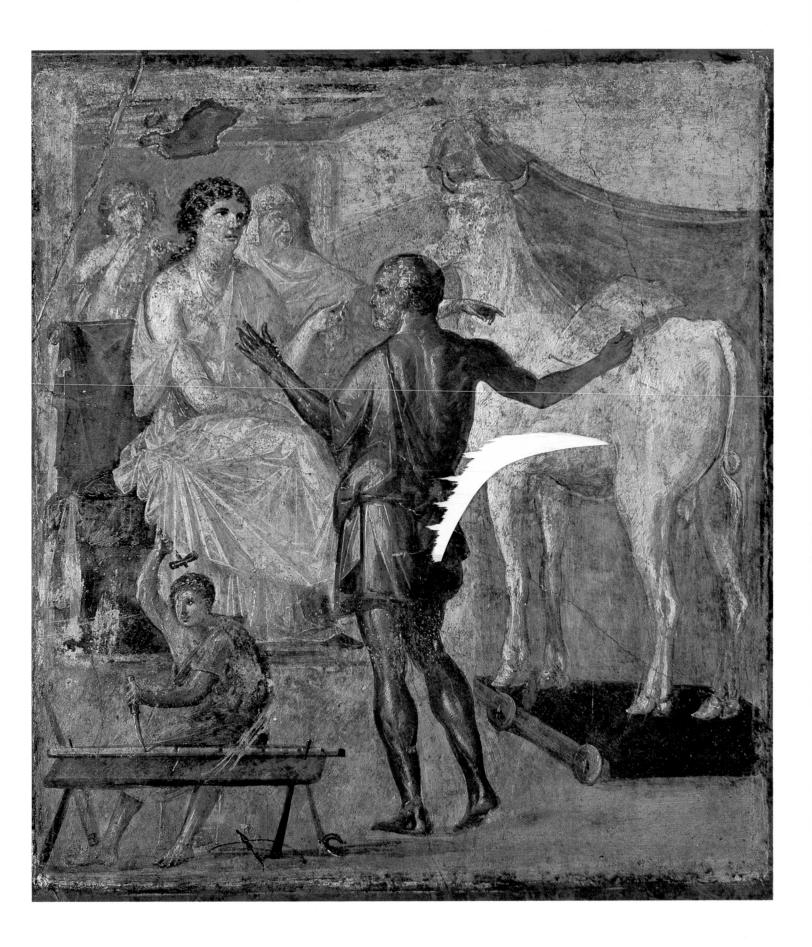

Sacrifice of Iphigenia

Wall Painting from House of Tragic Poet, Pompeii, Museo Nazionale, Naples

T HE STORY OF THE SACRIFICE of Iphigenia bears external resemblance to the sacrifice of Isaac by Abraham. Artemis, goddess of forest and the chase, has been angered by Iphigenia's father, Agamemnon; he has killed a hind sacred to her and boasted that he was a better hunter than she. As a result, she detains his ships bound for Troy at Aulis and lets it be known through the augur Calchas that only the sacrifice of Iphigenia will appease her. According to another version, Agamemnon had once vowed to sacrifice to Artemis the fairest thing brought forth in the year of Iphigenia's birth. He did not know that Iphigenia herself would one day be declared the fairest that year.

The seer Calchas is shown at right, waiting beside an altar. He is dressed in sacerdotal robes, holds a sacrificial sword, and has a long patriarchal beard, very much the way Abraham is customarily depicted as he sacrifices Isaac. Calchas doesn't really want to perform the sacrifice and puts his fingers to his mouth in a delaying gesture of perplexity. Two men, identified as the bearded Ulysses and Achilles, carry Iphigenia to the altar. They are also reluctant, and look about them as if hoping for a countermand. At the left is Agamemnon, too grief stricken even to look at his daughter. Standing by a columnar shrine of Artemis, he veils his head and looks away. Pliny the Elder attributed the inventive emotional expressions of the participants to the painter Timanthus (ca. 400 B.C.), and said that by the time he painted the father the artist had exhausted individual expressions of grief and so "veiled the face of Agamemnon, for which he had in reserve no adequate expression."

The story ends much as does the sacrifice of Isaac. Artemis appears in the clouds above at right, and just as the sacrifice is about to be carried out, she summons a nymph to bring a hind, which will serve as a substitute for Iphigenia. The despairing daughter does not know she will be saved, nor is she as resigned as Isaac. As Aeschylus says, she let her robe fall to the earth, then turned and looked at each of them, "and smote each one with the piteous glance of her eyes."

The artist sets the scene as if he were directing it on a narrow stage. The mortal characters are frontal and in the same foreground plane. Their crisp classical figures are outlined against a neutral backdrop and a few strewn rocks serve to establish an outdoors scene. The deliberate theatrical poses remind one of the silent movies.

1. Agamemnon, 239-241

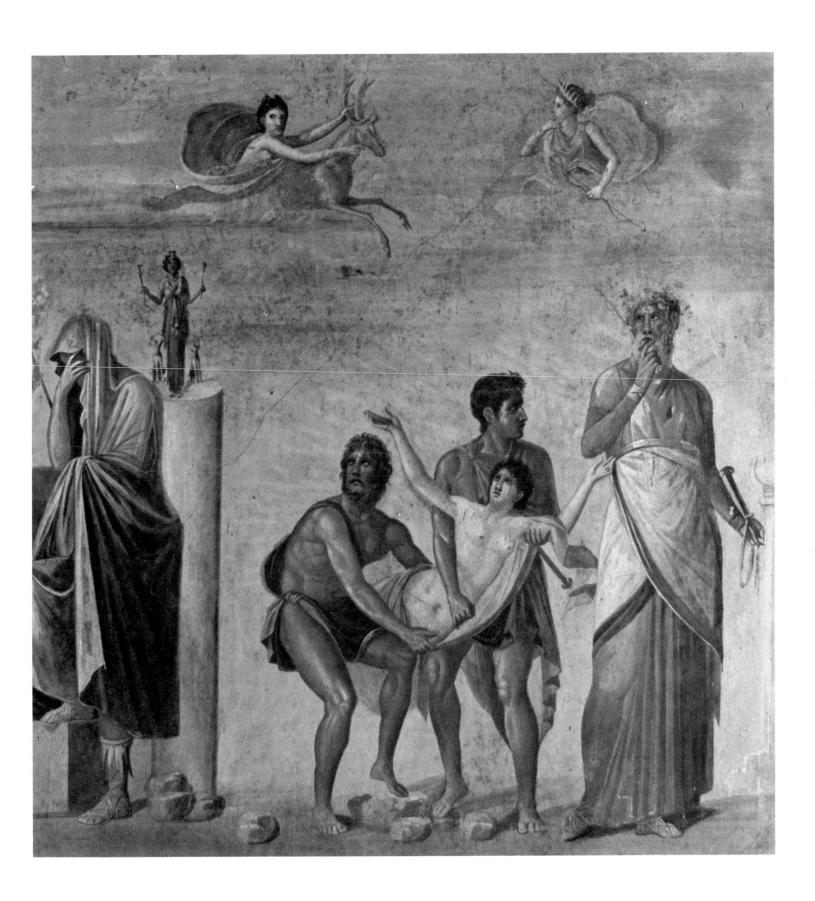

The Surrender of Briseis

From the House of the Tragic Poet, Pompeii

T his damaged late pompeian wall painting depicts Achilles surrendering his beloved captive Briseis to the heralds of Agamemnon. The artist paints the story exactly as Homer related it in the lliad (I, 320–355). Agamemnon, commander in chief of the Greek forces besieging Troy, is forced to relinquish a captive girl dearer to him than his own wife. He agrees to do this on condition that he be compensated by the surrender to him of the "fair-cheeked" Briseis, a captive awarded his ally Achilles. Achilles has fallen in love with Briseis, and views the request as a grave insult. Although he accedes to Agamemnon's impolitic demand, he prays for vengeance and temporarily withdraws from the Greek alliance.

The two men in the damaged portion at the left of the painting are Talthybios and Eurybates, the heralds sent by Agamemnon to claim Briseis. One holds his gold mantle in his outstretched hand, and the other bears a caduceus, the identifying staff of a herald. Achilles is enthroned at center in front of his tent, which has been pitched on a beach. To the left of the tent are the very faint outlines of the curved prows of his ships. He looks towards Briseis (far right), who is partly veiled and wears a ring similar to his own. Achilles motions toward the heralds, and instructs his faithful kinsman Patroclus to conduct her to them. Patroclus—shown with his back to us and his head in profile—takes the wrist of Briseis, who sadly obeys. Looking down over the throne of Achilles and wondering about the fatal consequences of this event is Phoenix, Achilles' old tutor and companion.

Six fully armed soldiers look on ominously from behind. Their shields highlight the heads of the principals, but they also serve to obscure their own faces. In so doing they symbolize the faceless and unthinking destruction which often attends such happenings, and which in this case will result in initial defeats for the Greeks and a heroic death for Achilles, who at the last moment intervenes on their behalf.

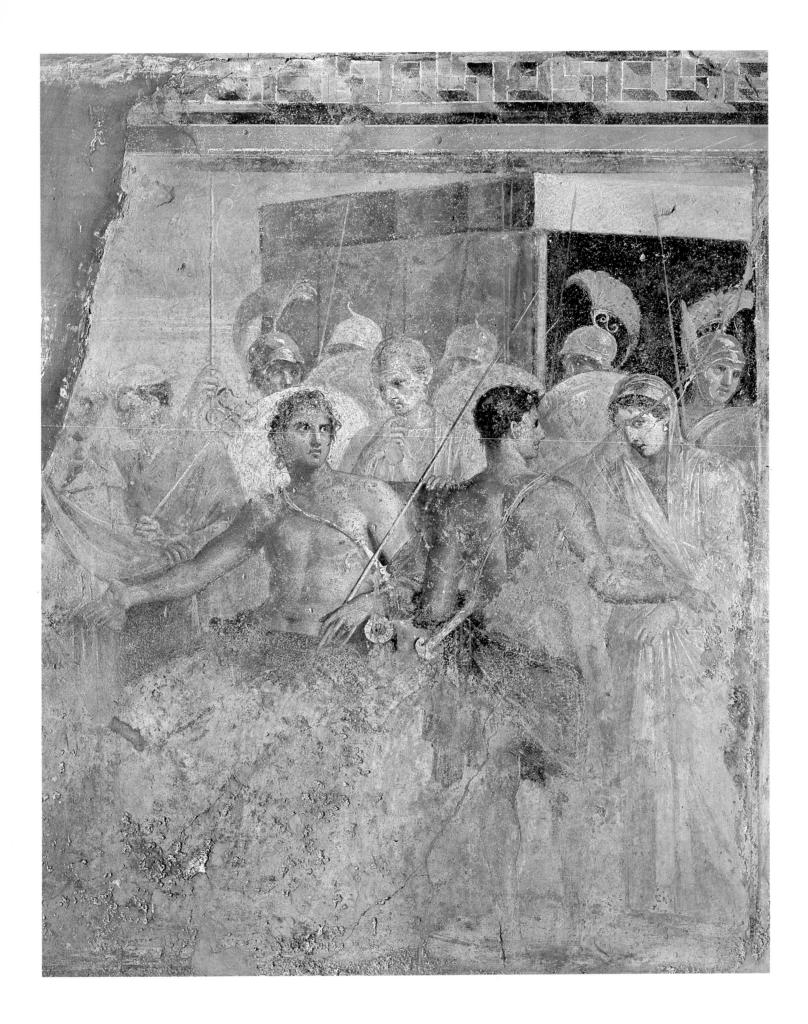

Primavera

From a Bedroom of a Villa in Stabia, Museo Nazionale, Naples

T HIS GRACEFUL YOUNG WOMAN picking flowers in a field has come to be called Primavera (spring). Her image has created a lasting impression on western art. Like the Three Graces, who partially inspire this figure, she is associated with spring flowers and represents an ideal of female beauty. She is specifically modeled after the middle figure among the Graces, usually identified as Thalia (Bloom), who also stands with her back to the viewer and holds or reaches for flowers with her outstretched right hand.

She is seen walking through a cool verdant field, barely pausing to break a sprig of flowers, which she places in her ample cornucopia. The graceful movement is conveyed through the bent knee and the lower part of her chiton, which is wafted by a breeze. She wears both her garments unselfconsciously; the sleeveless chiton slips to the side, revealing her back and left shoulder, and the practically discarded white outer garment hangs loosely around her torso. For the moment, she expresses the sense of joyful freedom and harmony with nature that we associate with ancient Rome at its best.

The evocative natural surroundings are represented as much by implication as by statement. The flowering shrub alone establishes a clear vernal setting, but having painted it, the artist employs a plain sea-green background to fill out the suggestion of a fresh spring day. No other scenery is included, but it is the light that finally completes the impression. With small splashes of yellow and violet, the spring sun dapples her robes and body in almost pointilliste style. Her back is turned towards us, and we cannot see her features. What is concealed may be more beautiful still, and what is not revealed cannot disappoint.

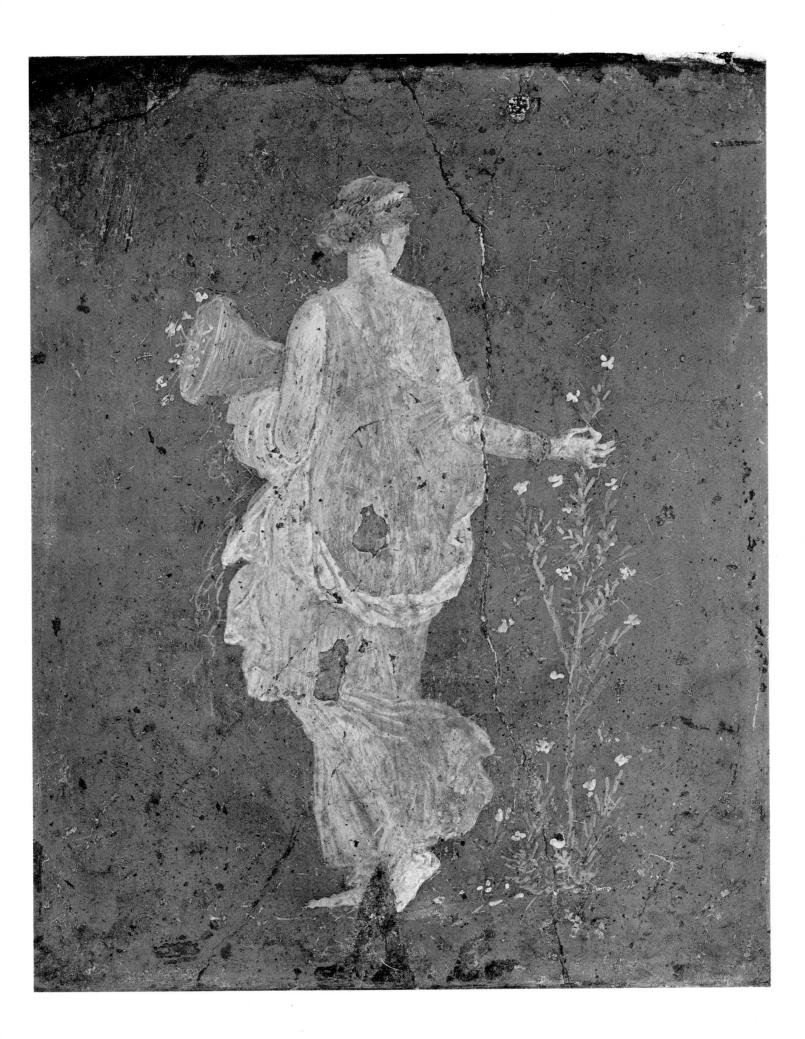

Diana

From the Bedroom of a Villa in Stabia Museo Nazionale, Naples

T his depiction of the goddess Diana is one of four small mural paintings of women that have been found in a house at Stabia. The other subjects are the Primavera (shown in the preceding illustration), Leda with the Swan, and Medea. In all four, the principal figures are women, the background is in monochrome, and practically nothing is added to define the setting. However, by a masterful selection of color and the use of a few suggestive lines, the artist succeeds in creating the impression of a complete scene.

Diana stands against a uniform midnight-blue background, but as she is a goddess of the moon and night, this suggestion of a celestial setting seems to suit her. There is no real indication of terrain. She is posed on a thin white line, and could be standing on earth or somewhere in the heavens, an ambiguity that was almost certainly intended by the artist.

Although Diana is the goddess of the hunt, she carries her bow in a diffident manner. Not only is her weapon inordinately small, but the bow is not pulled taut and the string hangs loosely from it. It is therefore doubtful that she has gone out this night to conduct a hunt; rather she carries the bow and arrow as her identifying insignia. She does not wear her light hunting garment, which is short and held in at the waist, but is attired instead in a long chiton and three-quarter-length mantle. Consequently, she is depicted more in the manner of a formal and passive cult statue than as an active goddess of the chase.

Diana was largely worshipped by women, who prayed to her for happiness in marriage and childbirth, and this helps to explain her presence in a room whose works are dedicated to women.

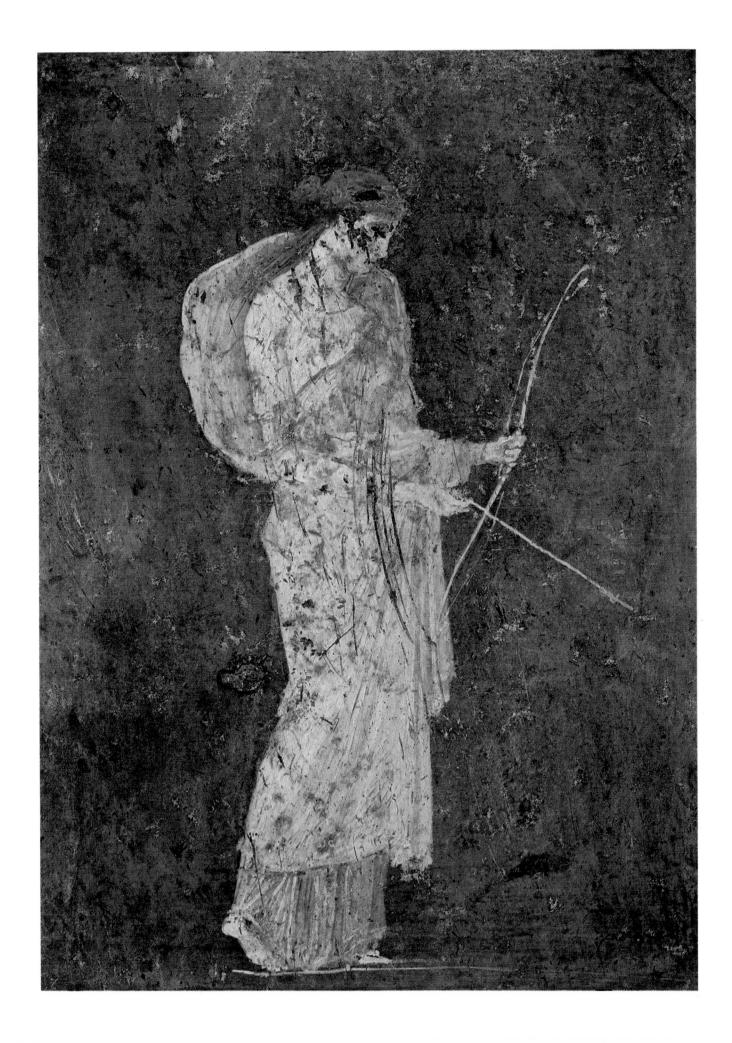

Court of the House of Neptune and Amphitrite

Herculaneum

T HE HOUSE OF NEPTUNE and Amphitrite derives its name from a small rear court whose walls bear a mosaic depicting the two deities. The court served as a summer dining room or triclinium, and the three raised masonry couches on which cushions and pillows were placed are still clearly visible.

The mosaic at right shows Neptune, the god of the sea, along with his consort Amphitrite. Since Neptune oversees the oceans he is especially important to the residents of Herculaneum, a seaside town. Both figures are frequently represented with motifs related to the sea. Here they are surmounted by a fan-shaped shell, and the mosaic is framed by real sea shells embedded in the wall. A little fountain at center carries out the water motif.

The end wall, with its central and side niches is a nymphaeum, a shrine to grotto-dwelling nymphs and naiads who guard and nourish life-giving waters. Above the niches is a hunting scene: deer being chased by hounds. Below, earthenware pots contain climbing vines and tendrils, which rise to enframe the composition. Surmounting all are theatrical masks inset into the wall.

Neptune is worshipped as both the god of the sea and as one who makes the earth quake beneath the blows of his trident. He is thus especially placated in coastal districts that are prey to earthquakes. Ironically, it was a combination of engulfing mud and quake damage that destroyed this house.¹

1. Maiuri, Herculaneum, 43-44

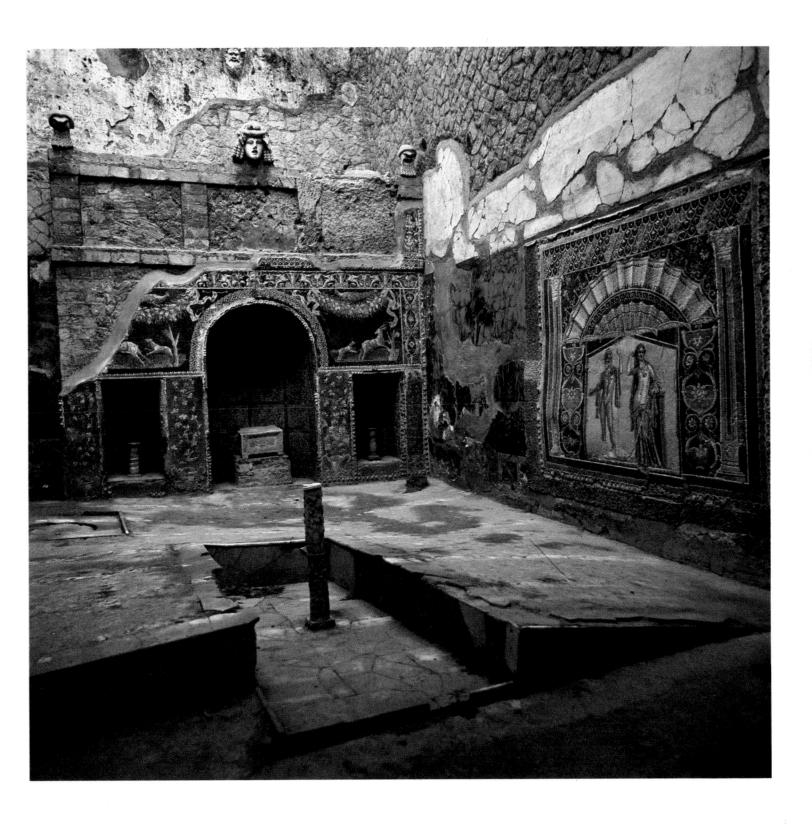

Punishment of Dirce

Wall painting from the House of the Vettii, Pompeii

DIRCE, THE CRUEL QUEEN OF THEBES, is here shown receiving the punishment she had devised for the mother of the two young men who flank her. Many years before—when they were but infants—she imprisoned their mother Antiope, forcing her to abandon the boys on Mount Cithaeron, the very summit which is the scene of their revenge. The infants, saved by local shepherds, have grown into impressive young men. Zethus, almost certainly the powerful nude figure at left, has become a warrior of uncanny strength, and Amphion, at right, an accomplished musician.

After almost twenty years of enforced separation, during which neither sons nor mother knew of the other's fate, Antiope has escaped from her prison and has made her way to Cithaeron, where the family was reunited. The implacable Dirce orders her men to find Antiope and decrees that she should be dragged to her death by a bull. In the interim, Dirce, a maenad, decides to go to Mount Cithaeron to offer sacrifices to Dionysus and to participate in one of the orginatic dances of his cult.

The sons discover Dirce on the mountain and punish her in the precise manner she had intended for their mother. In the painting, the Queen has been forced to the ground. Zethus holds her arm while he and Amphion tie her to the bull. She will soon die as she is dragged down the craggy slopes of the mountain.

The painter of this work is most probably the man who painted the *Slaying of Pentheus by the Maenads* (shown in a previous illustration), from the same room in the House of the Vettii. There are many similarities between the two. Both compositions are strongly symmetrical, with the central figure flanked by avengers; both show the death of a royal Theban on the slopes of Mount Cithaeron. Here, however, it is the votary of Dionysus who is punished, and her attachment to the deity is unavailing. To make this point, the artist shows her maenad's wand lying ineffectually at her side. According to one account, Dionysus later takes revenge by driving Antiope mad.

Zethus's robes billow out behind him in restless and agitated motion, while those of Dirce and Amphion have the same nervous little folds that characterize the drapery in the *Slaying of Pentheus*. The position of the bull, with forelegs outstretched over Dirce, is in the tradition of the *Farnese Bull*, one of the largest extant sculptural groups from antiquity.

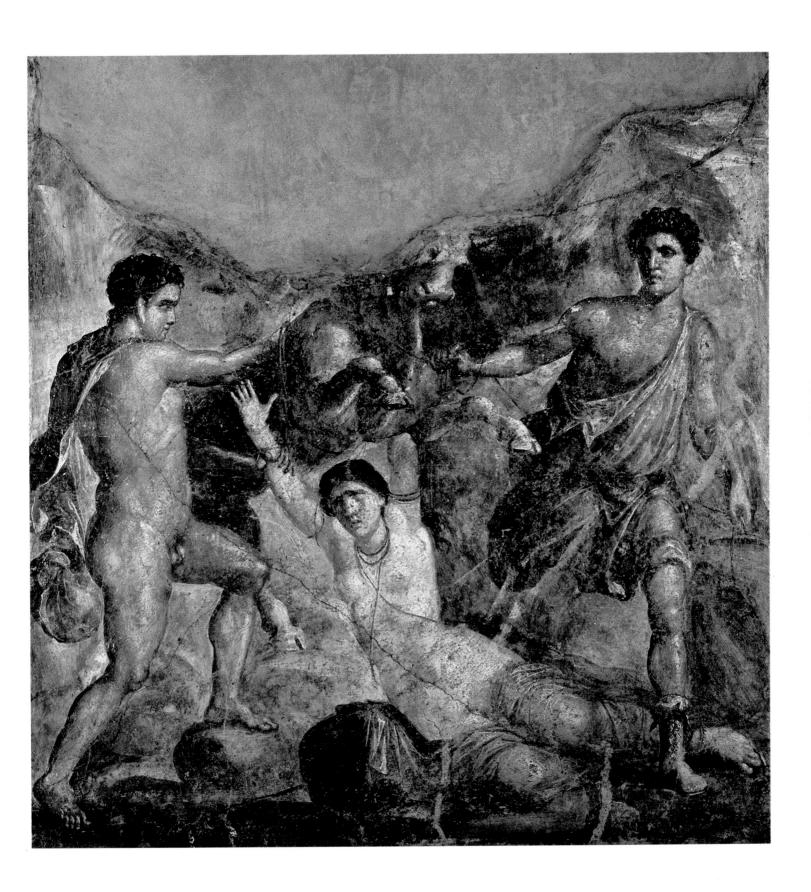

Apollo

(Bronze) From the House of the Citharist, Pompeii, Museo Nazionale, Naples

T HIS BRONZE STATUE OF APOLLO shows him in a typical classical pose of the mid-fifth century B.C., with weight resting on one leg and slightly downcast head turned to one side. Kraus has pointed out, however, that the slender proportions of the body, especially around the torso, are more characteristic of the fourth century B.C., and the figure's corkscrew-curled hair is typical of an even earlier Greek period; and so what we have here is an eclectic Roman work of an intentionally classicizing type, dating to the late first century B.C.

The statue is called *Apollo the Cithara Player*, but this may be a misnomer. The name is derived from the plectrum that Apollo is said to hold in his right hand, and which is used to pluck the strings of a cithara or lyre. He is supposed to have held the lyre, now lost, in his raised left hand. However, the object he holds in his right hand resembles the head of an arrow as much as it does a plectrum. If an arrow, it would mean that Apollo held a bow, not a lyre, in his upraised left hand. It is a difficult question to settle because his attributes are either the lyre or the bow, depending on whether he is represented as god of song or as an unerring archer. In either event, the youthful deity was honored as a patron of music and justice and as a straight shooter who always told the truth and possessed prophetic powers. His rites were widely celebrated, but nowhere more notably than at Delphi, where an oracular priestess, called a Pythia, prophesied in his name.

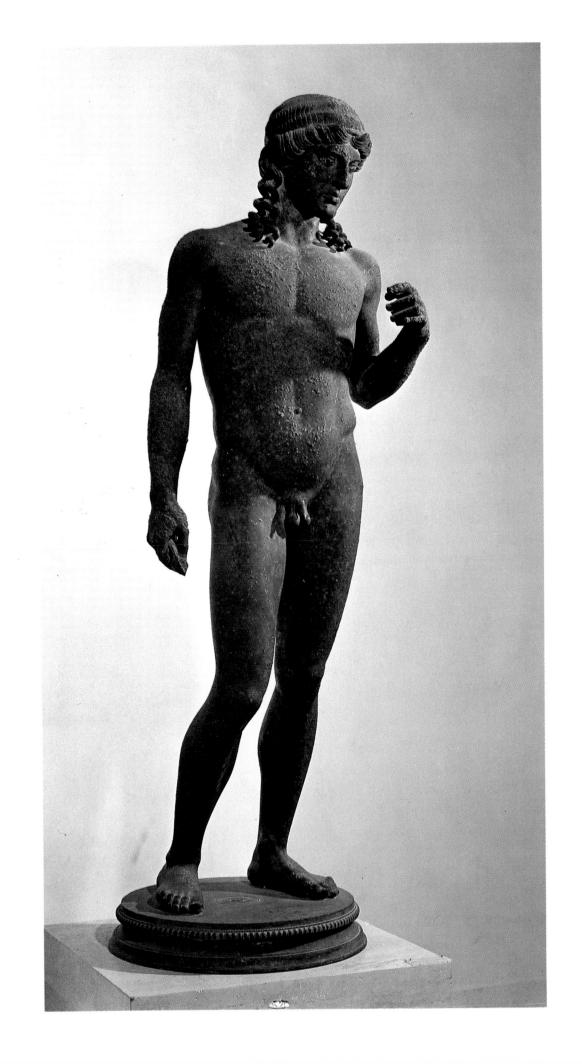

Statue of Aphrodite

(Marble) From House II, 4, 6. Pompeii

This marble statuette depicts the Greek goddess of love, Aphrodite. Some houses were so freely adorned with statuettes and other objects in marble that early excavators concluded there must have been marble workshops in the city. One such workshop was indeed found in 1798 on Stabia Street, near the great theater. It contained a number of unfinished herms, and marble tables. In one slab of partlyworked marble, the saw was found still in the cut.¹

This statuette comes from the property of Julia Felix, a woman entrepreneur who advertised a five-year lease on a piece of her holdings "consisting of a bath, 90 shops and porches, and an upstairs dining room." The Aphrodite was found in a part of the complex that may well have served as a brothel, judging by the graffiti and other evidence found there.

Aphrodite was originally a goddess of marriage and family life; but by a reference to her in a regulation of Solon, the Athenian lawgiver (ca. 640-559 B.C.), the name also became associated with prostitution, and in subsequent years she was widely worshipped as the goddess of sensual love.³

She is sometimes depicted emerging from the sea or leaving the bath. Here, she adjusts a sandal, aided by an eros who holds her foot, and by a Priapus on whom she leans. She still retains some of the original polychromy in the gilt neck band, scanty top, and bikini-like bottom. Priapus is a god of fertility, whose symbol is the phallus, and he is the offspring of Aphrodite by Dionysus. Pompeians have particular veneration for Aphrodite and her Roman counterpart, Venus, since Venus was made the tutelary divinity of the city by Sulla in 80 B.C. One finds little inhibition among Pompeians in the expression of their sexuality. One graffito from a brothel combines an endearing boast with a supplication: "May I always and everywhere be as potent with women as I was here."

1. Mau, 387 2. Tanzer, 52 3. Seyffert, 595 4. Tanzer, 53

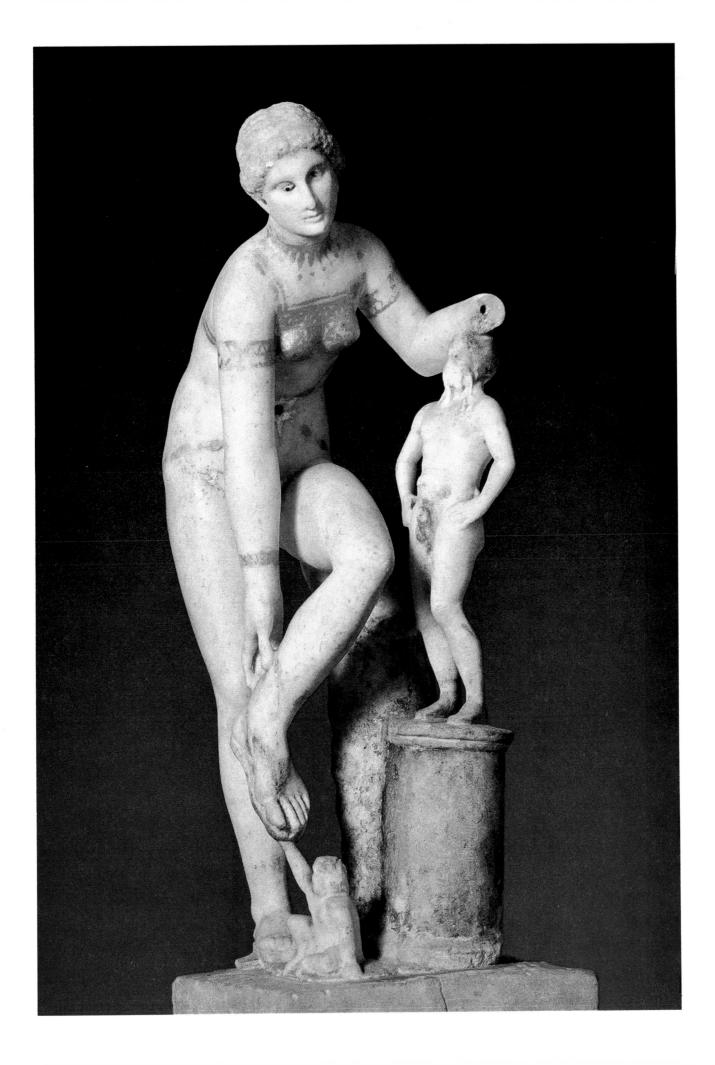

Dancing Satyr

(Bronze) From House of Faun, Pompeii, Museo Nazionale, Naples

PLINY COMPLAINS THAT the art of casting bronze sculpture had fallen into such decline in his day (ca. 50 A.D.) that it no longer claimed respect. He noted that "bronze was formerly alloyed with gold and silver, and yet the workmanship used to be more valuable than the metal; now it is hard to say which is worse." This bronze statue (ca. 100 B.C.), which considerably predates Pliny, is probably one he would have approved. It depicts a satyr who throws back his head, snaps his fingers, and moves in a lively step, probably to the rhythm of the *sikkinis*, which is the special dance of the satyrs. Budding horns and pointed ears project from his forehead, a short tail bristles out behind, and powerful leg muscles flex in response to the pressures put upon them. As an unrestrained lover of wine, women, and song, the satyr personifies abandonment and pleasure.

The statue may have been set up in the fountain of a garden or in the catch basin (impluvium) of the house in which it was found. Unlike work designed to be placed flat against a wall and which, therefore, features one dominant view, the open spiraling pose invites the viewer to walk around and experience a change of impressions from successive angles. The natural light of the unobstructed sun created different visual effects as it struck the satyr at different times of the day; and protruding parts of the body cast lively shifting shadows. These natural effects heighten the overall impression of vivacity, movement, and unpredictability, but are largely forfeited in the present controlled indoor setting of the work.

1. Natural History, xxxiv,5

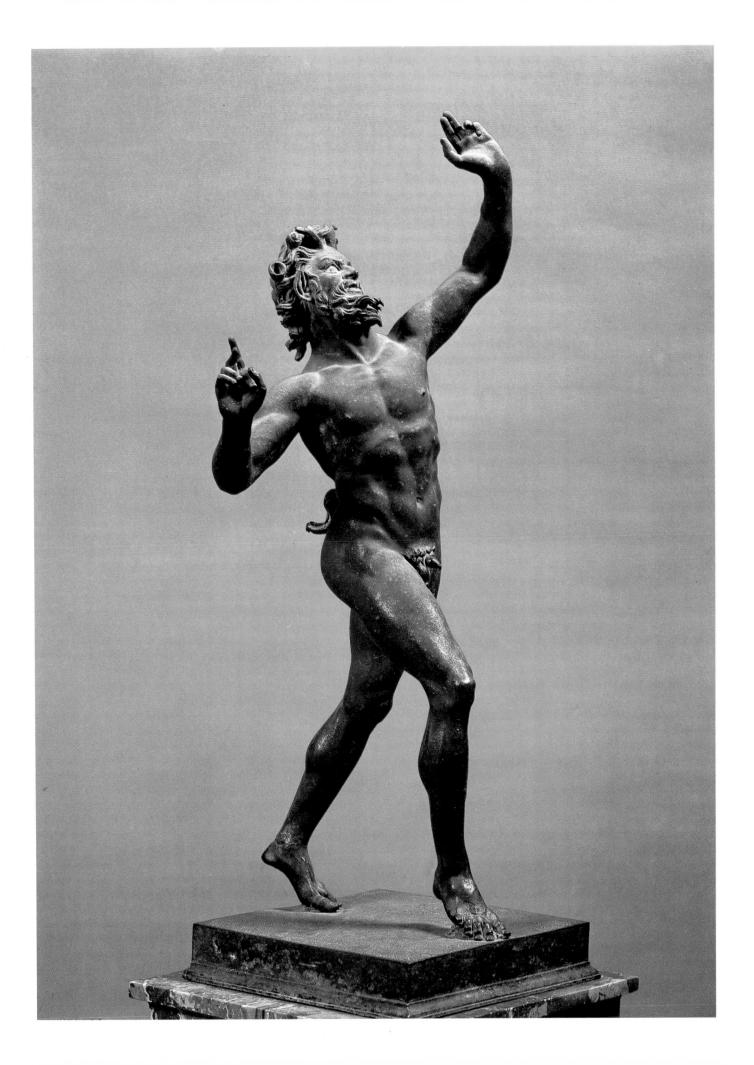

Maenad

Wall painting, Museo Nazionale, Naples

 $T_{\rm HE\,LAST\,PHASE\,OF\,POMPEIAN\,ART}$, called the Fourth Style (ca. 50–79 a.d.), produced a school of painters who felt so confident of their ability to depict the human figure that—like Michelangelo many centuries later—they experimented with suspending the body in mid–air in a variety of positions. In doing so, they sought to explore the effects of atmosphere on freely floating figures, and to test their ability to show the human anatomy retaining its volume and mass while freed of the normal restrictions of gravity.

The floating figures most often shown are those associated with the intoxicating worship of Dionysus. Here, a maenad, an enraptured follower of the god, soars in the ecstasy induced by his worship. As divinity of wine, song, and procreative nature, Dionysus inspired an orgiastic worship that freed his devotees from all terrestrial restraint. Completely liberated from daily conventions, and from the bonds of gravity, they rose heavenward in search of union with their god. Figuratively, they were among the forerunners of Christian angels, but while they shared some common spiritual goals, they were far from angelic in their religious practices.

This maenad glides through the air while carrying the long wand, or thyrsus, symbol of sacred revelry and of devotion to Dionysus. In her right hand she holds a timbrel, with which she will accompany herself in the nocturnal dances held in honor of the god. She wears a wreath, as his followers often did, and her diaphanous robes are blown about her by breezes, revealing her shoulders and outlining her rounded stomach, pelvis, and leg. Her sensual smile and wide-eyed look of veneration convey a mixture of sexual and religious inspiration, which characterized Dionysian worship and accounted for much of the cult's success.

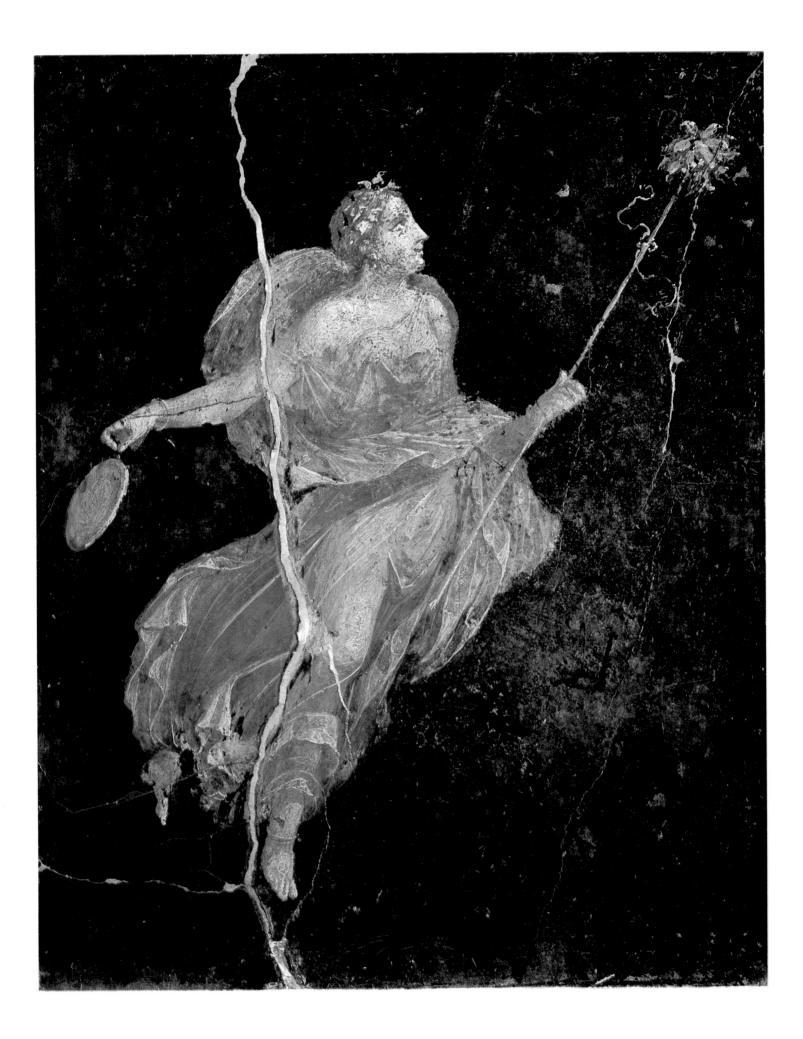

Villa of Mysteries: Lustration

T He visitor to pompeii would be well rewarded to follow the winding road from the Circumvesuviana Railway station up to the Villa of Mysteries, about a mile from the town walls. Here, one comes closest to experiencing ancient Pompeii. The road wends through orchards, groves, and gardens; the outlines of Vesuvius loom always ahead; and the scent of wild flowers mingles with country grasses.

Within the villa is the most splendid body of paintings to come down to us from antiquity. They depict the initiation of brides into the mysteries of Dionysus. Dionysus, also called Bacchus by the Romans, was the god of wine, vegetation, abundant nature, and religiously inspired sexual ecstasy. He had male and female followers, but one of his mystery cults was composed exclusively of women. They gathered secretly to celebrate the god's gift of wine and unbridled love, and some of their meetings were said to end in orgies.

The cycle of paintings consists of a continuous narrative of ten scenes, depicting the induction of a candidate into the cult. The initiation is conducted by members or priestesses of the sect, and is designed to simulate the candidate's mystical marriage and union with Dionysus. As her time for membership probably coincides with her actual plans to marry, the process becomes a symbol for all her marital aspirations. In the opening scene, not shown, a liturgy is read which prepares the initiate for the rites to follow. In the second scene, illustrated here, a member of the cult carries in an ornamental tray on which intertwined gold and purple cloth has been carefully laid. These are not sacramental cakes as is always assumed, purple being an unlikely color for cakes. Rather, they are carefully wound sacerdotal vestments of the cult, worn by all its priestesses, and these gold and purple garments will be draped over the bride in the course of her initiation. Wild grasses, which are barely visible, have also been placed on the tray.

The woman with the tray carries a branch in her right hand. It will be bound into a wreath similar to the one she wears, and it will complete the attire of the initiate at the end of the ceremony. In the end, she will also wear a marital ring, as do the priestesses.

The woman seated with her back to us has taken the branch and holds it out over a basin as an attendant pours a purifying liquid over it. Once this lustration or purificatory rite is completed, the priestess will transfer the branch to the shallow wicker basket held by an assistant at left. The basket is covered by a purple cloth, which may well be the folded one brought in on the tray; it too has probably been consecrated. The display and concealment of the cult paraphernalia heighten the mystery, and maintain a desired level of anticipation and awe.

The putting on of special attire was integral to the rites of passage and of cult initiation. A known example involving Dionysus was his urban festival, the Liberalia, when boys donned the *toga virilis*, signifying their coming of age.

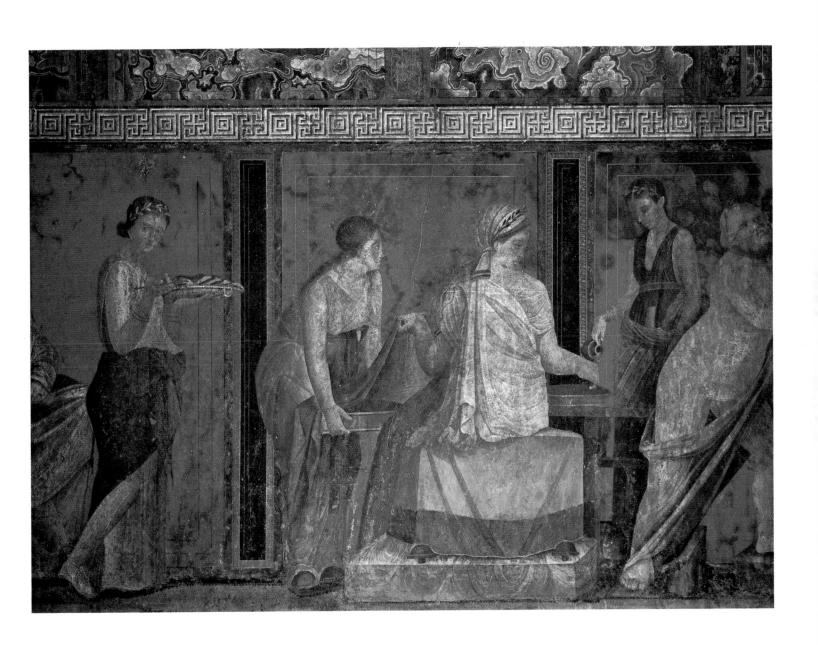

Villa of Mysteries:Silenus

In this scene from the great cycle, the initiate (at right) is now attired in the gold vestment, and raises a wind-swept purple veil, which billows out around her. She seems to be both executing a dance step and reacting apprehensively to what lies ahead. She looks toward an adjacent wall at the right, where two eventful scenes take place: a Silenus may be divining her future, and a winged daemon makes ready to enact a flagellation. Either event may account for her apprehension.

To her left are mythological creatures, including a standing Silenus whose musical enthusiasm for the lyre can be equated with the enthusiasm to be wrought by wine. Silenus is a divinity of the woodland; he was a teacher to the young Dionysus, and later his companion. He was also said to have inspired the god to invent the cultivation of the vine. He carefully observes the initiate, and with the lyre plays an accompaniment to her dance. Next to him is a Pan who plays the pipes (syrinx) and a satyress, who gives her breast to a young goat as another goat stands by. The only adult males to be admitted are these mythological creatures who are associated with the retinue of Dionysus. Pan is a protecting deity of flocks and herds, who is often seen playing the panpipes which he invented. He is said to excite terror (or "panic," a word derived from his name), in those who wander alone in the forest. This may contribute to the frightened expression of the initiate, who is a spiritual wanderer seeking to find her place at the side of Dionysus. Pan is also a god of prophecy and an important member of Dionysus' train. The rocks he and his companion sit on are among the few outdoor elements which appear in the cycle; they remind us that the natural abode of Dionysus and his followers is the fields and craggy woodlands.

1. Seyffert, 453

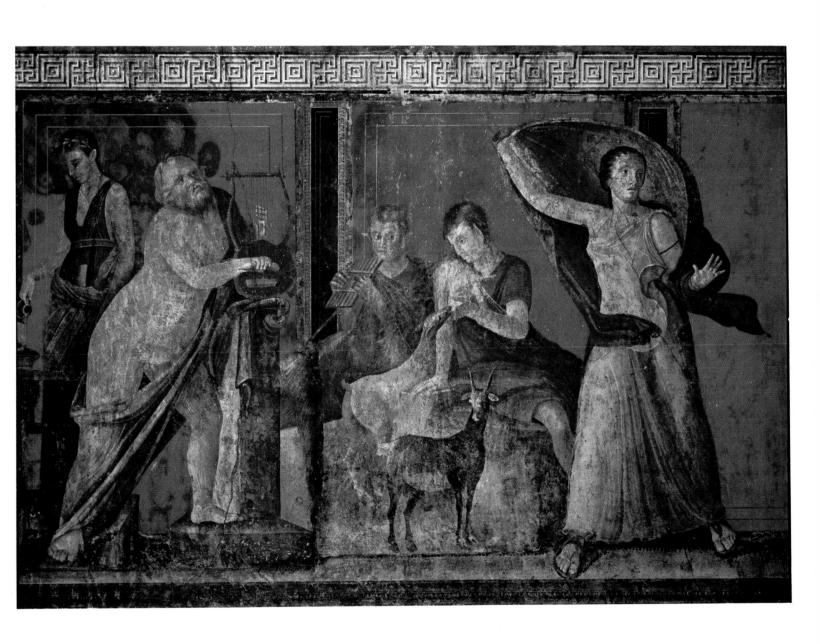

Villa of Mysteries: Winged Daemon

T his is the right half of the central scene in the Villa of Mysteries cycle. The half not shown depicts a loving communion between Dionysus and Ariadne, his mythological bride. She is enthroned in an elevated position, and he leans against her and adores her, just as he offers his love to all his female followers, who are his mystical brides. However, since he is also an exacting lover who demands fealty and obedience, he has sent his messenger, a winged daemon, to scourge the initiate, thereby making her worthy of union with him. This is the portion of the scene shown here. The daemon at right, her wings outstretched as if she has just alighted, raises her scourge to flog the initiate, who is shown kneeling in the adjoining wall (see the next illustration). The daemon is most probably Telete (Initiation), who strikes young girls as they are inducted into the mysteries of love and marriage.

Behind the daemon, and just above the head of the kneeling woman at right, is a saucerlike dish held by an attendant (the upper part of her body has been lost in damage to the wall). The dish bears wild grasses and small flowering sprigs drawn through a gold marital ring, the reward which awaits the initiate at the end of her ordeal. The ring and the wild flora it encircles have not been previously observed. They obviously symbolize a consummated marriage with Dionysus, god of fertility and vegetation.

The kneeling woman hovers over a broad wicker basket, a *liknon*, employed by harvesters for winnowing the chaff from the wheat. This is an apt symbol for testing the worthiness of a prospective member of any cult. A large object stands on the basket, and is draped by a purple cloth. It is very possible that the kneeling woman is about to unveil the object, but it is by no means certain that this is a phallus as is often claimed. The pyramidal contours and the squared head of the object simply do not conform to a phallus. It is more probable that the veil conceals a cult statue or a herm, on which a phallus may be featured. Indeed, the right hand of the woman holds the draped cloth at a point where a phallus would be indicated.

The display of secret symbols, relics, or statues is an important part of the mystery religions. They serve as the symbolic keys to a mystical body of information revealed only to the initiated through a process of purification and expiation. On a less exalted level, they are the signs of membership which only the inducted fully understand, and which therefore serve as a barrier between sectarians and the uninitiated.

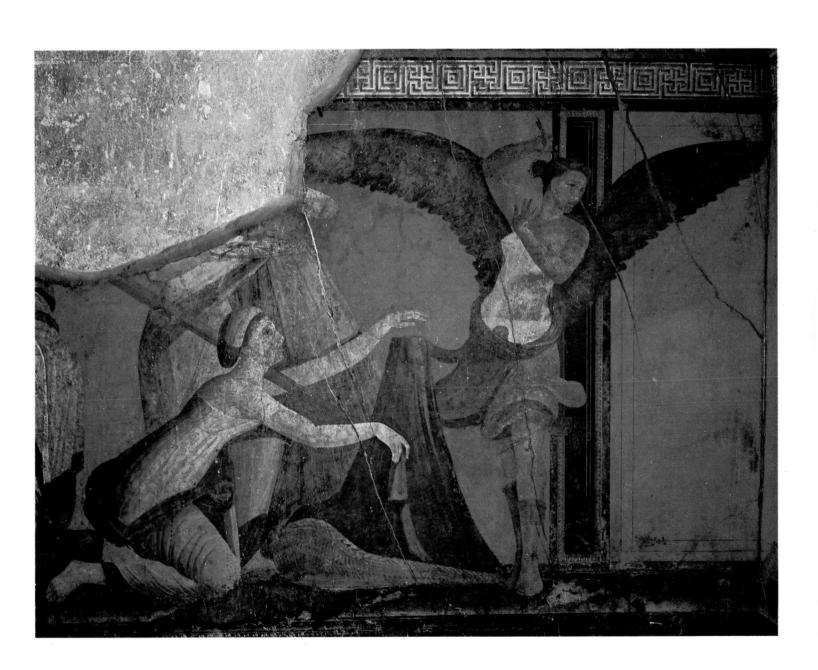

Villa of Mysteries: the Flagellation

In this scene from the villa of mysteries, the initiate is purified by means of ritual flagellation. She must undergo the ordeal-by-beating before celebrating her mystical marriage to the god Dionysus. Similar practices of flagellation existed in all the phallic rites of the Dionysiac cult, and in other fertility practies. In Rome, during the festival of the Lupercalia on February 15, women were flogged to drive out the demon of sterility. They were beaten with *februa*, and the whole month *Februarius*, "the month of purification," derived its name from the event.¹

The novice kneels across the lap of a member of the cult. The latter caresses her with one hand, while with the other she dutifully pulls back the purple robe in order to bare the flesh for the lash. The initiate rests her arm on the gold robes she will wear later. Her hair is now loose and disheveled; she is entranced by the wine, the sound of music, and the presence of the gods. She submits herself to the flogging willingly, knowing that great rewards await her; anticipating some immediate pain, however, she closes her eyes and waits.

The flagellator, on an adjoining wall at left, is a winged daemon, discussed in the previous commentary. Two followers of Dionysus are at right: one dances ecstatically while accompanying herself with small cymbals, and the other looks on intently, bearing the thyrsus, the tipped wand that identifies maenads and other followers of Dionysus. This culminates the rites of induction. In the next scene, the bride attires herself in the gold and purple robes, and in the final scene she is a fully prepared bride, wearing the ring which signifies her membership in the cult.

The well-proportioned figures are set on a shallow interior ledge against a simulated red wall accented by flattened black pilasters. It is as if the wall of the actual room were pushed back to create a narrow stage for the characters. Such an organization is typical of so-called Second Style painting, which is discussed more fully in the next commentary. In the realm of illusion, the viewer expands this space to give the characters more room, but the mysteriously flattened environment—which manages somehow to encompass all their spatial needs—is a striking feature of this style. The cycle is generally dated to the mid-first century B.C.

1. Seyffert, 365, Mauiri, 62

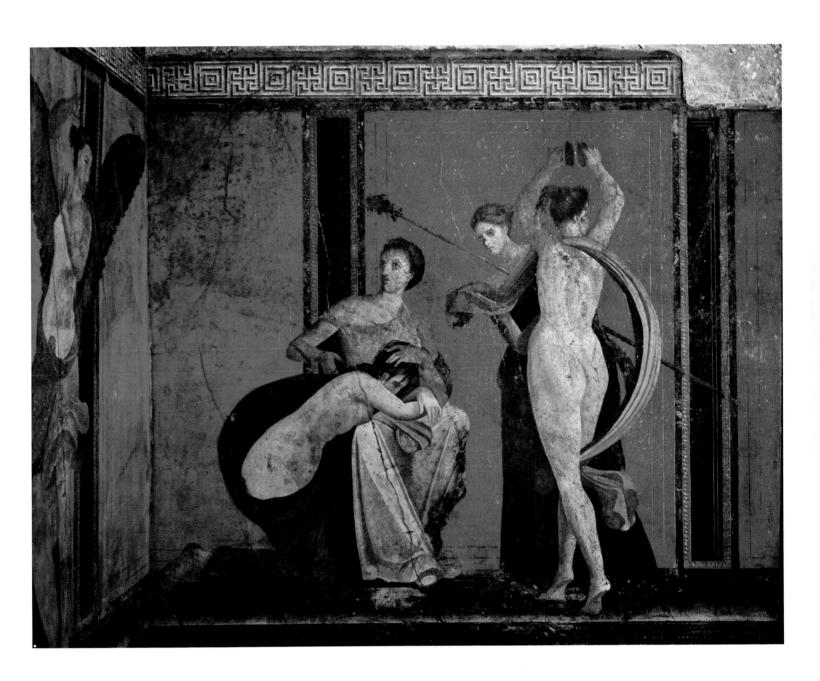

Scene from Boscoreale

Wall Painting from the Villa of Publius Fannius Sinistor Museo Nazionale, Naples

T his unusual wall painting was discovered in a villa at Boscoreale and is roughly contemporary to the Dionysiac cycle in the Villa of Mysteries, ca. 50 B.C. Like the cycle, this work depicts figures on a shallow stage, posed against a red background resembling a wall, which illusionistically extends the real wall on which it is painted. The positioning of such figures within a narrow architectural perspective, which simulates an unbroken extension of the room, is characteristic of what has come to be called Second Style painting. The background of Second Style paintings is regularly delineated by pilasters or columns; not seen here is a column separating these figures from an adjoining figure at left. Above, a richly gilded frieze of alternating triglyphs and decorated metopes completes the architectonic frame.

A majestic woman leans her chin on her hand while regarding a somewhat effete young man, who appears to be seated on a rock above her. Both wear exotic un-Roman headgear, and he carries a spear and shield. No convincing identification for these two wonderfully volumetric characters has been made. The theory most often advanced—but on no solid ground—is that he is the young King Antigonus Gonatus of Macedonia and that she is his mother Queen Phila. The adjoining figure, who is not included in our detail, would therefore be the stoic philosopher Menedemos of Eretria, who was welcomed at the court of Antigonus, himself of philosophic inclination. A more recent suggestion is that they are simply personifications of Macedonia and Persia.¹

The intense figures have an introspective and grave quality not often encountered in Roman art. They occupy their niche in a wonderfully convincing manner, and the artist has intentionally turned the female figure in to heighten the impression of space displacement.

1. Grant, 161

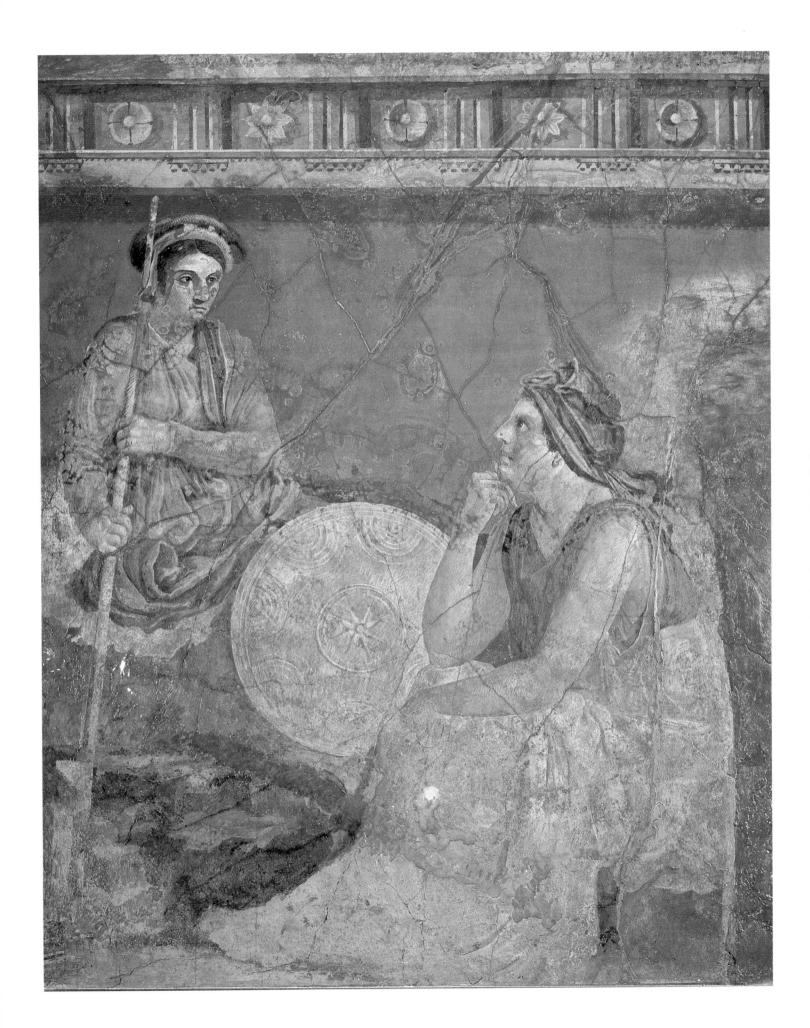

Alexander Mosaic

From House of The Faun, Pompeii
Museo Nazionale, Naples

T HIS IS THE LARGEST and most intricate of the mosaics found at Pompeii, measuring roughly 9 by 17 feet across. It probably depicts the Battle of Issus, a key encounter in the struggle of Alexander the Great to wrest control of Persia from King Darius.

Alexander is the bareheaded horseman at left, astride his warhorse, Bucephalus. His portraits almost always show him from the side, unhelmeted, with long disheveled hair and a look of wide-eyed intensity, which his admirers associated with genius. His opponent, Darius, stands with outstretched arm at the back of a chariot, right of center. Interestingly, the focus of the composition is on the defeated Darius, not on the victor Alexander, as if by exploring the nobility and psychology of the loser, the artist pays tribute to the man who defeated him.

According to historical accounts, Darius turned his chariot and fled when the tide of battle went against the Persians, and this is the moment shown here. Darius's driver has maneuvered the chariot almost completely around, and we see him furiously whipping the four horses on. The perspective of the composition is breath-taking. The chariot exists in a pivotal plane; at one end Darius gestures towards a fallen comrade, and at the other end the charioteer drives the horses in the opposite direction. With his upraised arm, he echoes the gesture of the hapless king. The lone horse at center foreground has its rump towards the viewer and is extremely foreshortened. By being turned in, it directs our attention deep into the picture plane, and this is one of the few ancient works which develops perpendicularly as well as horizontally.

On the left side, a tree rises behind Alexander, its stunted limbs reaching out against the white background in the same compositional manner as the figures of Darius and the driver, to which it is an important counterbalance. The link between Darius and Alexander is not direct, but occurs through a fallen member of Darius's retinue. This man is dressed in a distinctive gold tunic and straddles a horse that has collapsed to its knees, left of center. Alexander has pierced his body with a long lance, which the dying Persian grabs as if to stop it from doing further damage. It is this cherished member of his guard or family to whom Darius looks with great dismay, and to whom he reaches out his hand. The fall of this youth seems to break his will, and the rout ensues.

^{1.} Kraus has a fine description, 70-72

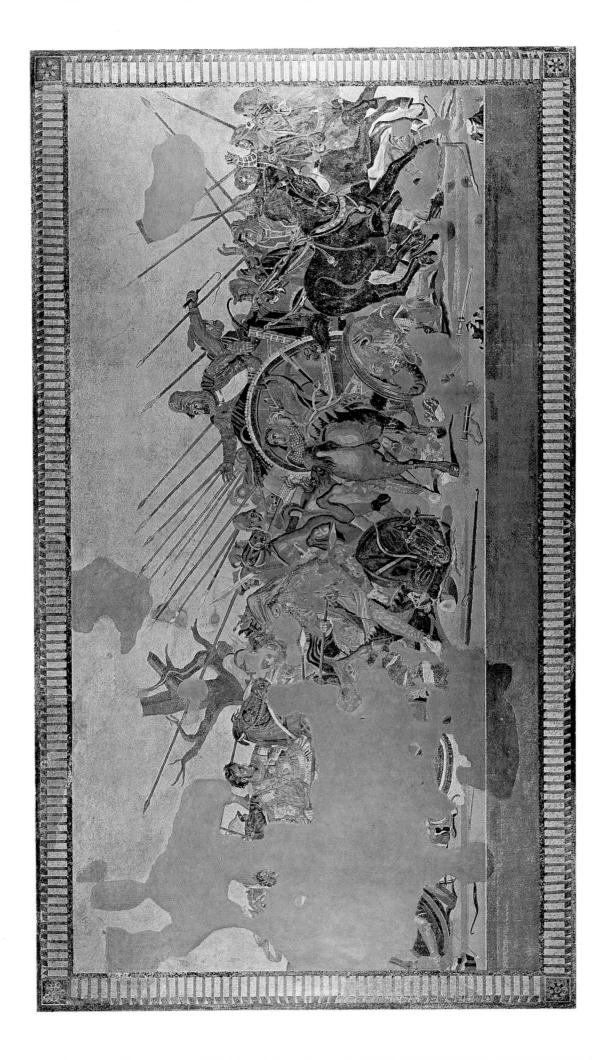

School of Plato (Mosaic)

From a Villa outside Pompeii, Museo Nazionale, Naples

Romans regarded the athenian plato as one of the great founding fathers of philosophy, as we do today. At Athens, Plato established his school of philosophy in a grove sacred to the hero Academus, from which it derived the name "Academy." Led by Plato for nearly forty years, it trained promising pupils and became a model for later academies and institutions of higher learning. His famous students included Aristotle, Speusippus, and Xenocrates. The Academy was also frequented by a large number of educated men and women. It had a venerable history of achievement in philosophy, music, astronomy, and mathematics, and endured well over nine hundred years, until it was closed by the Emperor Justinian in 529 A. D.¹

Plato's classes were given partly through dialogue and informal conversation and partly through systematic lectures. Here, a group of philosophers have gathered informally beneath a tree, grouped around a curved masonry bench. The geographic location is unmistakable, since the artist depicts the Acropolis and Parthenon of Athens in the upper right corner. Plato, third from left, conducts the session and points to a globe resting in an open box on the ground. This may be a reference to his great work *The Timaeus*, in which he says that the creator made the cosmos as a single spherical living thing. The other philosophers react to this with varying degrees of conviction; the standing figure at right holds himself a bit apart and looks somewhat sceptical. This may be Aristotle, who broke with his master's teaching and held that we should draw our conclusions not by hypothesizing from the cosmic and general but by a process of deduction from a careful study of the minute and particular in nature.

Above the heads of the group at center is a sundial, an invention attributed to the Greek philosopher Anaximander. The mosaic is beautifully framed with entwined garlands, fruit, and masks.

1. O.C.D., 1

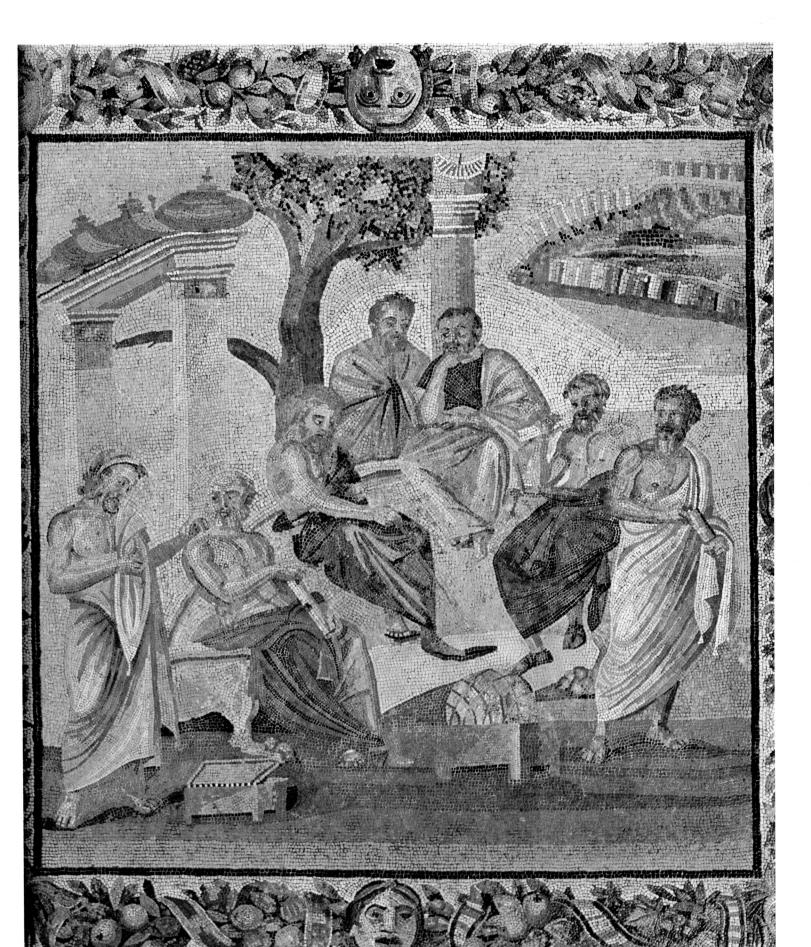

The Trojan Horse

From Pompeii, Museo Nazionale, Naples

T his depiction of the trojan horse is an outstanding example of the illusionist phase of late Pompeian painting, which is often compared to nineteenth-century impressionism. The objects are not shown completely, but by way of highlights. There are one or two basic contrast colors, modified white or yellow. No great care or precision is lavished on the modeling of figures, which are executed principally through a contrast of light and dark. The subjects are dramatic, and the picture plane is frequently filled with thrust and movement, with at least one strong diagonal area. The Romans recognized the peculiarities of the style and called it *ars compendiaria*, a quick and sketchy art.

In the story, the Greeks have just burned their camp outside Troy and have pretended to embark for home, leaving the offering of the wooden horse. The Trojans debate what to do with it: one party is for hacking it to pieces, another for throwing it over a cliff, and a third—which prevails—advocates setting it up as a dedicatory offering to Athena. In the painting, the horse has just been drawn through the turreted portals of Troy. Four men, painted solely in highlights of yellow and blue-gray, arch their bodies in unison as they haul the animal in. The sizes of the figures are disproportionate to the characters in the foreground. By all normal laws of proportion and perspective, figures of like dimension should diminish in size the further back they go in the picture plane. It should be evident, however, that practitioners of the illusionist style were no more obedient to the rules of proportion—as they were then known—than they were to those of color and line.

The horse is being hauled to a garlanded statue of Athena, mounted on a plinth at left and holding a shield and upraised spear. Athena looks away, possibly because she has inspired the Greek ruse and knows what is to come.

The scene is set at night and a crowd of Trojans holds torches to illuminate the sacred precinct. Later, as the Trojans celebrate their seeming victory, Greek warriors will emerge from the horse and signal the fleet to return. Troy will be captured and destroyed, thus fulfilling the prediction that it would only be taken by treachery.

Judgment of Solomon

From the House of the Physician, Pompeii, Museo Nazionale, Naples

This wall painting depicting *The Judgment of Solomon* attests to the presence of Jews in Campania and to the influence of their literature. Solomon is shown seated at center on a raised tribunal and flanked by two counselors. In keeping with the Old Testament story (I Kings 3, 16–28), two women have come to him, each claiming to be the mother of the same infant. When Solomon orders the baby to be divided in half, the real mother pleads with him at the foot of the dais to spare the child, and announces her willingness to relinquish her claim. The other woman is shown standing by the butcher block on which the infant has been placed. While a soldier raises an axe to do the king's bidding, she seizes what she believes will be her portion, saying, "Let it be neither mine, nor thine, but divide it." The child is given to the real mother, as soldiers and observers look on, marveling at Solomon's wisdom.

There is good evidence that Jews lived in Pompeii, but we do not know of their number. Kosher brands of the popular fish sauces were packed there, and appropriately labeled Kosher Garum and Kosher Muria (garum castum, muria casta). A two-word inscription, "Sodoma Gomora," survives from a house front in Pompeii, and may have been written by a Jew, or, less likely, by an early Christian, either before the eruption or by a digger immediately afterwards. It is also possible that it was hastily written in the midst of the eruption by a Jew who analogized the town's impending fate with that of the two doomed biblical cities.

There were Jewish communities in most principal towns, and it is estimated that Rome itself had a community of some twenty to forty thousand Jews in the early first century A.D. This number swelled after the defeat of the Jews in Palestine in 70 A.D. and their subsequent displacement. In Rome their principal languages, judging by surviving inscriptions, were, in order of use, Greek, Latin, Aramaic, and Hebrew. Over the course of the years they had as many as eleven synagogues in the capital, as well as their own social and welfare institutions. They fared well under the early Caesars. Julius Caesar enacted a charter of Jewish rights, which assured their religious freedom throughout the empire, and Jews greatly mourned his death.² Augustus confirmed these rights and took pains to be solicitous of their Sabbath observances. Others, however, resented and misunderstood them. Their resting on the seventh day was taken by some as simple laziness; their refusal to participate in the cult of emperor worship and the help they were said to render one another aroused suspicion and jealousy.

^{1.} Mau, 16

^{2.} Suetonius, Julius Caesar, 84, 85

Ceremony in a Temple of Isis

Wall painting from Herculaneum, Museo Nazionale, Naples

T HIS IS A DETAIL OF A PAINTING depicting a worship service in a Temple of Isis, or Iseum. The ceremony takes place in front of the temple steps, where the faithful have gathered and a priest stands at an altar. He fans the flames on the garlanded shrine, where burnt offerings will be consecrated to the deity. The arrangement of the altar at the foot of the temple steps corresponds almost exactly to the architectural remains of the Iseum at Pompeii, the best preserved of the Isiac temples in Italy. A receptacle for burnt offerings near the altar at Pompeii contained remains of fruits rather than animals, and these included burnt figs, pine kernels and cones, nuts, and dates. Ibises, who were revered as the sacred bird of Isis, roam freely near the altar.

In a portion of the painting not shown, a high priest appears at the top of the steps in front of the temple portal, holding a vessel with the sacred life-giving waters of the Nile. He is flanked by two attendants and statues of two sphinxes. The priest whom we see at the foot of the steps, with arm outstretched, appears to be conducting a chorus of the faithful arranged at both sides. Those at right in our detail raise their hands in choral gestures, and one seems to be rattling a sistrum, which provided a musical accompaniment in the worship of Isis.

The cult had its origin in Egypt, dating to the third millenium B.C. In the Hellenistic period, the goddess gained the rank of one of the leading deities of the Mediterranean world. She seems to have had an active following in the Greek-influenced cities of Campania as early as the second century B.C., and even in Rome it is reported that a college of the Servants of Isis was founded in the time of Sulla, ca. 80 B.C. The Temple of Isis at Pompeii was probably started about this time, and it was ambitiously rebuilt after the quake of 62 A.D. The Near Eastern cult, with its promise of a life after death, answered to a spiritual need which Christianity also and in the end more successfully addressed. The Isiac worship, however, did not in any way attempt to preclude existing Graeco–Roman practices; rather it pragmatically adapted to and amalgamated with them. Thus, Isis is the "goddess of many names," and she was identified at Pompeii with Diana as punisher of the guilty, and with Venus/Aphrodite as a goddess of love and facilitator of assignations. The cult was roundly condemned by early Christians, and Bulwer-Lytton paints it in the blackest colors in his romantic nineteenth-century novel, *The Last Days of Pompeii*.

On the day of the eruption, the priests of the Iseum at Pompeii hurriedly left their meal—whose remains survive, grabbed the temple treasures, and attempted to escape. One by one, they fell along the streets leading out of town, as falling columns or debris engulfed them. Each was found lying near a precious relic, a statue of Isis, or a purse of gold coins.

^{1.} Mau, 175

^{2.} Witt, Isis in the Graeco-Roman World, 86

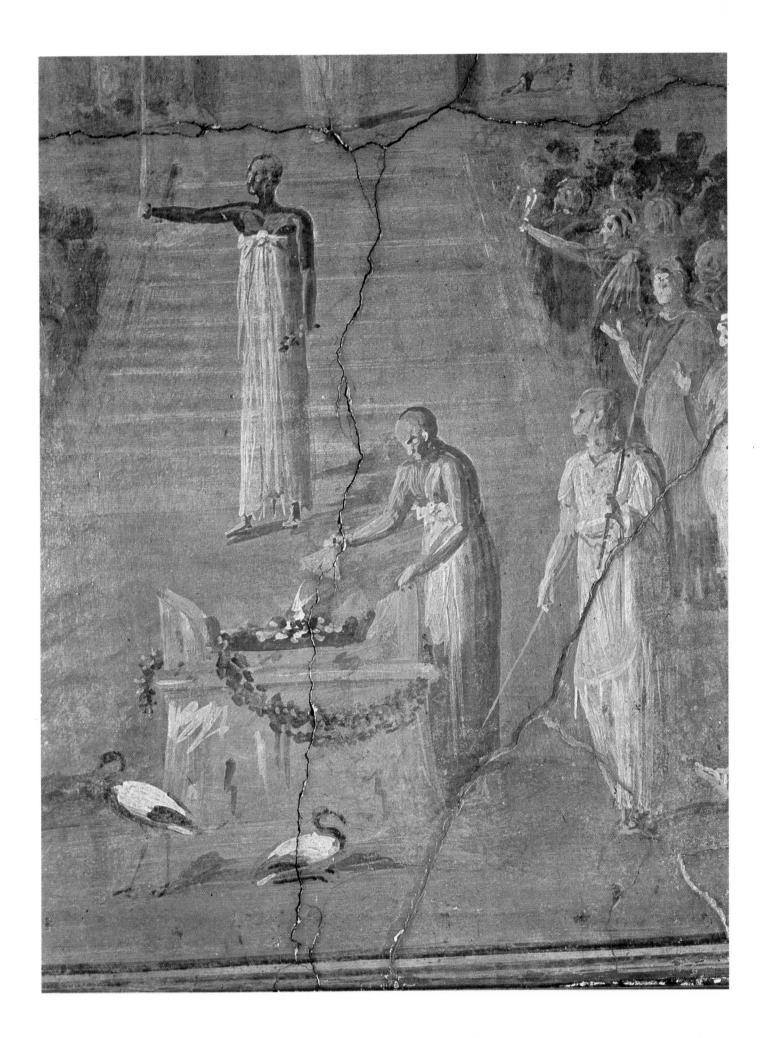

Harbor Scene

Museo Nazionale, Naples

Strabo spoke admiringly of the port facilities of the Campanian town of Cumae: "The city has become a very great emporium, since it has havens that have been made by the hand of man . . . They run jetties out into the sea and thus make the wide open shore curve into the form of bays, enabling the greatest merchant ships to moor with safety." Vitruvius said harbors should have colonnades bearing approaches to docks and to warehouses.²

We cannot say for certain that this is Cumae, but it is surely a Campanian port, embellished by the imagination of the painter. The work was found at Stabia, which was no more than a cluster of country villas, and thus too small to boast such a developed marina.

The painting is executed in a sketchy, illusionistic style, somewhat typical of the last phase of Pompeian wall painting (ca. 50-79). White caps in the water are indicated by an almost calligraphic riffling. Objects such as the column bearing statues and the series of gabled buildings near the pier are picked out in tones of light and shade, a chiaroscuro with little linear definition.

A colonnaded street ending in an arch leads to the shoreline and to the pier, which juts into the water. Behind the colonnade is the series of small gabled structures, possibly the warehouses of which Vitruvius wrote. Few piers in our own day are as elaborate or attractive as this one. It has a welcoming arch on which two tritons recline, and before and behind it are a series of statues, some conspicuously mounted on columns.

Across the pier in the foreground is a natural rocky headland in the shape of an arch on which a bent old fisherman perches, pole in hand. The outcrop is topped by a small lighthouse. Below and behind it are fishermen's boats; two of these in the foreground appear to be hauling nets.

Within the breakwaters, larger merchant ships have found safe harbor. There too the shore is dotted with rich colonnaded buildings and a series of raised statues, probably votives to Neptune and other deities placed by seamen and merchants.

^{1.} Geography, V, 5-6 2. On Architecture, V, 12

Idyllic Landscape With Sailing Vessel

From Pompeii, Museo Nazionale, Naples

T his illusionist fourth style landscape depicts the garden sanctuary and private dock of a great maritime villa. Parts of the master house, of domical construction, can be seen in the background. Between it and the dockside sanctuary is a stand of fir trees. The richly ornamented landing consists of a circular sanctuary, or tholos, at center, flanked by a series of miniature colonnades and walls, which form the back for a continuous masony bench running from one end of the structure to the other.

We may conjecture about the events shown. A woman of ease, perhaps the mistress of the house, sits cross-legged at right while a dog playfully vies for her attention. Two persons at center stand at the water's edge, looking out to sea. At left, five figures stiffly wait and watch the sailing vessel which has come into view at right. It is possible that they are the servants of the powerful master of the villa who is returning from some voyage on that ship. It will anchor at or near the dock, and its sailors have made to drive the vessel close to shore. One holds a pole to the top of the mast and will momentarily help lower the sail. A naval vessel, with its crew of many rowers, moves off at bottom left. It has possibly accompanied the sailing ship safely to its harbor, and now departs.

The quick sketchy brushwork is typical of the illusionist style. Green is used freely and interestingly as a highlight color against an almost ubiquitous ground of black in the ripples of the water, the terrain by the dock, and the loosely rendered foliage at left. The figures are executed with a minimum of strokes and with almost no detail, save for some dabs of black paint which serve to convey the features of the people on shore.

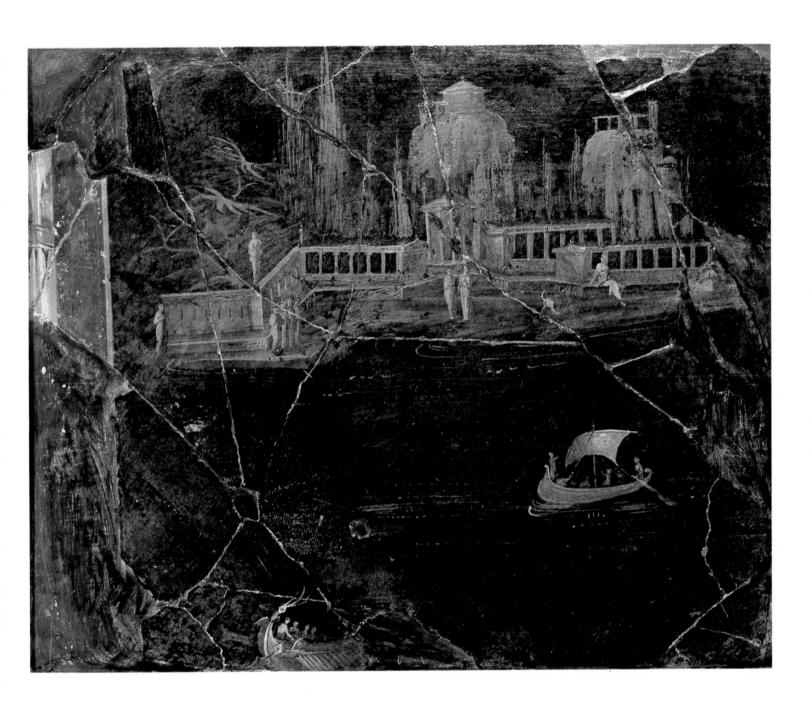

Sacred Landscape

From Pompeii, Museo Nazionale, Naples

Enchanted landscapes of this kind, in which dreamy sylvan settings are sprinkled with religious shrines, have come to be called sacro-idyllic landscapes. In this particularly appealing example, two rocky cliffs at the sides form the background for a valley floor, where a brook runs and cattle graze. A rocky island rises from the stream and bears an open four-sided shrine enclosing a sacred tree. A goatherd returns from visiting the shrine and leads a goat across a beautiful arched span. His clothes are highlighted by tints of sun-dappled gold, which also strike the footbridge and part of the island; by contrast, the obedient goat is entirely black. A small tetrastyle temple is at the rear right, and another more elaborate temple—also bearing a tetrastyle facade—is at the left. Behind it is a grove of poplars.

A statue, probably of Diana, is in the center, raised on a column. She is goddess of the wood, open air, mountains, streams, and brooks. She was commonly worshipped in woody places, and her shrines were frequently associated with groves and trees. Wonderfully sketched cows graze along the shore of the brook, and one has descended into it, as if heading for the cult statue. In this random lyrical observation, the artist has submerged a religious symbol, as cows were among the animals sacred to Diana.¹

Many of the motifs here can be read as elements of pure landscape or as religious symbols. The goat is dear to Bacchus; the staff carried by the goatherd is shaped like the thyrsus, the wand carried by followers of Bacchus. The earth, vegetation, and mountains are also sacred to Bacchus, and so it is likely one or another of these shrines is dedicated to him.

1. Seyffert, 183

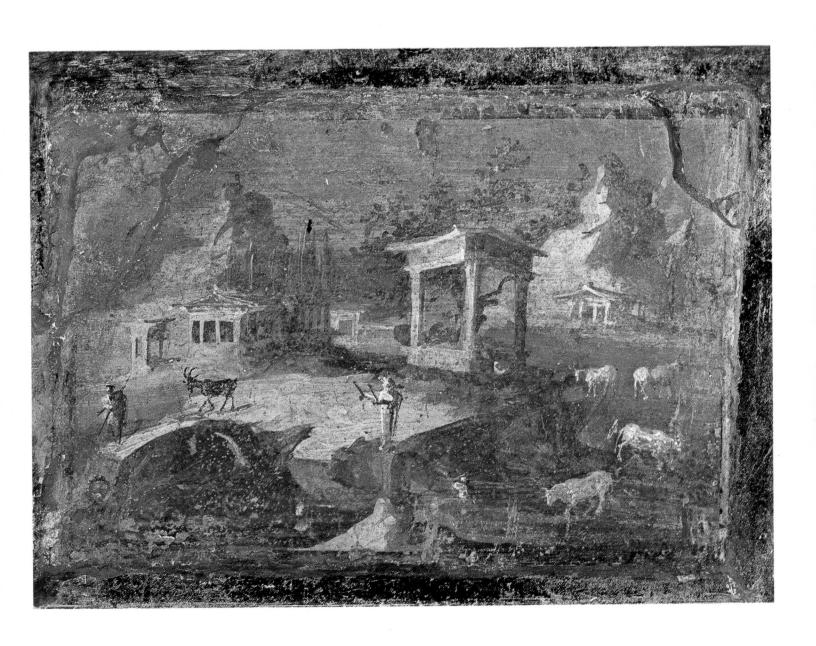

Pan and the Nymphs

Wall Painting from House of Jason, Pompeii,
Museo Nazionale, Naples

This landscape contrasts vividly with the true sacro-idyllic type (see the preceding illustration). There the bucolic setting is preeminent, and the figures play a subordinate role. In this work, the rural setting is no more than a backdrop for the prominent figures. At center is Pan with the pipes he invented and loved to play, flanked by music-making nymphs. The nymph at right plays the lyre, while at left another holds a tibia and looks away. Above Pan is a pine tree sacred to him, and at his feet is a goat, flocks of which he guards. The figures are executed in a restrained neoclassic style, with a preference for straight lines in flattened space and a suppression of diagonals. The shrubbery and pine tree, on the other hand, are realized with flickering brush strokes, more characteristic of the illusionist style, a strain in late Pompeian painting.

All the characters have been pushed forward to the same plane, and each is separately framed in a three-part division of wall, rock, wall. Each is isolated from the other, not only physically but emotionally. None interacts directly with any other, and in the case of the two women at right, they conspicuously look out of the picture plane toward the viewer. This is also true of the well-trained goat, who regards us while at stiff attention. The resulting impression is one of a detached and stilted theatricality, somewhat reminiscent of the organization of characters in the Sacrifice of Iphigenia (discussed earlier). As a matter of fact, this is a scene lifted directly from the stage. The painter tells us as much by placing the action on a stage floor, and by clearly showing the step which leads up to it at bottom. Thus the quality of illusion works at three levels: landscape, mythological scene, and theater. But here there is no real melding of the three, they coexist uncomfortably, and one—the theatrical recital—clearly predominates.

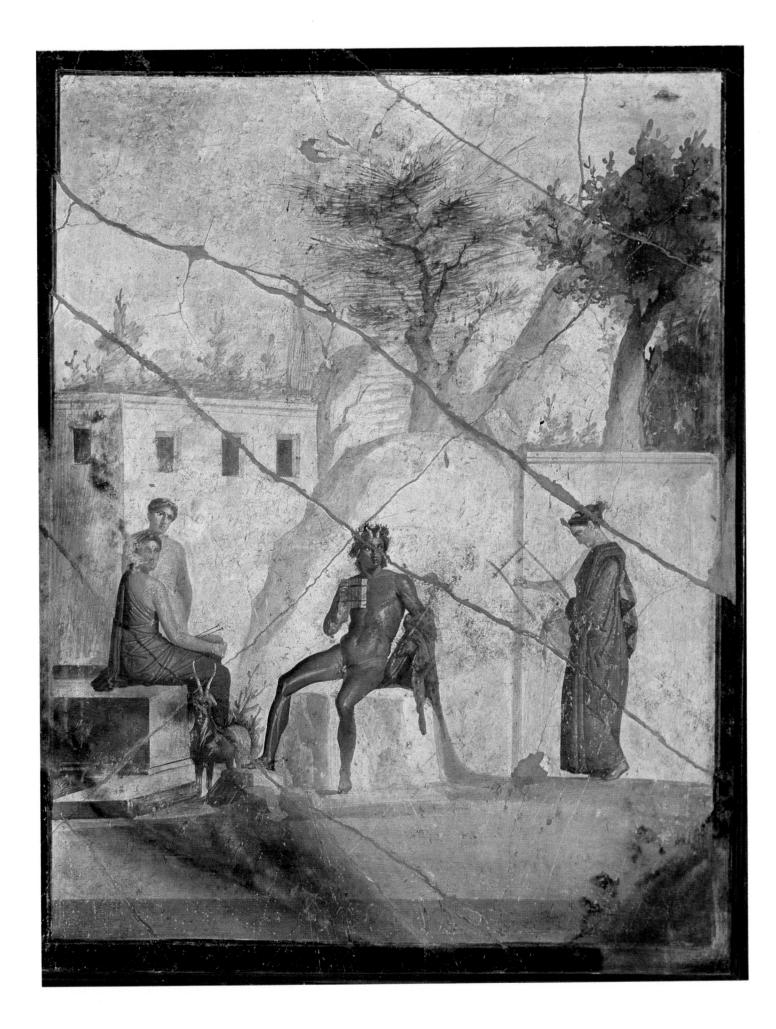

Gold Necklace, Armband and Bracelet

Museo Nazionale, Naples

T HE NECKLACE WHICH ENCIRCLES these pieces of gold jewelry is composed of forty-eight pieces of gold beaten and shaped to represent leaves of ivy. It culminates in a convex sun-like disk of gold, but the clasp is missing. An outstanding feature of the work is the veining the goldsmith has raised on each leaf, making them fresh and very lifelike.\(^1

The gold armband at left is in the frequently found shape of a serpent, though few examples are as finely wrought as this one. The scales of the snake, appearing on only one side, were impressed with a V-shaped punch. The tail doubles back gracefully to the body in a lovely figure eight. A vibrant note was originally added by green paste eyes, now lost.²

The gold bracelet at right is composed of two thick gold wires intertwined to form a series of eight loops, culminating in an ornament of scarab shape.

1. Siviero, no. 116 2. Ward-Perkins, I, 32

Earrings

Museo Nazionale, Naples

T HESE BEAUTIFUL EARRINGS are composed of pierced emeralds drawn together by gold wire tied against a gold frame. Clustered earrings of this type, which resemble bunches of grapes, were somewhat in vogue in the first century, and examples have been found with clusters of gold, glass beads, and pearl.

The jewelers had a ready market in Pompeii and formed an active profession there. Their organization, the *aurifices universi*, signed an electoral petition and supported candidates for office.¹ The level of business was such that even very specialized gem cutters and engravers were drawn to town and made a living there.

We know the names of at least two prominent local jewelers, who also sold gold and silver plate; Laelius Erastus and Pinarius Cerialis.² In the house of the latter, excavators found 114 stones of all kinds, some only partly cut, along with the tools for working them. In the shop of another, a visitor had left this note, perhaps shortly before the eruption: "I should like my jewel to be ready at three o'clock."³

1. Kraus, 152 2. Strong, 16 3. Tanzer, 54

Cobalt Blue Goblet

Museo Nazionale, Naples

T his is a glass drinking goblet of a type in general use by the middle of the first century A.D. For a long time before this, glass had been imported from Syria and Egypt, particularly from Alexandria, whose product was highly valued. Early glass was moulded or modeled, and the objects produced were both beautiful and costly. The invention of glass blowing in the first century B.C., probably in Syria, led to the mass production of glass objects, and for the first time, glass became available to the buyer of average means. This cobalt blue goblet was blown into a shaping mold. The two decorative bands on the outside were cut with a wheel, and the foot and stem were added separately. 1

The earliest glass works in Italy were established during the Augustan period at Volturnum in Campania, where sand from the Volturnus River proved ideal for glass making. Most fine glass in Campania came from there or from Puteoli, where glass blowing was a major industry. Trimalchio, in his villa at Puteoli, claimed that if glass didn't break, he'd prefer it to gold, and proceeded to tell the tale of a craftsman who invented unbreakable glass and rushed to announce the news to the emperor. When the emperor was assured that the inventor had not shared his secret with anyone else, he ordered him executed, saying: "If the secret were made public, gold would become as cheap as muck."

The predominant color for glass was bluish green, but a variety of colors are also found. Seneca writes of walls covered in glass tiles, and reported that glass globes filled with water were sometimes used to facilitate reading.³ Some glass windowpanes have been found at Pompeii and Herculaneum, and it appears they were coming into wider use at the time of the eruption. Seneca extolled baths that are so laid out that from the beginning to the end of the day they are flooded with sunlight through large windows: allowing one to be tanned as well as washed, with a view over countryside and sea.⁴

^{1.} Ward-Perkins, I, 30 2. Satyricon, XVI, 51 3. Newberg, 44 4. Brion, 120

Bowl with Birds and Cat

Mosaic, Museo Nazionale, Naples

T HIS LOVELY MOSAIC depicts two parrots and a pigeon perched on the rim of a birdbath. The bowl is probably part of the domain of the domesticated parrots, and they can afford to look away, knowing its nourishing waters will be there when next they desire them. The pigeon, on the other hand, is something of an interloper. He has just flown in and looks intently into the water, seeing a leaf and possibly his own reflection.

All is not peaceful, however. The ornery house cat at left ignores some fruit within its reach and hungrily eyes the more delectable fowl above. The parrots know him well, and it may be because of him that they are on guard and look away from the water

Campanians were very careful observers of animal life. A mosaic adjacent to this one in the National Museum at Naples shows a pigeon about to land on such a drinking bowl with his wings still outstretched in flight, but with its body drawn up and its claws reaching out for the rim.

The artist shows glints of sun on the scalloped rim of the metallic bowl through individual mosaic cubes of blue, red, and gold. The perspective of the plinth is slightly askew, but that does not in the least diminish the impact of this delightful work.

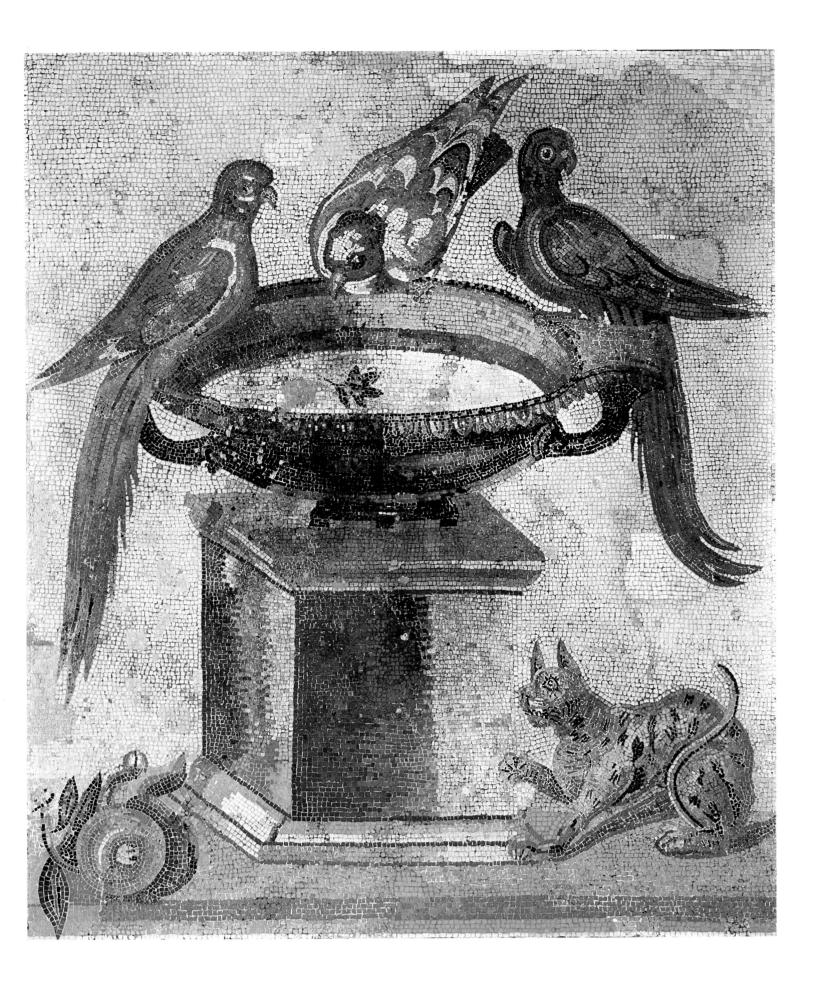

Marine Still Life

From Pompeii, Museo Nazionale, Naples

T HIS MOSAIC MIGHT WELL have served as the emblem of the fishermen and fish mongers of Pompeii. It is a virtual menu of all the fish which would have been available for sale then, and which are still found in local waters. The work does not come from the great fish counter of the provision market, the Macellum, where one would like to imagine it, but from the floor of a private home, whose owner we do not know. There is at least one other fine version of this theme.

The concept of sprinkling fish pell-mell over a neutral black ground would be surprising if we had no precedent for such an arrangement. We happen to know, however, that the mosaicist Sosos who originated the idea of strewing simulated objects on a tiled floor—trompe l'oeil representations of fish bones, claws, shell-fish, half-eaten fruit, and nutshells—earned a great reputation from his work. His mosaic came to be called "The Unswept Floor," and although this is not really an unswept floor, it is in the vein of that intriguing work.

The artist has depicted an outcrop of rock at the left border, on which a tern-like bird sits. There are also some rocks along the lower border, indicating a craggy coastline. If we were to take these landscape motifs seriously, we would have to object to the fish who seem to swim above water and to fly about with insouciant disregard of their natural habits.

At center, an octopus struggles with a giant lobster, while a moray eel looks on, possibly waiting for its chance to dispatch one of the former—Romans not only knew and observed animals well, they loved to watch them fight. Among the other fish shown are squid, bass, prawn, red mullet, dogfish, ray, wrasse, and a murex shell.²

In the days before the eruption, Pompeii was but a thousand yards from the sea; it is now somewhat over a mile from the sea at its nearest point. It had a lively fish trade, and its fishermen actively supported candidates for the municipal offices. The town produced and exported three much sought-after fish sauces, *garum*, *liquamen*, and *muria*.³ Many earthen jars have been found in distant sites bearing the label of the most prosperous of the Pompeian packagers, Umbricius Scaurus.

 $1.\ See\ Sterling,\ 11 \qquad 2.\ Ward-Perkins,\ I,\ 74 \qquad 3.\ Mau,\ 15$

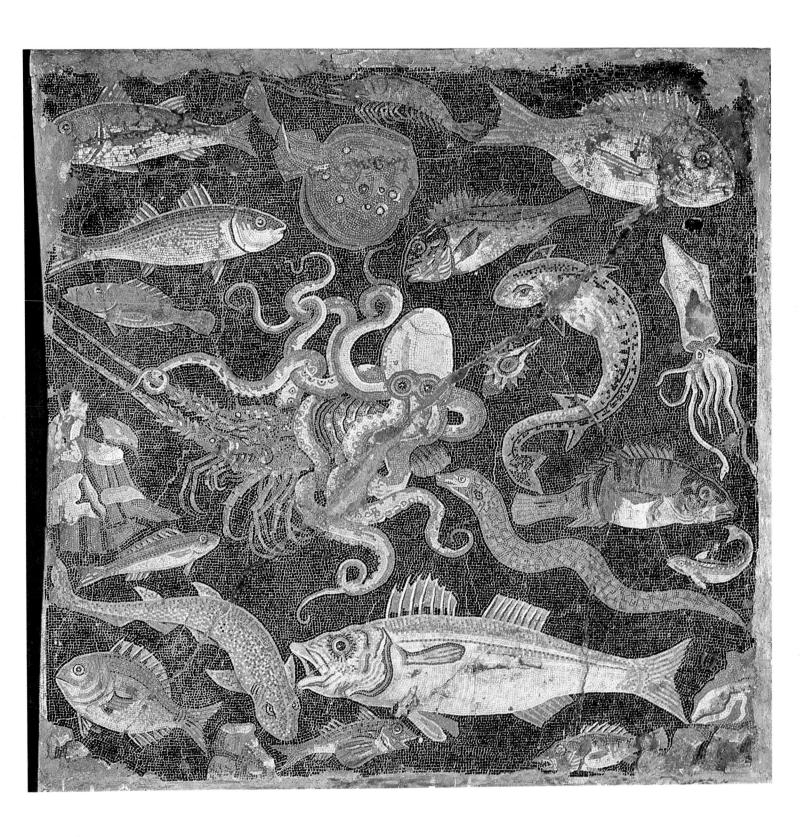

Still Life in Two Registers (Mosaic)

Museo Nazionale, Naples

 $P_{\text{LINY INFORMS US}}$ in the *Natural History* that the first painter to compose small genre pictures and still lifes of this kind was Peirakos, and that in painting food, asses, cobblers, and similar humble subjects, he earned the nickname "Painter of Odds and Ends." These gave much pleasure, however, and Peirakos was said to earn much more from them than other artists received for grander themes.

In the topmost register of this mosaic, a cat has fallen upon a bird and holds it down firmly with one paw. The bird, looking miserable, struggles to get free, but the cat is well in control and seems to be enjoying the action with wide glistening eyes.

In the lower register, ducks move tranquilly on a pond, one holding a marsh flower in its mouth. Below them, the artist has gathered all the fauna one might expect to find in a marshy seaside inlet: birds, sea shells, and fish: each arranged in its own schematic fashion. Thus, everything which flies above, swims beneath, nestles under, or glides upon this marsh is depicted here. The Roman's desire to categorize and list, which in this period produced some of the world's first encyclopedias in the natural sciences, is satisfied in this mosaic, as is, of course, his artistic sensibility, and in the top register, his love of combat.

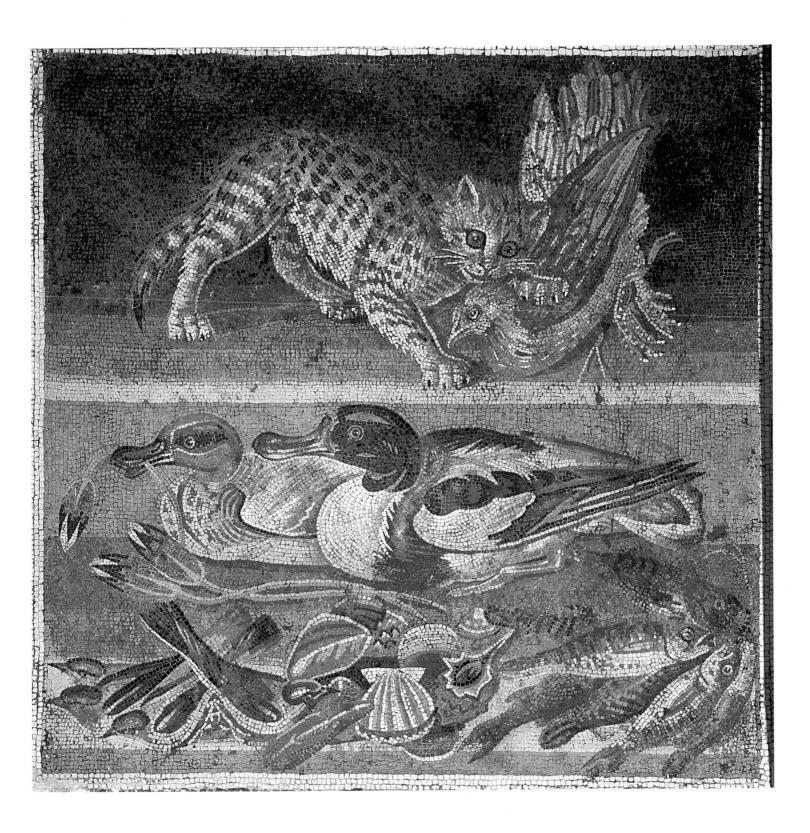

Still Life with Bowl of Fruit

From House of Julia Felix, Pompeii, Museo Nazionale, Naples

In this still life a delightful crystal bowl overflows with Campanian fruit. We recognize the large bunch of grapes, a staple of Pompeii's economy, and some apples, figs, and pomegranates. One ripe pomegranate has fallen from the bowl and split open, spilling some of its seeds onto the shelf.

At the right, an earthenware jug is piled high with what may be figs, and in the back an amphora leans against the wall, its lid sealed tightly with chords fastened to the handles.

The artist playfully reveals the contents of one container, wholly conceals the contents of another, and gives us a glimpse of the probable contents of the third, thereby seeming to satisfy and to tempt us at the same time. Compositionally, each container is echoed by a smaller shape at its side; with the ample bowl, it is the overripe pomegranate, with the closed amphora, an apple, and finally in the case of the earthenware jug, its own lid, which cannot fit over the bulging contents. The painting is organized on two tiers, with pride of place going to the raised glass bowl, which receives most of the light.

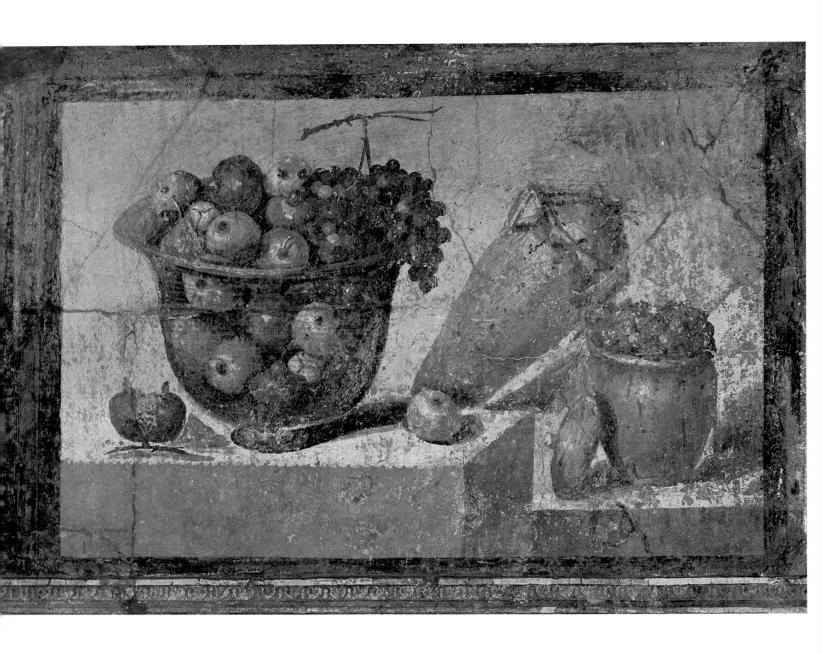

Leopard

Wall painting, Museo Nazionale, Naples

 $A_{\rm N}$ advertisement for upcoming games at the amphitheater of Pompeii promises thirty pairs of gladiators, and adds, "There will also be a combat between men and wild beasts." At Pompeii, animal baiting was on a comparatively modest scale when compared to the capital. In Rome, Titus alone put on a display in 80 A.D. (a year of plague and famine) in which nine thousand tame and wild animals were killed, some by women.²

The equivalent of private and public zoos existed, where animals could be visited or observed, and Romans commonly kept pets. Nevertheless, close contact with animals and genuine affection for some did not seem to breed a general sensitivity to their well-being, and we have but one record of a prominent Roman objecting to the cruelty practiced upon them: Cicero in *Ad Familiaries* asked, "What pleasure can a cultured man find in seeing a noble beast run through by a hunting spear?"

The earliest beast show to feature lions and leopards was given at Rome in 186 B.C. by Marcus Nobilior,³ but as Rome consolidated its foothold in Africa, great cats became increasingly available. Augustus displayed 420 leopards in one set of games, and as on all such occasions, it ended in the deaths of the animals. They were normally pitted against other beasts, convicts, or professional fighters.

This leopard may well have been intended for the games, or might have been among the relative few who were kept, or who were toured about provincial towns to be shown to the populace. Artists were avid students of their movements, behavior, and anatomy, as innumerable Roman works attest, so much so that perhaps no other period has produced such an abundance of fine art devoted to the animal. The half-seated, half-crouching leopard is beautifully observed. The artist conveys both a sense of rest and the potential for quick and sudden movement. The color harmony of the spotted coat against a pale gray-blue background is pleasingly completed in the burnt orange frame. Leopards and panthers were sometimes associated with Dionysus, as companion and preferred beast of conveyance, but even this mythological connection did not exempt them from the ring.

1. della Corte, 27 2. See Toynbee, 22 3. Toynbee, 19

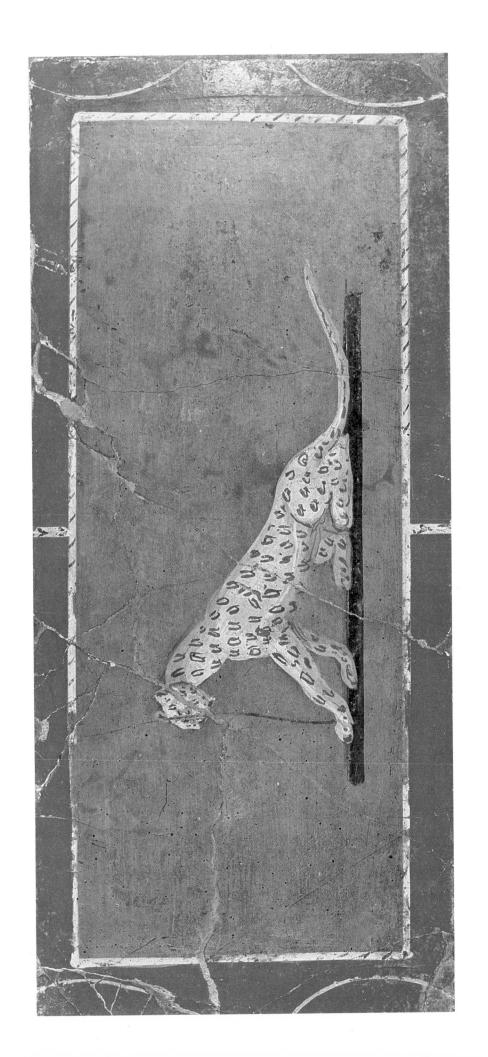

Fauna of the Nile (Mosaic)

Museo Nazionale, Naples

T HE ROMAN FASCINATION for Egypt, spurred by her conquest of that land in 30 B.C., is reflected in this mosaic depicting the animals of the Nile. As is so often the case in Roman representations of animals, the artist features situations of conflict. Three pairs of animals confront one another in the foreground plane, a mongoose and a snake, a hippopotamus and a crocodile, and two ibises. This is played out against a background of ducks peacefully gliding among the reeds of the river.

The hippopotamus who bares his teeth at center was very often associated with the Nile, and was conventionally shown immersed in water. The crocodile who confronts him was virtually a symbol of Egypt, and so it appears on coins struck by Augustus in 28 B.C., under the caption, "Aegypt."

The hissing snake, which is probably a cobra, attempts to fend off the persistent mongoose. As snakes were thought to embody or accompany the spirits of the dead, Romans did not look upon them with utter loathing. In Egypt too, positive theological connotations were often attached to snakes, and asps were kept by some as household pets. Aelianus said of them that when bidden from their lairs to table, they would come and eat gently, and by degrees, "with perfect table manners."

The ibises at right may be engaged in courtship play rather than combat. The ibis was sacred to the goddess Isis and was thought of as the quintessential Egyptian bird. The cult of Isis had widespread influence in Herculaneum and Pompeii, as well as in the rest of Italy, and we have the remains of a particularly successful Temple of Isis in Pompeii.

^{1.} Toynbee, 224

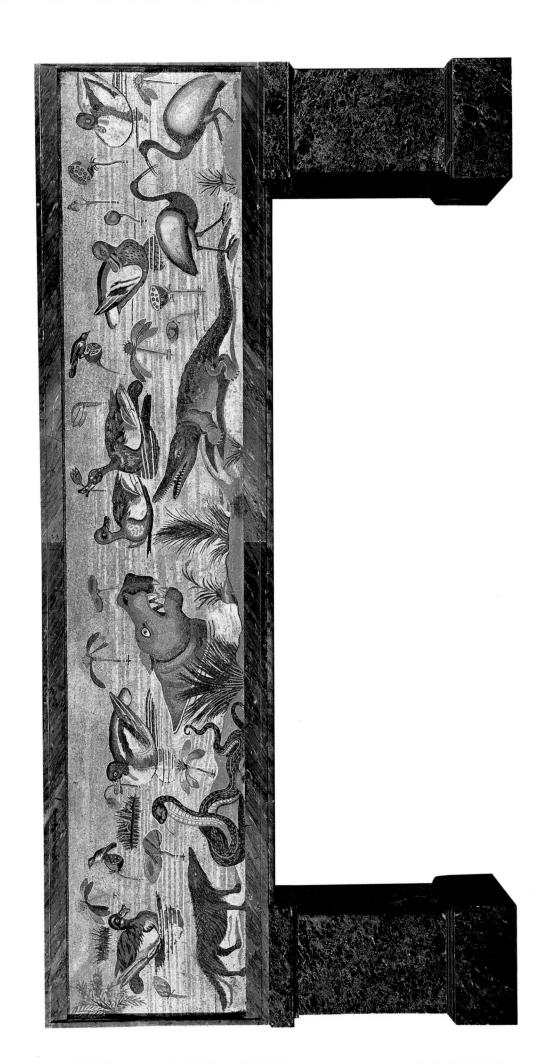

Death, the Great Leveler

Mosaic from Pompeii, Museo Nazionale, Naples

Symbolic of Man's fate, and particularly the fate of Pompeians, is this mosaic from an outdoor dining room. More than any other surviving work from Pompeii, it inadvertently summarizes the destiny of its people, while reminding all of the frailty of human existence.

The skull, of course, is a universal symbol of death; it looms large and overtakes everyone. Just beneath the death's head, a butterfly flutters to remind one that time flies and that the things of beauty and delight are evanescent and quickly disappear. The wheel beneath signifies the turning day and the wheel of fortune, which moves on. Above is a level with the plumb line hanging straight, indicating that all are made level by death, rich and poor alike. To expand on this point, the artist contrasts the accoutrements of the wealthy with those of the poor at either side. Beneath the arm of the level at right is a poor wanderer's staff, cloak, and pouch. Under the left arm is a mantle of royal purple, and the scepter of an emperor. Emperor and beggar alike are thus made equal by death, and not even a sovereign can arrest the mechanism of extinction. The shadows thrown by the mantle, wheel, and cloak are long—for the sun is setting.

Rather than shrink from such signs of death, Romans seem to have employed them as reminders to eat, drink, and be merry. This helps to explain why the mosaic was used as a table top. We have many examples of the adornment of cups or dining areas with such skeletal motifs. In the *Satyricon*, in the middle of the great banquet, a slave brings in a silver skeleton put together with flexible joints, and after it was flung on the table several times, the host Trimalchio recited:

Man's life, alas, is but a span So let us live it while we can, We'll be like this when dead.

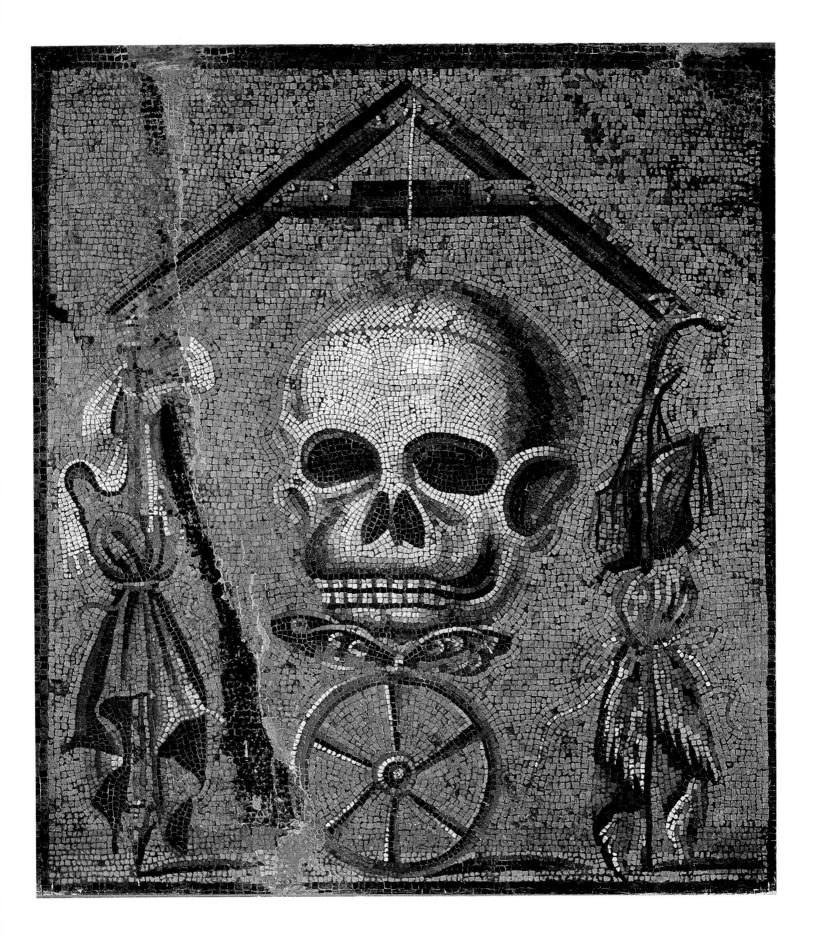

SELECTED BIBLIOGRAPHY

- Beare, M. A. The Roman Stage. London: 1964. (cited as:
- Bieber, M. History of the Greek and Roman Theatre. 2nd edn. Princeton: 1961. (cited as: Bieber)
- -Mystery Frescoes in the Mystery Villa of Pompeii.
- Breglia, Laura. Le Oreficerie del Museo Nazionale di Napoli. Rome: 1941.
- Brion, M. Pompeii and Herculaneum, The Glory and the Grief. London: 1960. (cited as: Brion)
- Corpus Inscriptionum Latinarum, Vol. IV. Ed. C. Zengemeister & A. Mau, Berlin: 1871. (cited as: C.I.L.)
- della Corte, M. Pompeii, The New Excavations. Pompeii: 1927. (cited as: della Corte)
- Croisille, J. M. Les natures mortes campaniennes. Brussels: 1965.
- Crook, J. Law and Life of Rome. Ithaca: 1967.
- Dawson, C. M. "Romano Campanian Mythological Landscape Painting" Yale Classical Studies. (1944) 9 & (1950) 12.
- Fattorusso, G. National Museum, Naples. Florence: 1925. de Franciscis, A. The National Archaeological Museum of Naples. Naples: 1974.
- -Pompeii. Naples: 1972.
- Gabriel, M. Masters of Campanian Painting. New York:
- Grant, M. Cities of Vesuvius: Pompeii and Herculaneum. London: 1971. (cited as: Grant)
- Higgins, R. A. Greek and Roman Jewellery. London: 1961.
- Isings, C. Roman Glass from Dated Finds. Groningen: 1957.
- Juvenal, Satires. Translated by P. Green. London: 1967.
- Kraus, T. and von Matt, L. Pompeii and Herculaneum, The Living Cities of the Dead. New York: 1975. (cited as: Kraus)
- La Rocca, E. Guida archaeologica di Pompei. Milan: 1976.
- Maiuri, A. Herculaneum. Rome: 1970.
- -Paintings from Pompeii, Herculaneum and Stabia. Milan: 1961.
- *——Pompeii*. Rome: 1965.
- ———Pompeian Wall Paintings. Berne: 1960.
- -Roman Painting. Geneva: 1953. (cited as: Maiuri)
- Maiuri, B. Museo Nazionale, Napoli. Novara: 1971.
- Martial, Epigrams. Translated by C. Ker. London: 1919.
- Mau, A. Pompeii, Its Life and Art. Translated by F. W.

- Kelsey. New York: 1902. (cited as: Mau)
- Neuberg. F. Ancient Glass. London: 1962.
- Oxford Classical Dictionary, 2nd edn. Oxford: 1970. (cited as: O.C.D.)
- Palombi, A. "La fauna marina nei mosaici e nei dipinti pompeiani," Pompeiana (1950) 425ff
- Peters, W. J. Landscape in Romano-Campanian Mural Painting. Assen: 1963.
- Petronius, Satyricon. Translated by J. P. Sullivan. London: 1965.
- Picard, G. Roman Painting. Milan: 1968.
- Pliny the Elder, Natural History. Cambridge: 1938-1962. (cited as: Natural History)
- —The Elder Pliny's Chapters on the History of Art. Translated by G. K. Jexblake. London: 1896.
- Pliny the Younger, Letters of Pliny the Younger. Translated by B. Radice. London: 1963.
- Reinach, A. Textes grecs et latins relatifs a l'histoire de la peinture ancienne. Paris: 1921.
- Ruesch, A. Naples National Museum, Excerpt of the Guide. Naples: n.d.
- Seyffert, O. Dictionary of Classical Antiquities. Revised by H. Nettleship and J. Sandys. New York: 1959. (cited as: Seyffert)
- Siviero, R. Gli ori e le ambre del Museo Nazionale di Napoli. Florence: 1954. (cited as: Siviero)
- Spinazzola, V. Le arti decorative in Pompeii e nel Museo Nazionale di Napoli, Milan: 1928.
- Sterling, Charles. Still Life Painting from Antiquity to the Present Time. Paris: 1959. (cited as: Sterling)
- Strabo, Geography. Translated by H. Jones. London:
- Strong, D. E. Greek and Roman Gold and Silver Plate. London: 1966. (cited as: Strong)
- Roman Art. Prepared for press by J. Toynbee. London: 1976.
- Swindler, M. Ancient Painting. New Haven: 1929.
- Tanzer, H. The Common People of Pompeii, A Study of the Graffiti. Baltimore: 1939 (cited as: Tanzer)
- Toynbee, J. M. Animals in Roman Life and Art. Ithaca: 1973. (cited as Toynbee)
- Vitruvius, On Architecture. Translated by F. Granger. London: 1931.
- Ward-Perkins, J. and Claridge, A. Pompeii A.D. 79, Vols. I & II. Boston: 1978. (cited as: Ward-Perkins)